Thames & Hudson

CRACKING ANIMATION

Peter Lord & Brian Sibley
Foreword by Nick Park

contents

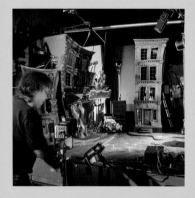

foreword Nick Park

I wish this book had been written in the Seventies when I was a teenager and started experimenting with animation and making my first movies. I did not meet another animator, or even anyone with a vague knowledge of the technique, for years. My early experience in animation was therefore a solitary one; a case of guesswork and trial and error. I felt that everyone else must be 'doing it right', and there must be something very obvious that everyone else knew about that I was not doing. I scoured old library books and movie magazines for any scraps of information, but found very little.

Later I met Peter Lord and David Sproxton whose work I had long admired. Through them and Aardman Animations I met more of our species, and was surprised to find that they had all felt similarly isolated and had worked through experimentation either at college or on the kitchen table.

Although there is now a great deal more information available about animation, especially now that computer animation has become so prominent, this book still holds a wealth of valuable hints, tips and insights. In the past few years it has actually become much easier to make animated films using small video cameras and simple computer systems, but the performance skills and story-telling aspects of the craft never change. I hope this edition fills you with enthusiasm for the world of 3-D animation.

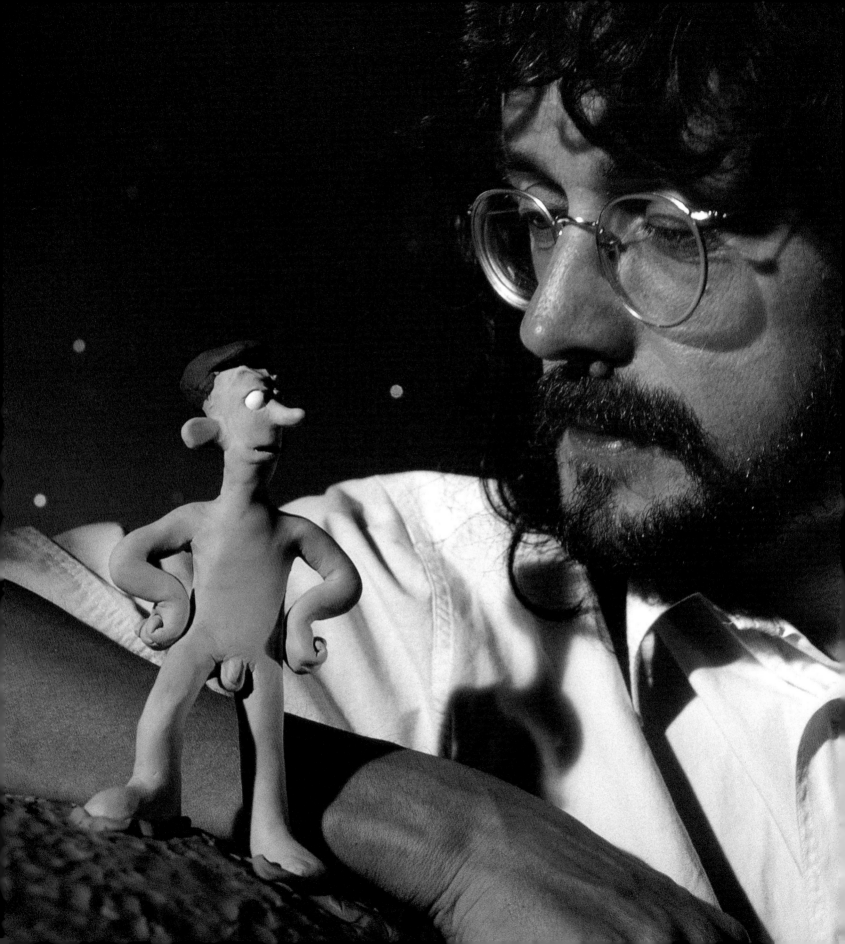

introduction Peter Lord

**Peter Lord with his
character Adam. Released in
1991, *Adam* won Aardman an
Oscar® nomination.**

I began animating as a hobby, when I was a teenager, many years ago; and though
of course it's now become a career, it's a career with much of the charm, and the
fun of a hobby. Other boys of my age were spending their leisure time building
model aircraft, or recording train numbers, or sitting on riverbanks awaiting the
appearance of fish. But Fate led me to animation. Fate in the shape of my best
friend's Dad, who owned a cine camera.

I met Dave Sproxton, my partner at Aardman, when we were both twelve. We
sat at adjoining desks at Woking Grammar School for Boys. His father was a keen
photographer, who worked for the BBC as a producer of religious programmes.
Like many a producer in those days, and probably to the despair of the Film
Union, Vernon Sproxton was not averse to shooting some of his own material if
he could get away with it. So he owned a cine camera, a clockwork 16mm Bolex,
which was the key factor in our decision to become animators. Along with access
to the camera, Dave picked up his father's enthusiasm for photography and an
understanding of how films are made. It is significant that Nick Park grew up in
a similar environment. His father was a professional photographer who had also
dabbled in film-making. He had even done a little bit of animation. So in Nick's
family too there was always a cine camera about the place. In both households,
film-making was made to seem possible and accessible, even normal.

So we had access to the camera; and one rainy day, probably encouraged by
his father, Dave and I experimented with animation. In the great tradition of
British amateurism our first film was made on the kitchen table. Only later, after
we had served our apprenticeship, and got in the way of everybody's mealtimes,
did we advance to the spare room. Our camera was mounted on a developing
stand pointing straight downwards at the table, and our first piece of animation
was achieved by drawing a chalk figure on a blackboard, shooting a frame, then
rubbing out part of the figure, redrawing it in a new position and shooting
another frame. And so on. At the time it seemed painstaking, but compared to
some of our subsequent experiences in animation, that first film was a high-speed,
spontaneous affair.

We did not launch into animation entirely unprepared. We had seen
documentaries about the world of cartoons, and heard how Disney and Hanna
Barbera made films with thousands of separate drawings on acetate sheets, but
we had no access to the techniques or the materials to shoot this sort of
'traditional' animation. We made up the chalk technique quite independently, to
suit our circumstances, though I now know that like so much else in the world
of animation it had all been done before - much of it ninety years ago or more!

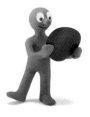

The original Aardman, a cel sequence featuring an inept figure with a costume based on Superman.

In a matter of hours we became bored with chalk animation, and tried a different technique: cut-outs. We cut pictures out of magazines, crudely cutting off their limbs so they could be animated as separate elements. We had discovered one of the quicker and simpler forms of animation. Our first 'film' consisted of several experiments like this. It was simply a string of animated events, lasting for a couple of minutes. We had no story to tell, no ideas to convey, it was strictly stream of consciousness. We called it *Trash* - not knowing that Andy Warhol had already used the name. It took only a couple of days to complete - although at the time that seemed a pretty mammoth effort - and for the first but not the last time we observed that animation was a slow process.

Now I've mentioned the camera and I've mentioned film. Remember this was in the late '60's. Animation then was all produced on film, whereas now just about everybody works digitally. The significance isn't in the animation itself, but in the way you record it and view it. When you shoot on film, you can't watch the animation that you're doing, or check on it until the film has been chemically developed. You just have to trust that you're doing it properly. We call it 'working blind'. So in those far-distant days there was an extra magic to animation: you'd work for hours, or even days, believing and hoping that your animation was going to be good. But you didn't know. So when the developed film was returned to you, perhaps two or three days later, you saw the result of your efforts in one amazing rush. Often exhilarating, sometimes disappointing. It's a way of working that now largely belongs in the past.

The studio during the early years - when the entire modelmaking department was confined to a single table.

Back then, when we sat down in the living room to show our short film to our admiring families, it was a truly amazing experience. We saw things moving and 'living' which never moved or lived. We felt, very briefly, like gods of creation. And I'm happy to say that now the techniques are so different still the excitement of creation is as strong as it ever was. There's a true, deep magic to animation that should never fail. The day-to-day business of it is often slow, repetitive and painstaking - and seldom particularly funny - but when it's all over, when the

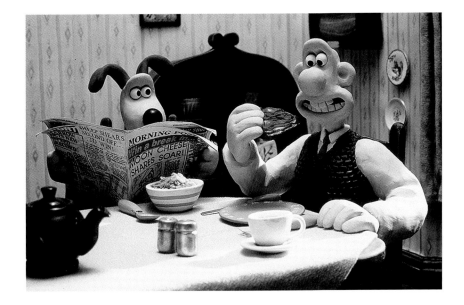

'Cracking toast, Gromit!' Wallace and Gromit at the breakfast table in *A Close Shave* (1995).

performance is finished and the hard work mostly forgotten, then you see the result and bingo! - It's alive.

We followed *Trash* with a film called *Godzilla*. Naturally it had no giant lizards in it. It was a similar mix of techniques: cut-outs, chalky, swirly transformations which used the properties of chalk to blur and soften and drag out a line, and a couple of 3-D objects, like toy cars, thrown in for good measure. Though I have not seen either film for twenty years, I assume it was an improvement on *Trash*. When you are just starting out in animation, you learn really fast. Every new completed piece is a revelation. It's only by watching your finished work - for better or worse - that you learn about clarity, readability and above all timing. You realise how every fragment of a second can be crucially important.

Shortly after this, Dave's Dad arranged for us to show our work to a producer at the BBC. Patrick Dowling produced the 'Vision On' series, which was specifically designed for deaf children. It was a great programme - imaginative, brave, technically innovative and stimulating for those with hearing as well as the deaf because it presented visual information in an intelligent and surprising way. The outcome of our first meeting was that PD, as we called him - everyone knew that TV execs were known by their initials - gave us a 100ft roll of film to experiment with. In the late 1960s this precious roll of unexposed negative probably represented the BBC's total investment in new animation talent.

We filled that roll with tests and experiments - some chalk animation, a cel sequence (the original Aardman film), some pixilation (where human beings are

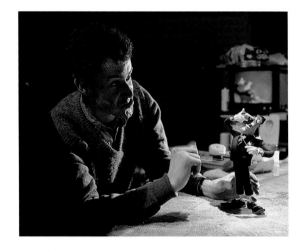

Today the Aardman studio plays host to a growing number of talented film-makers. Here Jeff Newitt acts out the facial expressions of his character while animating him for *Loves Me ... Loves Me Not* (1992).

treated as animation puppets), and a couple of sequences where we experimented with modelling clay. In one of these, we made a low-relief clay model of a cottage - a crude, childlike thing, I recall. As before, the camera was directly above, looking down on to the model. Under the camera it metamorphosed, as only modelling clay can, into a low-relief model of an elephant. Not the world's greatest storyline, I agree. The BBC showed no inclination to buy this piece, or to commission more, but for me a seed was sown. I had tried this new malleable medium and found it strangely attractive. It took another couple of years for the technique and the storylines to evolve, but our animation future was going to be in three dimensions.

In fact what the BBC did buy was the Aardman sequence. It was a piece of traditional cel animation, and I remember it as the most 'professional' piece on the roll. I should explain the name: Aardman is a character that I originally drew in a strip cartoon. He was based on Superman - in costume, at any rate - with a jutting chin, a cape and a large letter 'A' on his chest. He became the star of our first cel animation, though we left the letter 'A' off his chest, because it took too long to draw.

In his first animated appearance Aardman is walking past, as I recall, a background of brown wrapping paper. He has a goofy walk: legs bent, leaning well back, his arms not swinging but hanging straight by his sides. As he walks, he approaches a cartoon 'hole' - the classic black ellipse on the ground. He stops, sticks out a foot and taps the ellipse. It seems solid. He walks on, right over the 'hole', quite unharmed. One step later, he falls through the ground, down an invisible hole. After a pause, his hand emerges from the ground, feels around, finds the ellipse and pulls it over himself. Then he climbs out and walks off.

That may not be a gripping read, but it was good enough to get bought - and for £15 or so. This was the moment when, faced with a 'purchased programme' agreement and a cheque from the BBC, we opened a bank account in the

name of Aardman Animations. I remember discussing the merits of 'Dave and Pete Productions', 'Lord Sproxton Films' and numerous other possibilities - but 'Aardman' it was.

Two teenagers picked a name, little dreaming that it would hang around so long and travel round the world. Now so many years later, the name no longer stands for a couple of enthusiastic schoolboy animators; now it stands for a diverse group of film-makers, producers and writers - a studio, in fact. We've produced numerous children's TV series - like *Morph* and *Shaun the Sheep* - we've made hundreds of TV commercials, we've created web sites and filled them with animation and stories, we've made numerous short films - a few of which have won Academy Awards! - and we've produced a number of full-length feature films. But the impulse that drives us is still the same - we want to tell stories and we love making films.

Scene from Peter Lord's medieval fantasy *Wat's Pig* (1996).

Initially, it was terribly simple: two young men making short animated films to amuse themselves, for the pleasure of creation, for the pleasure of communication, to show off, to do something a little different, to get a laugh, to affect people we had never met. Later, as Aardman got bigger and more established, we discovered that we were not just individuals whistling in the dark but part of a scattered and formless community of film-makers in Britain and worldwide.

Then gradually the approval of the wider world became important. Suddenly a film was more than just a story told for a few friends, or broadcast to a large invisible TV audience. It became like a public statement, or a brick in the wall of something much larger and oddly noble: 'The World of Animation'. Later on the game changed again as we started to employ people, like Nick Park and Richard Goleszowski who made their own films - independent creative voices which became crucially and definingly 'Aardman'. For Dave and I, the source of pleasure changed slightly. From being entirely selfish, it became broader: from look-at-me to look-at-us. It was a bit like becoming a parent. Before you become a parent, life is more or less selfish. Then, when you have kids, you start to live through them to some extent - for good or ill - enjoying their triumphs and sharing their defeats.

When we were just a two-man partnership, life - or at any rate business - was simple. But now we are a studio, often employing hundreds of people, and our operation has become very complex and fascinating - not to mention

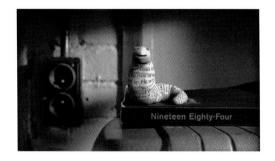

bewildering. The last seven or eight years have seen huge changes as we've embarked on feature films and entered the world of computer animation.

Making features like *Chicken Run* and the *Curse of the Were-rabbit*, was a challenge we couldn't resist. There's not much point in making films if you don't show them to other people; and while a large TV audience is a very satisfying thing, there's nothing to beat the excitement of showing your work to hundreds of people in a cinema. With a live audience, the film itself comes to life in a way which never happens on the small screen. Anyway, for whatever reason, we were determined to 'crack' Hollywood, and I can report that it was a massive effort. Though *Chicken Run* was only three times as long as *The Wrong Trousers*, the whole scale of the shoot seemed to be about twenty times bigger. We had to train new animators, convert a warehouse into a customised stop-frame studio and build hundreds of chickens. I'm proud of the fact that we managed to expand the operation to an almost industrial scale and yet still retained the heart of stop motion animation. Our feature films are still truly Aardman films. They're made by huge teams of talented people - who love what they're doing and do it especially well.

At about the same time as we were embarking on feature films, we started seriously developing our CGI department, and every year we produce more and more computer animation alongside our traditional work. Of course these days, when most people in the film industry talk about 3-D animation, it's CGI animation they're talking about and probably in stereo too. So I'm happy to claim that we're involved in the best 3-D animation - whether it's actual or virtual. Within Aardman, there are some of us who cross over from the hands-on world of the studio floor, with its cameras, lights and modelling clay, to the world of computers and monitors. Others stay firmly on one side of the fence or the other and show no desire to move. There's no doubt in my mind that in our traditional hand-made animation we produce something unique and increasingly rare. But to me, the essential point is the similarities between the techniques: both require an expressive use of camera angles, lenses and lighting. Both depend on acting, movement and the expressive use of the body, the hands, the face and especially the eyes. All the really important things apply to either medium: storytelling, editing, composition, design, and performance.

So Aardman is still growing, and changing as it has done ever since 1976 when we officially decided to go professional. Today we employ all the skills and the crafts of a busy film studio. There are animators, of course, but we also employ

A scene from *Chicken Run,* Aardman's first feature-length film. The chicken's sense of rhythm has been set alight by their American visitor.

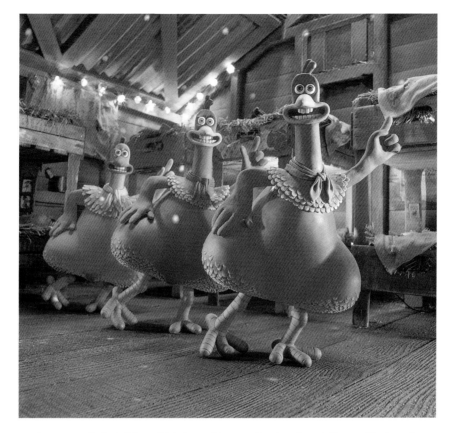

A scene from *Chicken Run,* Aardman's first feature-length film. The chicken's sense of rhythm has been set alight by their American visitor.

engineers and electricians. Lighting grids need to be rigged, films edited, and scripts developed, but the year-end accounts also have to be prepared on time. As well as people who make models we need people who strike deals. We need to be profitable to continue to do what we love, but making money is not what interests or motivates us. It is certainly not why we make films.

The big pleasure for me at this stage in Aardman's evolution is the sense of being surrounded by an immensely talented community. I love being among creative people, under one roof, generating ideas, discussing them, interacting, being influenced and affected by each other. And the studios are a very exciting workplace, the product of thirty-five years of growth change and innovation. Ever since the old days of the kitchen table, we have steadily opened ourselves up to new ideas and technology. As we have met other specialists in our tiny field we have learnt new techniques, tricks and practices which have changed our way of working. Part of what we do is standard film-industry practice, part we have learned from other animation studios, part from the theatre and much has simply evolved on site. Technology, culture and working practice have slowly accumulated like a coral reef, or like a junk pile, if you prefer. All that knowledge has been built up by trial and error and by word of mouth over many exciting years and this is a chance to share at least some of it. How often we wished in the early days that some predecessor of ours had written a book like this, to pass on the precious information.

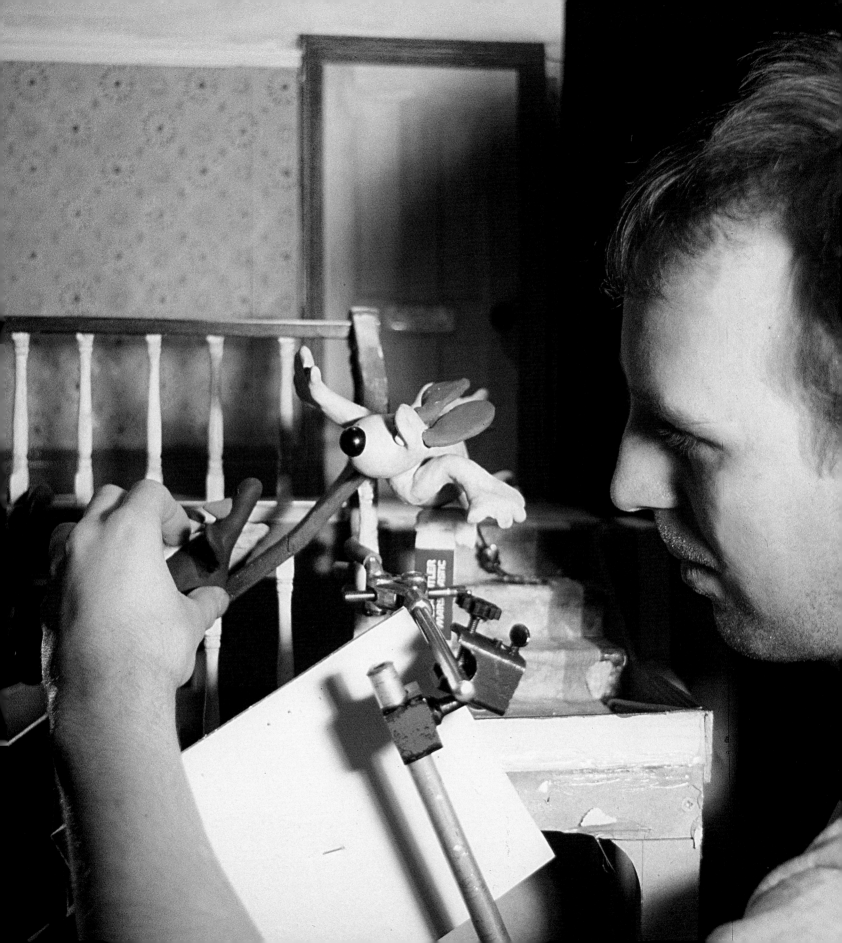

the medium Brian Sibley

Steve Box animates the fleeing Penguin in the staircase sequence of *The Wrong Trousers* (1993).

Animation is a form of movie magic that has its origins in a tradition that is longer and older than might, at first, be supposed. The aim of this opening section is to provide an independent view of the history of animated films, both drawn (2-D) and model (3-D) animation, and to place the work of Aardman Animations within the broader context of a film-making technique that began in the 1890s.

One of the earliest films by Peter Lord and Dave Sproxton shows a human hand flattening and shaping a ball of clay that then takes on animated life. A tiny hand and arm reach up out of the clay, then another hand and arm emerge, followed by the head and torso of a little man, struggling to haul himself free. Then the human hand reappears, seizes the man and wrenches him - fully formed - out of the clay. This little being, made from the very stuff of the earth itself, looks towards his creator, sits down and assumes the position of Rodin's sculpture, *The Thinker* ...

The creation myth is very old and is found, with variations, in many different cultures and faiths. As a symbolic picture, explaining not just the origin of man but also the source of man's creativity, it has provided a recurrent image for artists down the centuries and, in particular, for the work of the three-dimensional animator. Peter Lord, for example, returned to the idea in his 1991 Oscar-nominated film *Adam*, in which the relationship between an animator and his clay became an amusing analogy for the relationship between God and Man.

But first things first: what is 3-D animation? Most forms of animated film-making achieve their effect through essentially flat images usually drawn on cels (transparent sheets which can be overlaid on background paintings and then photographed), but occasionally painted on glass or even directly onto the film itself. A three-dimensional animator, however, works with articulated puppets or with models built around a metal, moveable 'skeleton' called an armature, and made of modelling clay, fabric or latex. Occasionally, the 3-D animator will work with cut-outs, and he often uses his skills to give animated life to a bizarre range of inanimate objects from a bra to a burger.

The power of animation lies in the fact that, like all film, it plays with an optical illusion known as 'persistence of vision'. The human eye retains an image for a fraction of a second after it has been seen. If, in that brief time-space, one image can be substituted for another, slightly different, image, then the illusion of movement is created. What we are really seeing when we look at a cinema screen is not a 'moving picture' at all, but a series of still pictures - 24 every second - shown in such rapid succession that our eyes are deceived.

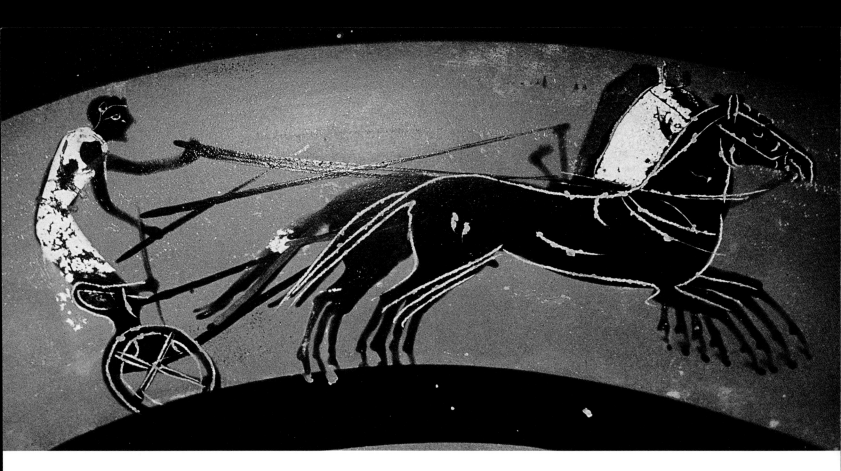

**Capturing the dynamics of
action: a Greek image of
chariot racing from the 6th
century BC.**

The essential difference between making a live-action and an animated film is
that the live-action camera captures a scene moving in *real* time, automatically
'freezing' it into separate still pictures, which can then be projected onto a
screen. For the animator, however, nothing exists to be filmed until it is created
and put in front of the camera. Using drawings, models or, increasingly
nowadays, computer imagery, the animator creates every single frame of film
from scratch. In a live-action film, there is nothing hidden between one frame
and the next, whereas the space between every frame of an animated film
represents a complex series of creative actions which, if the film is well made,
will be undetectable to the audience.

Not only must characters and settings be designed, but decisions must also be
taken about what movement will be involved in a scene and the kind of shot -
such as a close-up or a long-shot - that will be used. So, whilst animation is a
highly creative medium, it is weighed down by time-consuming processes that
require the successful animator to have vision, vast quantities of patience and a
sustained belief in the film that is being made.

There is also a major difference between drawn and model animation, as Peter
Lord explains: 'Drawn animation is a process that develops in a very controlled,
measurable way. When your character is walking (or jumping or flying) from A
to B, you start by drawing position A and position B, the key positions, and
then you systematically draw all the positions in between - the animation. But
in puppet animation, when you set off from position A you do not know where
B is, because you have not got there yet (like real life, come to think of it). So

every single stage of a movement is an experiment, or even an adventure. You have this idea of where you are heading, but no certainty of getting there ...'

The desire to animate is as old as art itself. The early man who drew pictures on his cave wall depicting spear-waving hunters in pursuit of a wild boar attempted to convey the illusion of movement by showing the beast with multiple legs. The vases of ancient Greece with their gods and heroes, and the friezes of Rome with their battling warriors and galloping steeds, also sought to capture, in static images, the dynamics of action. Stories of pictures that came to life can be found in folklore and fairy-tale, but it was not until the 19th century - in the years leading up to the invention of the motion picture - that animated pictures became a real possibility.

Among the many pioneers in Europe and America who explored ways of capturing images of real life, and attempted to analyse and replicate movement, were Britain's William Henry Fox Talbot, who devised a photographic method for recording the images of the 'camera obscura', and English-born American, Eadweard Muybridge, who, in 1872, began producing a series of studies of human and animal life, photographed in front of a plain, calibrated backdrop. The photographs, shot every few seconds, revealed what the human eye cannot register: the true complexity involved in the mechanics of physical locomotion.

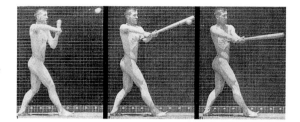

Muybridge's baseball hitter, who served as a model for the animated sequence shown on pages 142-143.

A photographic sequence by Eadweard Muybridge, whose 19th-century experiments have been of priceless help to later generations of animators.

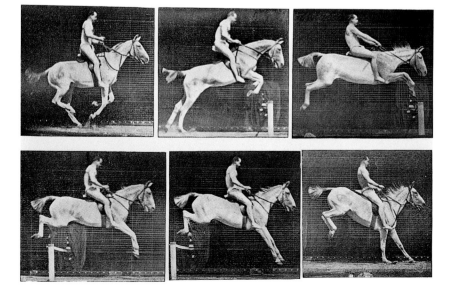

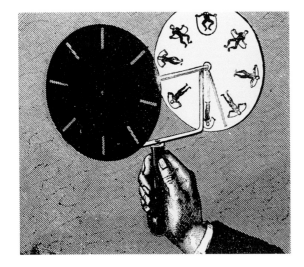

The Phenakistiscope, invented in 1832 by Joseph Plateau. When the picture disc is spun, a viewer looking through the slots sees continuous movement. In other versions the slots and pictures are combined on a single disc, and viewed in conjunction with a mirror.

In 1880, Muybridge conducted one of his most sophisticated experiments when he photographed a running horse using 24 still cameras set up alongside a race track and triggered by a series of trip-wires. Muybridge's photographs of horses, dogs and the naked human form would become an indispensable aid to later generations of animators. Indeed, while Peter Lord was working on some of the models shown in this book, such as the baseball player on page 142, Muybridge's book was a constant source of reference.

Experimentation with photographic and optical techniques led to various devices such as the Stereoscope, which used two slightly different photographic images to create the illusion of 3-D pictures, and sophisticated magic-lantern slides on which parts of the picture could be made to move: a ship tossing on a stormy sea, a rat running into the open mouth of a sleeping man.

There were also a number of popular optical toys, designed to recreate the illusion of life. The earliest, and simplest, devised in 1825 by Dr John Ayrton Paris, was the Thaumatrope: a disc of card with a picture of a bird on one side and a bird-cage on the other. Strings attached to either side of the disc were twisted tight and held taut; then, when the tension on the strings was released, the disc spun so fast that the bird appeared to be inside the bird-cage.

Seven years later, Joseph Plateau, a physicist from Belgium, invented the Phenakistiscope, a disc fixed to a handle (rather like a child's windmill toy) so that it could spin freely. Around its perimeter the disc had a series of drawn figures in various stages of movement, separated by slots. The disc was held up to a mirror and spun, while the viewer looked through the slots and saw - reflected in the mirror - a running horse, a leaping acrobat or some other moving miracle.

William George Horner of Britain was the first to attempt to create moving images for more than one viewer. He devised the Zoetrope, in which spectators looked through slots in a fast-moving drum at a continuous strip of drawings arranged around the inside. The speed with which the drum revolved blurred the slots into a 'window' and gave life to the static pictures. For variety, the strips of drawings could be changed, but the sequences were limited and repetitious such as a dog jumping through a hoop, or a clown's nose endlessly growing and shrinking.

The Praxinoscope, a drum viewer. The images on the perimeter of the drum are reflected in a mirror as they flash past the viewer's eyes.

It was due to a visionary Frenchman, Emile Reynaud, that the evolution of the animated film took two major steps forward. The first of these, invented in 1877, was the Praxinoscope, a sophisticated development of the Zoetrope, which enabled viewers to watch the moving pictures as they turned past the eye on a rotating drum.

Reynaud, who was a painter of lantern-slides, spent the next fifteen years improving his device until he found a method of combining the illusion created by the Zoetrope with the projected images seen at the magic-lantern show. The Théâtre Praxinoscope, as it was called, used light and mirrors to show a limited cycle of moving figures against a projected background on what looked like the stage of a toy theatre. Reynaud then further refined his device into the Théâtre Optique, first demonstrated at the Musée Grévin, Paris, in 1892. This elaborate machine simultaneously projected 'moving pictures' and backgrounds onto the same screen. The shows, entitled 'Pantomimes Lumineuses', were not limited to the short cycles of action seen on a Praxinoscope but lasted up to fifteen minutes and comprised some 500 pictures on a transparent strip of gelatin. Although the mechanism had to be turned by hand (a laborious process for the operator), Reynaud's equipment anticipated various cinematic devices including the film-spool and sprocket-holes for moving the pictures on while, at the same time, keeping them in focus. Interestingly, Reynaud used drawings rather than photographic images, and every subsequent animated film using line animation - from Felix the Cat and Mickey Mouse to the Rugrats and the Simpsons - is a successor to the moving pictures that he created.

Reynaud's 'films' were simple - sometimes mildly saucy - tales mainly concerned with love and rivalry: a young lady at a seaside resort goes into a beach hut to change into her bathing costume, unaware that a peeping tom is watching her through the door. The cad is eventually given the boot by a young man who, as a reward for his gallantry, is allowed to accompany the young lady on a swim. Audiences were amazed and delighted by these moving drawings, but rapid developments quickly provided new entertainments that were to upstage Reynaud's Théâtre Optique.

Experiments by Etienne-Jules Marey in France, Thomas Edison in America and William Friese-Greene and Mortimer Evans in Britain resulted in coin-in-the-slot 'box-projectors' showing acrobatics, ballet and boxing matches, slapstick

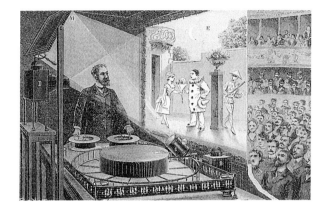

Emile Reynaud and his Théâtre Optique, which projected 'moving pictures' and backgrounds on to the same screen.

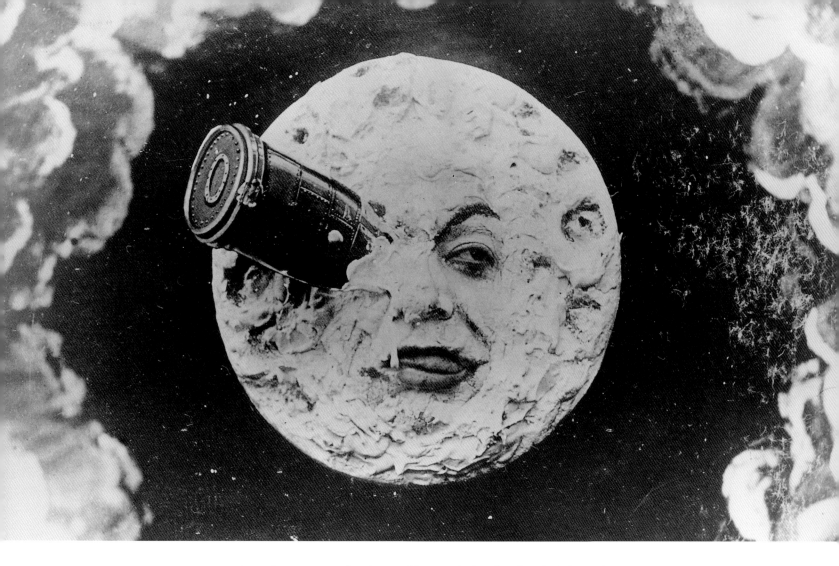

The rocket lands on the eye of the Moon, from Georges Méliès's fantasy film *Voyage to the Moon* (1902).Many of the visual tricks employed in this film were achieved by stopping the film, altering the image and photographing the new scene.This later becameone of the basic techniques of 3-D animation films.

comedy routines or saucy fan dancers. The popularity of such entertainments was eventually eclipsed by the invention of a device that was, for ever, to change the culture of the world - the Cinématographe.

It was in 1895, just three years after Emile Reynaud showed his Théâtre Optique, that two French brothers, Auguste and Louis Lumière, presented the first authentic demonstration of what we now think of as cinema. There was nothing particularly sophisticated about the Lumières' first films - workers leaving a factory, a baby being spoon-fed, a train entering a station - but to those early audiences they were nothing short of miraculous. Indeed, when the railway engine rushed towards the camera, billowing clouds of smoke and steam, some patrons were so startled by the realism that they fled the theatre before the engine could run them down!

Emile Reynaud's presentations of moving drawings had been superseded. The Lumière brothers were offering audiences not characters from a toy-theatre, but images of real people. However, since the appeal of mere novelty tends to be short-lived, the time soon came when audiences ceased to be astonished at the moving picture's ability to hold a mirror up to life and began to demand

stories. The fledgling cinematographers responded not just with dramas, comedies and romances but also with fantasies. And there was one fantasy film-maker in particular who made a discovery of vital importance to the technique of animation.

The films of Georges Méliès grew out of his childhood love of marionettes and toy theatres combined with an adult fascination with conjuring. Describing himself as 'a great amateur of the magical art', Méliès was an accomplished stage-illusionist who saw the new medium of cinema as a natural extension of his magical arts with their transformations, metamorphoses and mysterious appearances and disappearances. The sources for his fantastical films were fairy stories, popular tales and the science-fiction sagas of fellow-Frenchman Jules Verne. He also recreated various classics of magic in which the conventional skills of the magician were replaced by trick photography.

Curiously, the technique enabling Méliès to transform a girl into a butterfly, or make a woman vanish and replace her with a skeleton, was discovered by accident: 'The camera I was using in the beginning (a rudimentary affair in which the film would tear or would often refuse to move) produced an unexpected effect one day [in 1896] when I was photographing very prosaically the Place de l'Opéra. It took a minute to release the film and get the camera going again. During this minute, the people, buses and vehicles had, of course, moved. Projecting the film, having joined the break, I suddenly saw a Madeleine-Bastille omnibus changed into a hearse and men into women. The trick of substitution, called stop action, was discovered, and two days later I made the first metamorphoses of men into women and the first sudden disappearances which had a big success ...'

Although this camera trick had first been used a year earlier in America to create a compelling illusion in the Edison Kinetoscope film, *The Execution of Mary Queen of Scots* (in which, just before the executioner's axe fell, a dummy was substituted for the actress playing the Queen), Méliès was unquestionably the first European film-maker independently to discover this technique and to then use it to great effect.

Stop action (or stop motion) enabled Méliès to create astonishing visual illusions in such trick-film masterpieces as *Voyage to the Moon* (1902), and it subsequently became the standard technique by which, over the decades, many cinema special effects were achieved. 'I do not hesitate to say,' wrote Méliès in 1907, 'that in cinematography it is today possible to realise the most impossible and the most improbable things.' Whilst the basic film technique of animation is universal - film an image, stop the camera, alter the image, film it, stop the camera and alter the image again - the animated film has employed a diversity

Chalk animation by J Stuart Blackton in *Humorous Phases of Funny Faces* (1906). Blackton drew his image on a blackboard, photographed it, then erased it, or at least took out the 'moving' part, then drew in the next phase.

of media with which to create its illusions of life. The most popular has been drawn animation, probably because of the important link between storytelling and illustration, the heritage of cartoonists and caricaturists and the visual impact of graphic design in advertising.

The history of line animation is fascinating but, in this book, must be briefly told. In 1906, J Stuart Blackton, a Briton who settled in America and who was to make trick-films with various media (including, as we shall see, puppets and clay models), produced a film entitled *Humorous Phases of Funny Faces*, inspired by a then-popular stage entertainment. One of the speciality acts seen at turn-of-the-century vaudeville shows was the 'Lightning Sketch' artist who created rapid pictures and portraits, sometimes undergoing a comic metamorphosis. Blackton recreated this effect on film with faces drawn on a chalkboard which were then brought to life with amusing results, as when smoke from a gentleman's cigar billows across the smiling face of a lady and leaves her scowling. Blackton's process of drawing a picture, photographing it, rubbing part of it out and then redrawing it was the most basic use of the stop-motion technique.

A similar process was used, in 1908, by the Parisian caricaturist and film-maker Emile Cohl in *Fantasmagorie*. The adventures of a little clown, drawn as a rudimentary stick figure, used some two thousand drawings and ran for under two minutes. What made *Fantasmagorie* memorable were the bizarre, dreamlike transformations: a champagne bottle changing into a pineapple which then becomes a tree, while an elephant turns into a house. There were many artists who advanced animation such as the brilliant American cartoonist, Winsor McCay, whose comic newspaper strip 'Little Nemo in Slumberland' (which frequently had the appearance of being a series of film frames) became an animated picture in 1911 and was followed, three years later, by *Gertie the Trained Dinosaur*. This interactive entertainment allowed the real Winsor McCay to 'converse' with the on-screen Gertie. At the end of the show, McCay would walk off-stage and reappear as a diminutive animated figure in his own cartoon.

Raoul Barre, whose film series 'The Animated Grouch Chasers' featured a caricature album that came to life, was responsible for several significant technical developments such as registration holes in animation paper, to stop the drawings from wobbling when filmed. Barre also devised a simple method for cutting down the time-consuming process in which not just the characters but also the backgrounds had to be redrawn for every single frame of film. Barre's solution was to draw a single background picture and then animate on

pieces of paper that had been carefully cut so as not to obscure the setting.

It was J R Bray (creator of the comic character Colonel Heeza Liar) who came up with the idea of drawing the backgrounds on sheets of celluloid and placing them on top of the animation drawings. This served until Earl Hurd refined the process by animating his characters on sheets of celluloid that were positioned over painted backgrounds. This technique, pioneered in Hurd's 'Bobby Bump' series, remained (until the recent introduction of computer technology) the standard procedure throughout the industry.

The scene was now set for the emerging talents of a group of artists who would dominate the early years of film animation. They included Pat Sullivan (creator of Felix the Cat) and his collaborator Otto Mesmer; Dave Fleischer (responsible for the 'Out of the Inkwell' series); Paul Terry ('Aesop's Fables'); Walter Lantz (Dinky Doodle and, later, Woody Woodpecker), and the man who created Mickey Mouse, introduced sound and then colour to the animated film, pioneered feature animation and whose name eventually became a synonym for the cartoon film - Walt Disney.

The development of three-dimensional animation is less easily charted since it employed two distinct techniques - one using puppets, the other clay models - each of which went through a particular evolutionary process. In outlining the history of these two traditions, it should be understood that many of the animators whose films will be discussed worked in more than one medium.

One such was J Stuart Blackton who, with his partner Albert E Smith, had used stop-motion photography to create startling effects in his 1907 live-action film *The Haunted Hotel* and, the following year, produced what is claimed as the first stop-motion puppet film, *The Humpty Dumpty Circus*. This film, now lost, used jointed wood toys of animals and circus performers belonging to Smith's daughter, which were posed and then photographed. Looking back, years later, on the making of this film, Smith recalled: 'It was a tedious process in as much as the movement could be achieved only by photographing separately each position. I suggested we obtain a patent on the process. Blackton felt it wasn't important enough. However, others quickly borrowed the technique, improving upon it greatly.'

A rival claimant for having made the first puppet animated film is the British film-maker Arthur

Scene from *Gertie the Trained Dinosaur* (1914) by Winsor McCay, an interactive show in which the artist appeared live on stage and as an animated character in the film.

Melbourne Cooper. Among Cooper's earliest experiments with stop-motion photography was *Matches: An Appeal*, a film of 'moving matchsticks' made in 1899 for the match manufacturer Bryant & May, and probably the world's first animated commercial. For his entertainment films, Arthur Cooper looked for inspiration to the nursery toy cupboard, producing such titles as *Noah's Ark* (1906) and *Dreams of Toyland* (1908), in which a child is given various toys, including a teddy bear and a little wooden horse, and then falls asleep and dreams that the toys come to life. Although Cooper's method of filming outdoors with sunlight had its drawbacks - the combination of the stop-motion process and the earth's rotation produced strange, flickering shadows - he went on to make other successful films on similar themes, including *Cinderella* and *Wooden Athletes* (both 1912) and *The Toymaker's Dream* (1913).

The 'toys come to life' was a recurrent scenario with early animators partly because toys (particularly ones with jointed limbs) made good actors and because the idea connected with a strong European literary tradition of stories about living toys. A typical example - which also incorporated the popular dream device - is Italian film-maker Giovanni Pastrone's film *The War and the Dream of Momi* (1913), in which an old man tells his young grandson, Momi, tales of war. Falling asleep, Momi dreams of a dramatic battle between puppets, during which he gets spiked by one of the soldiers' bayonets. The boy wakes to discover that the weapon was in fact only a rose-thorn.

Children's dreams and animated toys figure prominently in the films of the pioneering puppet animator, Wladyslaw Starewicz. In *The Magic Clock* (1928), automata figures of kings, princesses, knights and dragons, decorating a fantastical clock, come alive and embark on an adventure which is not controlled by clockwork. Another, *Love in Black and White* (1927), concerns an accident-prone travelling showman whose puppet performers include likenesses of Hollywood stars Tom Mix, Mary Pickford and Charlie Chaplin.

A child's toys come to life in ***Dreams of Toyland*** (1908) by Arthur Melbourne Cooper.

Born to a Polish-Lithuanian family in 1882, Starewicz had a passion for drawing and sculpture and was interested in photography, magic lanterns and early attempts at film animation such as Emile Cohl's 1908 film *The Animated Matches*, which he saw when it was screened in Russia. Starewicz was also fascinated by entomology and it was while studying (and attempting to photograph) insect life that he decided to adopt the stop-motion technique used in Emil Cohl's film: 'In the mating

Charlie Chaplin is one of several Hollywood-inspired performers in *Love in Black and White* (1927) by Ladislas Starevich, the pioneering puppet animator.

season, beetles fight. Their jaws remind one of deers' horns. I wished to film them but, since their fighting is nocturnal, the light I used would freeze them into total immobility. By using embalmed beetles, I reconstructed the different phases of that fight, frame by frame, with progressive changes; more than five hundred frames for thirty seconds of projection. The results surpassed my hopes: *Lucanus Cervus* (1910, 10 metres long), the first three-dimensional animated film ...'

Within a year, Starewicz had produced a more ambitious film. Entitled *The Beautiful Leukanida*, it was 250 metres long and told how the beautiful beetle, Elena, became the subject of a duel between two rival insect suitors. The film was widely acclaimed and audiences were astonished, and mystified, by Starewicz's photography. Many people found the film totally inexplicable, and journalists in London confidently revealed that Starewicz had filmed living insects that had been carefully trained by a Russian scientist! It is small wonder that such theories were put forward, since Starewicz's animation of his spindly-limbed characters was extraordinarily accomplished.

Starewicz's cast of insect characters appeared in a series of modern fables, among them *The Cameraman's Revenge* (1911) that featured such tiny miracles as a grasshopper on a bicycle and a dragonfly ballet dancer. Perhaps because they take the viewer into a secret world, these films are as amusing and ingenious as when they were made eighty years ago. In 1919, Starewicz moved to Paris, adopted a French spelling of his name - Ladislas Starevitch - and, for a

The country lad and the sophisticated urbanite in one of Ladislas Starevich's animal fables, *Town Rat, Country Rat* (1926).

time, occupied a studio formerly used by Georges Méliès. Recognising that the characters in his insect films were limited by their lack of facial expressions, Starevitch began making puppets of mammal characters for such films as *Town Rat, Country Rat* (1926) and his elaborate feature-length film, *The Tale of the Fox*, which he began working on in 1925 and completed five years later, but which was not released until 1938.

The Tale of the Fox, an episodic story based on the fables of La Fontaine, features the exploits of a cunning Fox who is forever tricking the other animals - particularly a slow-witted Wolf. There is also a Lion King and his Lioness Queen as well as a wily Badger who acts as defence counsel when charges are brought against the Fox by assorted chickens, ravens, and rabbits. Although the animals in Starevitch's films wear human clothes, in the style of a thousand book illustrations, they seem more like human characters in animal masks. Starevitch crams every scene with characters and activity: frogs sing, mice dance and birds flutter among the trees. The physical animation is exceptional: when the fox schemes, his eyes narrow and his lip curls in a sinister sneer, and when a feline troubadour serenades the Queen, Her Majesty closes her eyes in ecstasy and we see the royal breast heaving with emotion.

In *The Mascot* (1934), Starevitch returned to toys with a live-action story about a poor toy-maker whose daughter is feverish and asking for the impossible - a cool, juicy orange. Duffy, a toy puppy-dog, hears and notes her request. The following day, the toys stage an escape from the van that is taking them to market and Duffy sets off to find an orange. Duffy succeeds in his mission, but among his adventures in the real world - represented by inter-cutting with live-action - is a nightmarish episode in which he finds himself in a sinister backstreet underworld ruled by a Devil doll and inhabited by goblins, insects and reptiles, anthropomorphic turnips, carrots and hair-brushes, a moth-eaten stuffed monkey, a gruesome mummified character with trailing bandages and the animated skeletons of chickens and fish. At the conclusion of this scary sequence, the Devil bursts open and collapses into a heap of sawdust.

An eccentric restaging of Lewis Carroll's mad tea-party in Jan Svankmajer's *Alice* (1987).

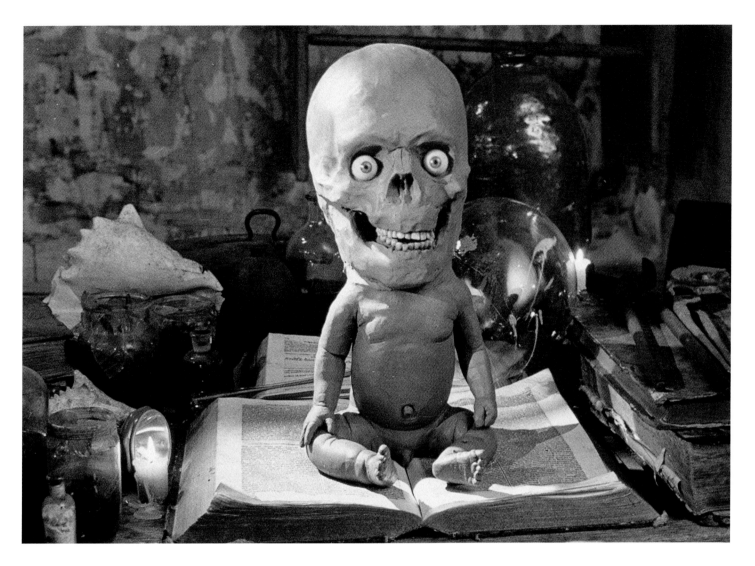

In its more bizarre and beastly moments, *The Mascot* foreshadows the films, three decades later, of Czech animator Jan Svankmajer. In his film *Alice* (1987), a skeletal fish and a small animal skull with doll's eyes and tiny human legs travel in a coach pulled by white cockerels with skulls instead of heads.

From his first film, *The Last Trick* (1964), Svankmajer brought to the cinema the theatrical skills of masks and puppets, combining them with film animation techniques using clay, models, cut-outs and inanimate objects conjured into life with a sharply focused surreal imagination that is endlessly startling. Svankmajer's films play on universal phobias: dark cellars and empty houses; dead things - such as an ox's tongue - that look uncomfortably human; and dangerous things such as nails, scissors and broken glass. His subject matter flies in the face of social taboos, linking food, death and sex, pain and pleasure in shocking, unforgettable imagery.

Film titles such as *Jabberwocky* (1971), *The Fall of the House of Usher* (1981) and

Homunculus figure in Jan Svankmajer's treatment of Faust (1994). Svankmajer achieves haunting effects in his films with his mixtures of live action and animation.

The Brothers Quay, Stephen and Timothy, on the set of *Street of Crocodiles* (1986). The original films of these two Americans bear the influence of both Jan Svankmajer and the Eastern European puppet tradition.

The Pit and the Pendulum (1983) reveal two of the major influences on Svankmajer - Lewis Carroll and Edgar Allan Poe - and reflect his fascination with dream states: those uncertain regions where reality and unreality are excitingly, and often frighteningly, blurred; states of mind where a pile of old shoes, their soles coming adrift from the uppers, become a pack of snapping dogs, or where a stuffed rabbit can sew up a gaping seam to prevent the sawdust from spilling out.

Svankmajer's films often combine animation with live action, as in *Alice* and his other feature *Faust* (1994), but whether pixilating live actors or manipulating china dolls, joints of uncooked meat or, in *Dimensions of Dialogue* (1982), two lumps of deathly-grey clay which form themselves into heads and then eat and regurgitate one another, Svankmajer is an undaunted renegade of animation art.

A compelling animated documentary on Svankmajer's work, The *Cabinet of Jan Svankmajer: Prague's Alchemist of Film*, was made in 1984 by Stephen and Timothy Quay, twin brothers born in Philadelphia, USA, but working primarily in Britain. The Brothers Quay, as they are known, owe much to Svankmajer's inspiration and their films, which include *Nocturna artificialia* (1979) and *Street of Crocodiles* (1986), present a complex vision of a dusty, decaying world where the overpowering feeling is one of claustrophobia and Kafkaesque confusion. For all their originality, the Quay brothers' films acknowledge the Eastern European heritage of puppet film-making, a tradition which itself springs from the long and distinguished heritage of the puppet theatre.

That heritage was the motivating force behind many of the earliest puppet films which - although now virtually unknown or seldom seen - were hailed in their day as being innovative cinema. *The New Gulliver* (1935) by the Russian animator, Alexander Ptushko, features another dream story in which a boy falls asleep over a copy of *Gulliver's Travels*. Ptushko's film includes scenes filmed in the camera (as opposed to being created through optical techniques in processing), incorporating a live actor and some 3000 puppets. Ptushko went on to produce a number of feature-length films combining animation and live-action including *The*

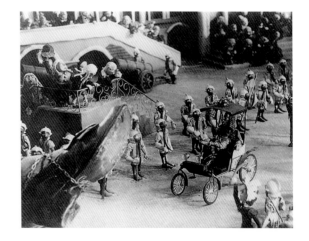

Soldiers parade next to the bound body of their captive, from *The New Gulliver* (1935) by Alexander Ptushko.

Fisherman and the Little Fish (1937) and *The Little Golden Key* (1939), based on a Russian version of *Pinocchio* by Alexander Tolstoi in which an organ-grinder, Papa Karlo, transforms an amazing talking log into a little wooden boy named Buratino.

In 1935, the same year that Ptushko released *The New Gulliver*, the Hungarian-born animator George Pal produced an exquisite film, *The Ship of the Ether*, featuring the voyage of a ship made from blown glass. Pal's earliest films were made in Germany, where he used stop-motion photography to produce an animated commercial for a cigarette company in Cologne: 'They liked it so much that they ordered other films where the cigarettes spoke. So we put little mouths on them - no faces yet, just mouths. And then we put faces on them, and put hats on them, and put arms and legs on them - wire legs with buttons for feet...'

A ship made from blown glass in George Pal's exquisite film *The Ship of the Ether* (1935).

With the rise of Nazism in 1933, Pal moved to Eindhoven in Holland where he produced a series of fairy-tale subjects such as *The Magic Lamp* and *Sinbad the Sailor*. At what was soon the biggest puppet-animation studio in Europe, Pal was making short entertainment films for commercial sponsors such as Phillips Radio, Unilever and Horlicks. Then, in 1939, George Pal moved to America and set up studio in Hollywood where, assisted by some of the finest puppet animators from Europe, he began producing a series of theatrical shorts called 'Puppetoons'.

George Pal's musical fantasy *Tubby the Tuba* (1947), using techniques developed in his short puppet films which he called 'Puppetoons'

Pal's early puppets were very basic: heads and hands tended to be wooden balls, bodies were blocks of wood and limbs were made of bendy covered wire. Although they would become more sophisticated, they remained highly stylised with movements that have an almost mechanical precision producing a look not unlike that achieved, decades later, with early computer animation. Pal's films required the use of a great many models or part-models: for a Puppetoon to walk through a scene might require the use of as many as 24 sets of legs, while up to 100 replacement heads could be used for a character in one of his more elaborate films such as *Tubby the Tuba* (1947).

31

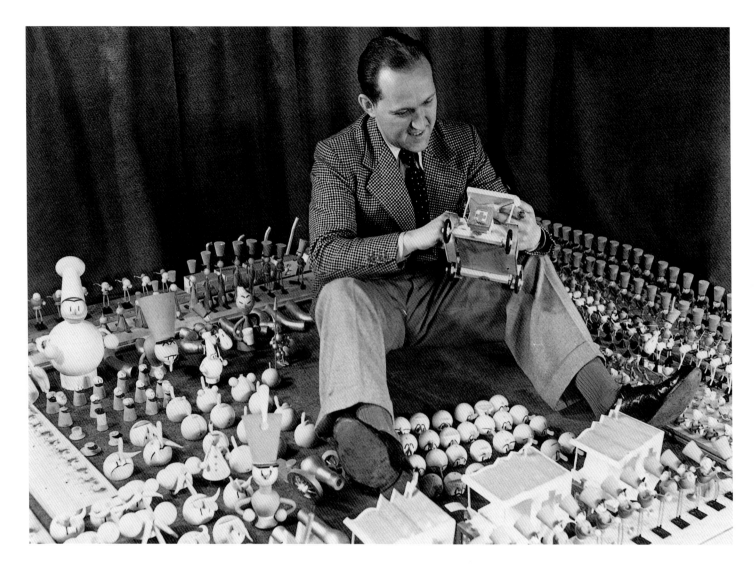

George Pal surrounded by some of the army of puppets he used to film by the substitution method (see also pages 90-91).

Based on a story by Paul Trip and music by George Kleinsinger, *Tubby the Tuba* was a tale about a tuba in an orchestra who (much to the amusement of the other instruments) wanted to play a 'tune' as opposed to just oompah-ing away in the background. With the help of a genial bull-frog, Tubby learns a tune and, in turn, teaches it to the rest of the orchestra. This simple fable about accepting others for what they are (and, indeed, learning to accept yourself) is a good example of Pal's film-making: funny, touching and deftly animated.

Pal was, however, capable of darker visions such as *Tulips Shall Grow* (1942), a powerful anti-Nazi film in which an idyllic picture-book portrayal of Holland - tulips, windmills and a pair of cute, clog-wearing lovers - is suddenly overrun by a marauding army of goose-stepping mechanical men. Made from nuts, bolts and washers, the robotic soldiers carry banners bearing the name 'Screwballs'. Bombs rain down from metal, bat-shaped planes until the windmills are broken skeletons against a blood-red sky. Only when it rains do the armies finally grind to a halt in a sea of rust.

One of the most popular of Pal's characters was a little black boy named Jasper who appeared in almost twenty films with such titles as *Jasper Goes Fishing* (1943), *Jasper and the Beanstalk* (1945) and *Jasper in a Jam* (1946). Also in 1946 Pal made *John Henry and the Inky Poo* (1946), a powerful little film based on the American folk tale of the black railroad ganger who competed with a track-laying machine called the Inky Poo. John Henry, depicted in a naturalistic style that is far removed from that of the Jasper films, wins his spike-driving contest and, though he dies in the effort, proves that 'there ain't a machine made that can beat a man once a man's got a mind he can beat that machine'.

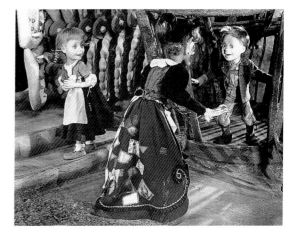

George Pal's Puppetoons won an affectionate audience in America and a number of model animators who worked on the films went on to successful careers of their own, including Joop Geesink who produced his own series of puppet films under the generic title 'Dollywood', and Ray Harryhausen who, in 1945, began producing a short series of films with fairy-tale subjects.

Laurence Harvey as the Shoemaker with George Pal's elves in *The Wonderful World of the Brothers Grimm* (1962).

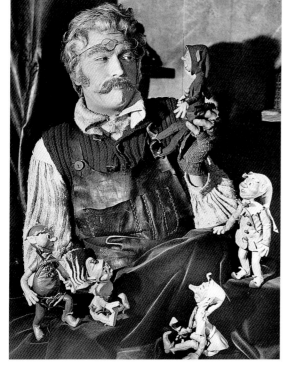

The first of these films, *Mother Goose Stories*, featured highly detailed sets and charming 'cartoon-style' puppets of Humpty Dumpty, Little Miss Muffet, Old Mother Hubbard and others. Harryhausen then made *Little Red Riding Hood*, *Hansel and Gretel*, *The Story of Rapunzel* and *The Story of King Midas* before concentrating on stop-motion special effects. Harryhausen's fairy-tale films show the skill of an exceptional puppet-maker. His slavering wolves, bald-headed demons and warty-nosed hags foreshadow the fiends and monsters which he was later to create for the live-action cinema.

As for George Pal, he went on to produce and direct a memorable string of science-fiction and fantasy films such as *Destination Moon* (1950), *When Worlds Collide* (1951) and his unforgettable versions of HG Wells's *The War of the Worlds* (1953) and *The Time Machine* (1960). Many of these films

There have been several animated films of Hansel and Gretel; this one, based on the Humperdinck opera, was made in 1954 by Michael Myerburg using stop-motion techniques or, as the publicity called them, "electronic puppetry".

The hand of dictatorship in Jiri Trnka's last film *The Hand* (1965).

included brilliant special effects using model work and stop-motion photography, and some of them - *Tom Thumb* (1958) and *The Wonderful World of the Brothers Grimm* (1963) - featured superbly crafted puppet sequences with animated toys, elves and dragons.

Pal's doll-like puppets have a strong affinity with those of another significant animator, Jiri Trnka, who was born in the former Czechoslovakia, worked with various puppet theatres and went into film-making after the Second World War when he set up the animation division of the nationalised Czech cinema and became its first head of production. Trnka was also an illustrator, working with an assured and elegant line and delicate palette of pastel colours with which he decorated various books of legends and fairy-stories including those by Hans Christian Andersen and the Brothers Grimm. It was natural, therefore, for Trnka to turn to an illustrative form and work in conventional cel animation, creating what critics described as 'Disneyfied' characters in such filmed folk-tales as *Grandpa Planted a Beet* (1945) and, the following year, *The Animals and the Brigands*. Also in 1946 he made a biting satire in stark black and white, *The Devil*

on Springs (also known as *The Chimney Sweep*), reflecting on the German occupation of his country and the role of the SS collaborator.

Eventually, Trnka tired of cel animation, feeling that too many processes intervened between the concept and the finished film and that this way of working required the talents of too many other artists to bring his ideas to life. He turned instead to the puppet film, drawing on his years of experience as a maker and operator of marionettes. His earliest experiments were made with the help of the Czech animator Bretislav Pojar: 'We animated one of my oldest wooden puppets, a ballerina. It moved well, but gave an abstract impression. The effect was nice, but did not mean anything. Thus we understood that a puppet film needs concrete situations, or a "story".'

Trnka's later films varied in subject matter - a Hans Andersen fairy-tale, *The Emperor's Nightingale* (1948); a Western parody, *Song of the Prairie* (1949) and a three-part serialisation of Jarolev Hasek's comic novel, *The Good Soldier Schweik* (1954-5) - but his style remained virtually unchanged for almost a decade, his films peopled with squat, chunky characters who lacked the gracefulness found in his book illustrations. However, in two films, *Old Czech Legends* (1953) and *A Midsummer Night's Dream* (1955), Trnka showed himself capable of evoking moods of mystery and rare beauty, demonstrating the truth of his philosophy of film-making: 'Puppet films stand on their own feet only when they are outside the scope of live-action films - when the stylisation of the scenery, the artificially heroic look of the human actors and the lyrical content of the theme might easily produce an effect both unconvincing and ludicrous or even painful ...'

In Jiri Trnka's last film, *The Hand* (1965), the central character has a typical impassive face, and although he is presented to us as a sculptor, he is dressed and has the look of a pierrot. With an outsized head, a beaky nose and two large, soulful eyes, he is clearly the comic tragedian. A gigantic Hand (symbolising dictatorship) demands that this innocent little artist carve a likeness of him for a monument. When the sculptor refuses, the Hand imprisons him in a cage and forces him to carry out the commission. Having reluctantly completed the work, the sculptor escapes, but Trnka concludes his allegory on the freedom of art with the Hand pursuing and destroying the sculptor and then celebrating his work with a grand funeral.

Following Trnka's retirement, Bretislav Pojar continued the puppet film tradition with films such as *The Gingerbread Cottage* (1951), *One Too Many* (1953), a piece of anti-drink propaganda in which a motorcyclist takes the fatal decision to have 'one more for the road', and *The Lion and the Song* (1958), in which a lion encounters a musician singing in the desert and shows his bestial taste in music by eating the singer.

Floating, Chagall-like image of Ariel with Prospero in Stanislav Sokolov's *The Tempest* (1992). This was one of a series of films called 'Shakespeare, the Animated Tales' made as a co-production by S4C/BBC/Christmas Films, Moscow.

Another of Trnka's creative heirs is the Japanese puppet animator Kihachiro Kawamoto. Born in Sedagaya in 1925, Kawamoto saw Jiri Trnka's *The Emperor's Nightingale* and travelled to Europe to study with the Czech film-maker before working in Hungary, Poland, Rumania and Russia and then returning to Japan. Kawamoto's films, which include *Demon* (1972), *A Poet's Life* (1974), *Dojoji* (1976) and *House of Flame* (1979), unite the European approach to puppet film-making with the long tradition of puppetry in Japan which dates back to the Bunraku puppet plays first presented in the 17th century.

Drawing his inspiration from the masks of the Noh drama, Kawamoto's puppets are not only animated with precision, they are also painstakingly made: 'The creation of a single puppet takes ten days. The head requires particular care. First I prepare a plaster mould with which I fashion the head from an agglomerate of Japanese paper, which is then covered with a fine, supple leather and subsequently painted; thus it is light but solid. Eyes, mouth and eyebrows are moveable, and the ears, in plastic, are made from moulds ... Teeth are fashioned from a type of paraffin, the chests from rigid paper; the hands, in supple rubber, are easily moved. For ten minutes of animation, one year of preparation is required.'

Scene from Galina Beda's
Ruth (1996), one of the
'Testament' series made by
S4C/BBC/Christmas Films,
Moscow.

Where some puppet-film animators have followed the aesthetic principles of Jiri Trnka, including Polish-born Yoram Gross, whose *Joseph the Dreamer* (1961) was the first such film to be animated in Israel, others, such as Norway's Ivo Caprino, have returned to the realistic style of Ladislaw Starewich. Caprino's masterpiece, *The Pinchcliffe Grand Prix* (1975), is a fast-paced action-comedy about a remarkable car called 'Il Tempo Gigante', and contains scenes that are literally crowded to overflowing with charming and eccentric characters.

Some of the finest puppet animation in recent years has emerged from a collaboration between the British television company S4C, the BBC and the Moscow-based group of animators, Christmas Films. Three series (using a variety of animation media) have been made: 'Shakespeare, The Animated Tales', 'Operavox' and 'Testament' including, among many fine pieces of animation, Stanislav Sokolov's elemental visualisation of *The Tempest* (1992); Maria Muat's *Twelfth Night* (1992) which captures the romance, confusion and buffoonery of Shakespeare's comedy, and Galina Beda's *Ruth* (1996) which retells the moving Old Testament story of love and loyalty with a precision and delicacy that recalls the work of Trnka.

These films received great acclaim in Britain and America, two countries that - whilst slow to embrace the puppet film - have had a long fascination with automata, marionettes, glove-puppets and ventriloquists' dolls. Unlikely though it may seem, two of the greatest stars in the early days of American radio were ventriloquist Edgar Bergen's dummies Charlie McCarthy and Mortimer Snerd. Similarly, in Britain, Peter Brough and his cheeky companion, Archie Andrews, were hugely successful on both radio and television.

One of the top-rated TV shows in America in the 1950s featured the string-puppet Howdy Doody, while, for a later generation, Jim Henson's glove-puppets achieved national, and then international stardom with 'Sesame Street' and 'The Muppet Show'. In Britain, where puppet plays featuring the characters Punch and Judy have been a centuries-long part of the nation's popular culture, many of the earliest television shows for children featured marionettes. Rather than use expensive and time-consuming stop-motion photography, the puppets were manipulated 'live' before the camera and appeared, strings and all! Nevertheless, characters such as Andy Pandy, Muffin the Mule, The Woodentops and Bill and

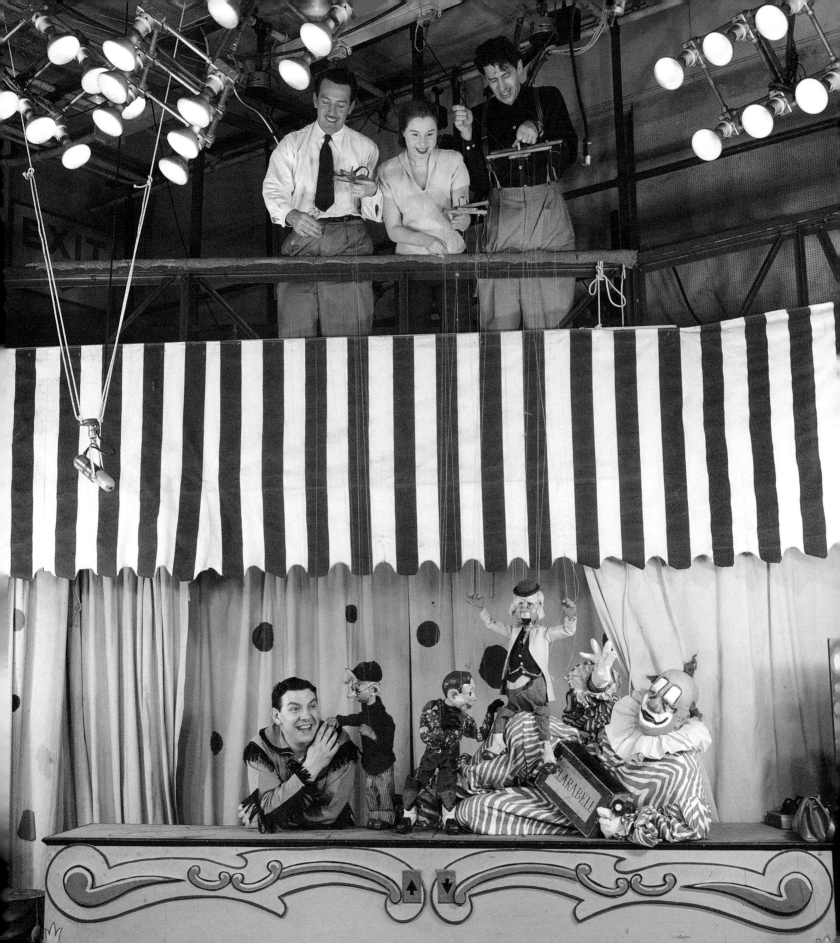

Puppeteers on the set for
Bob Smith's 'Howdy Doody'
show, which had a great
success on American TV in
the 1950s.

Right: Bob Smith with his
puppet characters Howdy
Doody and Heidi Doody.

Puppeteers on the set for
Bob Smith's 'Howdy Doody'
show, which had a great
success on American TV in
the 1950s.

Right: Bob Smith with his
puppet characters Howdy
Doody and Heidi Doody.

Ben, the Flowerpot Men (all between 1950 and 1955) quickly established themselves as children's favourites.

By the end of the 1950s, puppet shows on television were becoming more elaborate with Gerry Anderson's 'The Adventures of Twizzle' and 'Torchy the Battery Boy', both of which featured fantastic child heroes: Twizzle, with endlessly extending arms and legs, and Torchy, a human battery with a light in his hat that had magical properties. Anderson also made a puppet Western series, 'Four Feather Falls', featuring Sheriff Tex Tucker, Rocky his horse and Dusty his dog. This was a revolutionary series that aimed at satisfying the expectations of an increasingly sophisticated audience. New techniques enabled Anderson to manipulate his puppets with extra fine wires that, at 1/5000th of an inch thick, were scarcely visible. A further development, electronically sychronising lip-movements, added a sense of realism not usually associated with puppet characters.

Anderson's pioneering television puppet films continued with 'Supercar' (1961), 'Fireball XL5' (1963), 'Stingray' (1964), and the phenomenally successful 'Thunderbirds' (1965), filmed in what Anderson called 'Supermarionation'. But, despite strong characters, dramatic plots and the endlessly fascinating sci-fi gadgets and gizmos with which the cars, boats and planes were fitted, Anderson's puppets still had strings attached.

One film-maker who found the confidence to cut the strings and turn to stop-motion photography was Gordon Murray who, at the beginning of the Sixties, was producing elaborate puppet plays about the bewigged inhabitants of a Ruritanian principality named Rubovia, but who within only a few years was producing stop-motion films about the small-town dramas in idealised rural communities (represented by model-village settings and characters in 1930s costumes) called 'Camberwick Green' (1966) and 'Trumpton' (1967) .

In 1964, modelmaker Oliver Postgate and writer Peter Firmin created one of the earliest stop-motion puppet series on British television with their forest fantasies about the lives of the folk in 'Pogles' Wood'. Postgate and Firmin's company - modestly named Smallfilms - went on to produce such series as 'The Clangers' (1969), about a race of small pink knitted creatures (vaguely resembling aardvarks) who lived in holes - covered by dustbin-lids - on a small blue planet; and 'Pingwings', about a race of black-and-white knitted creatures (something like penguins) who lived in a barn on Berrydown Farm.

In France, Serge Danot created 'The Magic Roundabout' (from 1965) with its cast of memorable eccentrics, including a dog that looked like an animated floor mop, a pink cow and a moustachioed character on a spring. This series was greatly loved in France and - thanks to a free-wheeling translation - in Britain, and later inspired a feature-length film, *Dougal and the Blue Cat* (1970). One of Danot's animators was British-born Ivor Wood, who later joined Filmfair, a stop-motion animation studio founded by Graham Clutterbuck and responsible for such series as 'The Wombles' (1973), about a race of shaggy-haired, long-nosed litter-gatherers who live on Wimbledon Common. Ivor Wood went on to create his own enchanting series, 'Postman Pat' (1981), about the daily exploits - and occasional daring adventures - of a genial, bespectacled country postman and Jess, his black-and-white cat.

All these series - regardless of whether their characters were made out of wood, fabric or knitting-wool - had a Trnka-like simplicity of shape and fixed expressions. In contrast, many of the films produced by Cosgrove Hall (a partnership of two British artists, Brian Cosgrove and Mark Hall) have preferred the detailed realism and moving features pioneered by Ladislaw Starewich.

Cosgrove Hall's full-length film of *The Wind in the Willows* (1983), and the series

The characters' mobile features and subtle eye and lip movements were widely praised in the Cosgrove Hall films inspired by *The Wind in the Willows* (1983).

which followed it, featured finely crafted puppets meticulously brought to life with movements which suggest a combination of animal behaviour and human nature ideally suited to Kenneth Grahame's original characters, who sometimes seem to be animals in human clothes and at other times appear more like humans wearing animal masks.

Lou Bunin with a character from his *Alice in Wonderland* (1948), which included live and puppet players.

Working with rubber moulded heads, Cosgrove Hall have shown that it is possible to achieve the most subtle eye and lip movements. However, because latex always has a rubbery look, it is far more suited to modelling animals with skin, such as Toad, than furry creatures like Mole and Rat. Additionally, all moulded rubber puppets run the risk of showing tell-tale traces of the joins on the plaster moulds from which they are cast.

Despite these drawbacks, Cosgrove Hall's numerous films - in various animation media - have been extremely successful. Their later puppet film series include a superb three-dimensional recreation of the Toyland home of Enid Blyton's 'Noddy' (1992) and 'Oakie Doke' (1995) which introduced the title-character - an engaging tree-sprite with an acorn head and oak-leaf 'ears' - who helps the woodland creatures to solve their various

In Tim Burton's *Vincent*, the eponymous hero is a seven-year-old boy who models his life on the movie career of horror star Vincent Price, whose voice is heard on the soundtrack.

problems. In 1991, Cosgrove Hall also made a feature-length puppet film, based on *Truckers*, Terry Pratchett's novel about a diminutive - and fast-diminishing - race of 'Nomes' who survive by travelling the motorways of Britain in 'borrowed' trucks. Most recently, their sensitivity in creating small, utterly convincing imaginary worlds has been demonstrated in the film versions of Jill Barklem's stories about 'Brambley Hedge'.

In America, Lou Bunin made a version of *Alice in Wonderland* (1948) which used live and puppet players, and Jules Bass produced a series of Christmas specials, such as *Rudolph the Red Nosed Reindeer* (1964), and a feature-length film, *Mad Monster Party* (1968), in which Dr Frankenstein summons a convention of movie monsters. Apart from these films, however, and the work of George Pal, American puppet animated films have been a rarity. Even the powerful Disney studio only ever flirted with the medium a couple of times making *Noah's Ark* (1959) and *A Symposium on Popular Songs* (1962). Both films were nominated for Academy Awards and featured animated characters made from fabric and assorted household objects including an Arkload of kitchen-utensil animals. Then, in 1982, a young artist at the Disney studio came up with a bizarre idea for a short puppet horror film aimed at children!

Tim Burton's *Vincent* told the story of a strange little boy who modelled his life on the movie career of his idol, the horror star Vincent Price. Burton's stylised

puppets - uncomfortably sharp and angular - were animated by Stephen Chiodo and shot in black and white with a lot of atmospheric shadow. The hero's unnatural preferences for the dark, for reading books by Edgar Allan Poe and conducting Frankenstein-like experiments on his dog, were wittily presented and perfectly complemented by the voice of the real Vincent Price on the soundtrack. But, at the time, the film was decidedly not a Disney picture.

Burton made one more attempt to exercise his macabre imagination at the Disney studio with *Frankenweenie* (1984), a live-action pastiche of Universal's *Frankenstein*, after which he left to become a Hollywood legend in his own right with such grotesque films as *Beetlejuice*, *Edward Scissorhands* and the first two of the new dark breed of Batman movies.

While pursuing his live-action film-making career, Tim Burton still had in mind a scenario which he had developed while he was with Disney, but which had never been put into production. Eventually, at what was by now a very different Disney studio, work began on *A Nightmare Before Christmas*. Directed by a talented animator, Henry Selick, Burton's *Nightmare* told the saga of Jack Skellington, the Pumpkin King, who rules the darkly sinister world of Halloween but who would much rather have the job of being Father Christmas. The elaborate film featured 227 puppets - vampires, werewolves, ghosts, gargoyles, mummies and freaks - many of which could be fitted with an extensive range of heads or faces in an animation process that, though superbly executed, was merely a sophisticated version of the methods used, years before, by George Pal.

The mischievous Lock, Shock and Barrel in Tim Burton's *A Nightmare Before Christmas* (1993).

A Nightmare Before Christmas (1993) was the first stop-motion feature film to receive worldwide distribution. Some of the finest model animators in the world brought the creepy characters eerily to life on elaborate sets with grotesque anthropomorphic buildings, crumbling masonry, rusting railings and dank cobbled streets, all of which were textured to have the look of the scratchy, cross-hatched pen-work found in Tim Burton's original drawings.

Many of the figures were a triumph of modelmaking and animation, for example the cadaverous Jack - a black-suited figure, all skull and bones - whose arms and legs had no more thickness than a pipe-cleaner, yet who moved with an elegant gracefulness without a hint of a shimmer or a shake.

The popular and critical success of *Nightmare* prompted the Disney studio to make, again under

the direction of Henry Selick, a puppet animated film based on Roald Dahl's best-selling children's book, *James and the Giant Peach* (1996). Despite a strong narrative and original characters - including a cigar-chomping Centipede from Brooklyn, an aristocratic, violin-playing Grasshopper with a monocle, and a seductive French Spider - *James and the Giant Peach* was weighed down by musical numbers and, for all its charms, failed to capture the imagination as Burton's darkly disturbing *Nightmare* had done.

Puppet film-makers have, over the years, used all manner of materials: wood, metal, rubber, fabric, leather, paper and plastic. Then there is a material called modelling clay, invented as long ago as the 1890s, which offers a different kind of potential to the animator. Film-makers began using clay-like substances to create animated effects from the earliest days of the movies and, as with line animation, their efforts owed a debt to the theatre.

An early experimenter with clay animation was an American teenager named Willis O'Brien, who in 1915 was working in a small decorator's shop in San Francisco. O'Brien was keen on boxing and one day, when work was slack, he modelled a small boxer out of a piece of clay. When a colleague did the same, the two lads staged a mock boxing-match by posing and reposing the little figures. For O'Brien, it was the beginning of a thought process that carried him to the idea of making motion-picture cartoons with clay instead of drawings. He made a one-minute film featuring a miniature caveman and a model dinosaur made with clay built around a wooden skeleton. On the strength of this experiment, a San Francisco producer advanced the money for a five-minute comedy entitled *The Dinosaur and the Missing Link* (1915). For this film, O'Brien refined his animation process by constructing prehistoric creatures from jointed metal skeletons covered in sheet rubber.

O'Brien continued making short prehistoric comedies such as *Curious Pets of our Ancestors* and *The Birth of a Flivver* (both 1917) in which two early inventors create a dinosaur-pulled form of transport that ends in disaster. In 1919, he made a two-reel dinosaur drama, *The Ghost of Slumber Mountain*, which led to a full-length film version of Arthur Conan Doyle's *The Lost World* (1925). The animation, by today's standards, was crude but to an audience in the mid-Twenties it appeared so authentic that when Conan Doyle showed advance footage from the film to the Society of American Magicians (without declaring its origin) many observers were convinced they were looking at authentic film of prehistoric wildlife.

The success of Willis O'Brien's early animations and a public fascination with dinosaurs in the 1920s - spurred on by several notable fossil finds - inspired other model animators. Buster Keaton's film, *The Three Ages* (1923), opened

44

Tim Burton's elaborate film *A Nightmare Before Christmas* (1993) which used 227 puppets and was the first stop-motion feature film to receive worldwide distribution.

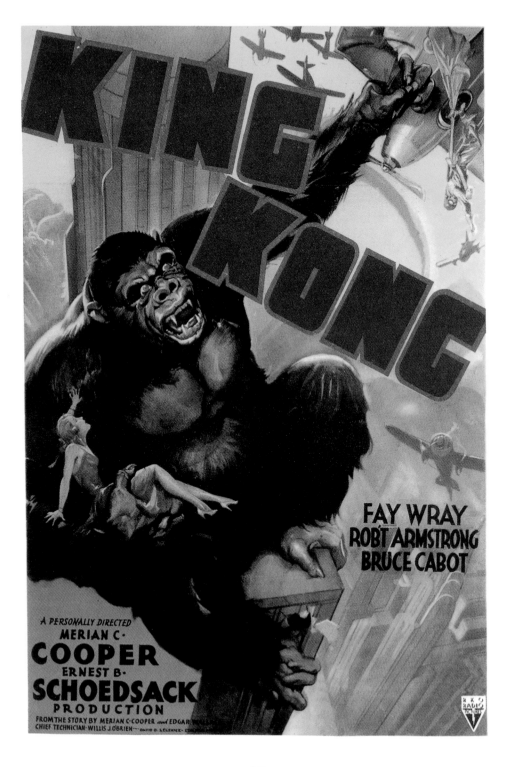

with a model of the deadpan comic riding on the back of a clay dinosaur. Later, in 1928, animator Virginia May made *Monsters of the Past*, which featured a battle between those ever-popular prehistoric combatants, the Triceratops and the Tyrannosaurus Rex.

Eight years after *The Lost World* (and having failed to complete another prehistoric project, *Creation*), Willis O'Brien created the special effects for Merian C Cooper's classic fantasy, *King Kong*: a film which so powerfully created its illusions that, more than fifty years on, it still haunts the imagination. *King Kong* is full of stunning animation sequences, many of which incorporate footage of the film's live-action stars. Among its most memorable scenes are those in which Kong battles with various prehistoric creatures, including a Tyrannosaurus Rex and a Pteranodon, and the unforgettable climax on the top of the Empire State Building when Kong attempts to fight off the attacking aircraft.

O'Brien's animation, in which he was assisted by long-time associates E B Gibson and Marcel Delgardo, was exceptional and even minor imperfections - the fluttering effect on Kong's fur caused by the animator's handling of the puppet - cannot detract from its towering achievement. The success of *King Kong* led to a sequel, *Son of Kong* (1933), and several other monster and fantasy films to which O'Brien contributed effects. His work has been the inspiration for many, including his protégé, Ray Harryhausen, whose animation techniques were to surpass even those of the Master.

Left: Poster for Merian C Cooper's classic fantasy *King Kong*, with special effects by Willis O'Brien.

Kong and the Pteranodon battle over Fay Wray, one of the film's many animation sequences incorporating live action.

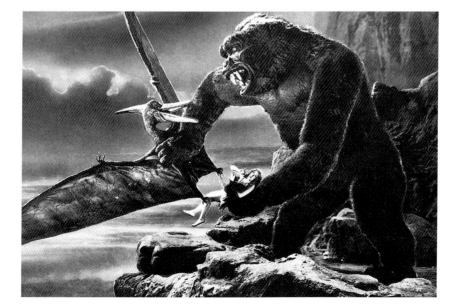

Harryhausen worked as O'Brien's assistant on a further ape picture, *Mighty Joe Young* (1949), and was responsible for the greater part of the film's animation effects. He also animated O'Brien's dinosaur models in the prehistoric sequences of *The Animal World* (1956) and, in his own right, went on to create some of the most memorable stop-motion monsters in the history of the cinema: *The Beast from 20,000 Fathoms* (1953); the giant octopus in *It Came from Beneath the Sea* (1955); the Ymir, duelling with an elephant in the Colosseum in *20 Million Miles to Earth* (1957), and yet more dinosaurs in *One Million Years BC* (1966) and *The Valley of Gwangi* (1969).

In fantasy films that range from *The 7th Voyage of Sinbad* (1958) to *The Clash of the Titans* (1981), Ray Harryhausen brought to life a troupe of terrifying mythological creatures - sirens, dragons, centaurs, griffins, a two-headed roc and a one-eyed Cyclops. Ray Bradbury once referred to these alarming and alluring creatures of Harryhausen's genius as 'the delicious monsters that moved in his head and out of his fingers and into our eternal dreams'. In what is probably Ray Harryhausen's finest film, *Jason and the Argonauts* (1963), there is a stunning episode in which live-action star Todd Armstrong fights a skeletal army, born from the scattered teeth of a Hydra. It is a breathtaking sequence of screen magic which has inspired many animators, including Aardman's Peter Lord and Dave Sproxton.

Although, in the earliest days of cinema, clay animation had featured prominently, its use declined as a reaction to the increasing sophistication in cel-animation techniques. A curiosity from this transitional period is *Modeling* (1921), a film in the 'Out of the Inkwell' series in which live-action footage showed animator Max Fleischer drawing his cartoon character Ko Ko the clown, who would then embark on some escapade both on, and off, the drawing-board. In one episode, Max's fellow animator, Roland Crandall, is seen sculpting a bust of a gentleman with a grotesquely large nose. The sitter arrives and is not best pleased with the likeness. Meanwhile, on paper, Ko Ko is having fun in a winter landscape, building a snowman which also has a huge nose. To stop Ko Ko's antics, Max throws a lump of real clay on to the line-animated image. The clown throws the clay back, escapes from the drawing and runs amok in the studio. Before being returned to the inkwell, Ko Ko climbs on to the sculpture of the large-nosed gentleman and hides in one of the cavernous nostrils.

Drawing by Ray Harryhausen for one of the animation sequences in *Jason and the Argonauts* (1963).

The dynamic on-screen realisation of the skeleton battle in *Jason and the Argonauts*.

Following the release, in 1927, of Walt Disney's *Steamboat Willie*, the first cartoon with synchronised sound, the public appetite for cel animation left little room for any other medium. Apart from one or two highly stylised experimental films, such as Leonard Tregillus's and Ralph Luce's *No Credit* (1948) and *Proem* (1949), clay animation had all but been abandoned.

The medium was not revived until 1955, when Art Clokey created a character who has been described as 'almost irritating in his utter cuteness', but who became an American institution - Gumby. Art Clokey produced 127 six-minute films featuring Gumby and his little horse, Pokey, each of which was a combination of ingenious animation effects (frequently achieved on a shoestring budget) and scenarios that reflected their creator's strongly held beliefs in fairness, tolerance and goodness. The innocence in Gumby's personality is reflected in his look: an arrangement of geometric shapes making the character easy to construct and animate. Gumby is essentially a flat, upended rectangle of greenish-blue clay, divided at the bottom into two splayed, footless legs.

Art Clokey's character Gumby, with his faithful steed Pokey, whose success in the mid-1950s revived interest in clay animation films.

Gumby's tubular arms end in mitten-shaped hands and his facial features are limited to those simple circles and semi-circles that you find on the face of a gingerbread man. His most sophisticated feature is a 'bump' on the left side of his head, intended to suggest (though it is not entirely obvious) a quiff of combed-back hair.

The Gumby 'look' has a child-like naiveté, although most children would probably be more likely to model a man using conventional round and sausage shapes, closer in appearance to Peter Lord's Morph. Although Gumby could scarcely be described as cuddly, his characteristic kindheartedness and upbeat attitude to life endeared him to a generation and, following the revival of interest in clay animation in the 1980s, gave him the chance of a comeback. The new Gumby series, which began in 1987, had greater sophistication than had been possible with the earlier series, which had been made with great economy and had used doll's house furniture as props along with occasional toy cars and space-rockets. The mix of clay people with objects that are

recognisably from the 'real' world never bothered Art Clokey, but other animators have adopted the purist attitude that stories told in clay should not include anything that is not made of clay. One such artist is the man who did much to revive an interest in clay animation, Will Vinton.

It was in 1974 that Will Vinton and his then-partner, Bob Gardiner, came to prominence with *Closed Mondays*, a film about a drunk who gets into an art gallery where - to his inebriated gaze - the pictures appear to come to life. *Closed Mondays* won an Academy Award in the category previously called 'Best Short Subject - Cartoon' but now renamed 'Best Short Subject - Animated Film'. Although Vinton's early models were relatively unsophisticated, his technical aims were ambitious, with painstaking attempts to achieve lip sync by studying the film footage of actors reading the lines of dialogue. Vinton's films also involved complex camera moves including pans, zooms and tracks - all of which had to be created frame by frame.

Vinton eventually coined the term Claymation to describe his work and, like many animators before him, turned to folk- and fairy-tales for his inspiration. A film version of Leo Tolstoy's *Martin the Cobbler* (1976) was followed by Washington Irving's *Rip Van Winkle* (1978) and Antoine de Saint-Exupéry's *The Little Prince* (1979), which included innovative sequences by Joan Gatz, an animator who 'paints' on glass using a palette-knife and a mix of clay and oil. Gatz, whose work with Vinton includes *Creation* (1981) and *A Claymation Christmas Celebration* (1987), went on to win the 1992 Academy Award for her film *Mona Lisa Descending a Staircase*.

Vinton's films show a meticulous attention to detail in creating worlds in which everything, being made of clay, has a uniformity of vision. There are, however, limitations to the Claymation technique: some objects and aspects of the settings have a soft, squashy, chunky look that draws undue attention to incidental background detail, while the predominantly human characters tend to have a heavy, leaden look that is a world away from the fluid human animation created on cel by Disney and others.

Short films such as *Dinosaur* and *A Christmas Gift* (both 1980) and *The Great Cognito* (1982) led to Vinton making the first feature animated in clay, *The Adventures of Mark Twain* (1985). Also known as *Comet Quest*, this is an ingenious but episodic tale in which the great American writer and wit sets out on a wild journey to meet Halley's comet on a vessel that is an amalgam of hot-air balloon and Mississippi paddle-steamer. Twain is joined by three of his fictional characters - Tom Sawyer, Huck Finn and Becky Thatcher - for whom some of the author's less well-known stories are inventively brought to life. The film contains exceptional animation, especially in the creation and manipulation

Characters in one of Will Vinton's adventurous advertising films made for the California Raisin Advisory Board.

of the title character with his mane of white hair, walrus moustache, twinkling eyes and ever-present cigar. Will Vinton's Twain is an incomparable example of human animation in a style that subtly combines naturalism with caricature. The film also contains numerous stunning special effects as when one of the books in Mark Twain's airborne library snaps open and a river of multi-coloured clay flows and splashes out. *The Adventures of Mark Twain* received a limited critical success as did the Disney live-action feature film, *Return to Oz* (1985), to which Will Vinton contributed amazing animated effects. This sombre, songless sequel to the happy-go-lucky MGM classic returns Dorothy to a now ruined Emerald City and, among various scary encounters, she visits the underworld domain of the Nome King who, in an ingenious Claymation sequence, is gradually transformed from an animated rockface into the actor Nicol Williamson.

The weird and wonderful vessel in Will Vinton's *The Adventures of Mark Twain* (1985), also known as *Comet Quest*, the first clay animated feature film.

In America, Will Vinton's pioneering work has since been overshadowed by the phenomenal success of his clever series of advertising films for the California Raisin Advisory Board. Designed to make raisins appealing to a young audience, Vinton created a group of anthropomorphic raisins who sing and play rock-and-roll music. Beginning with Marvin Gaye's song, 'I Heard It through the Grapevine', the series went on to feature the music of Michael Jackson and Ray Charles, performed by raisin caricatures of those musicians. Although Will Vinton took the art of clay animation to new heights of invention and

Morph, with his friend and alter-ego Chas, was an early creation of Peter Lord and Dave Sproxton, and first appeared in the BBC 'Vision On' series in 1976.

sophistication, the medium failed successfully to challenge the supremacy of cel animation, particularly with the revival of animation talent at the Disney studio, beginning in 1989 with *The Little Mermaid*.

The present renaissance in clay animation had its origins in 1960s Britain with the work of Peter Lord and Dave Sproxton. Whilst still at school, and then university, Lord and Sproxton began contributing short animated films to a BBC television programme for deaf children called 'Vision On'. They were influenced in their ambition to animate by the films of Ray Harryhausen (especially *Jason and the Argonauts*) and by Terry Gilliam's work for the avant-garde television comedy series, 'Monty Python's Flying Circus'. They also aspired to equal the quality of animation seen in some of the puppet-film series then being shown on British TV, such as 'The Wombles' and 'The Magic Roundabout'. The fact that Serge Danot's 'Roundabout' had also established a large adult following suggested to them that the appeal of animation might not simply be limited to 'kid's stuff'.

Lord and Sproxton eventually focused on developing their skills with modelling clay animation, mainly because nobody else in Britain appeared to be working in the medium (which gave it a saleable uniqueness) and because it offered a flexibility denied to the most sophisticated puppet. An early example of a clay film sequence for 'Vision On' featured a real table with a real plate on which clay food - sausages, peas and potatoes - moved around before merging into what Peter Lord describes as 'a muddy brown quadruped like a bear or a wombat', which then walked off the plate.

The success of these short pieces led to the creation, in 1976, of Morph, the small terracotta man who interacted with the programme's artist Tony Hart, and who had a propensity for 'morphing' into animals, objects or sometimes just a ball of the raw material of which he was made. Viewers responded to Morph's simple shape, friendly features and warm colour; he quickly became a star of the small screen and secured Lord and Sproxton's reputation. His regular appearances on 'Vision On' were followed by a series, 'The Adventures of Morph' (1981-3), in which he was joined by an ever-expanding family of delightful and quirky characters.

In 1978, Aardman Animations' work took a quantum leap when they were commissioned to make two short films, called 'Animated Conversations', for

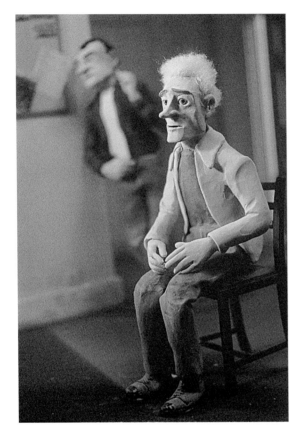

A scene from **On Probation**, one of five ground-breaking films in the Aardman series 'Conversation Pieces' (1982-3). For these films, Peter Lord and Dave Sproxton built their stories around real-life taped interviews, but they themselves never met the people involved.

late-night screening by BBC Bristol. Taking the skills mastered in animating Morph, Lord and Sproxton applied them to realistic human figures acting out small, intimate dramas based on true-life situations.

The soundtracks for 'Animated Conversations' used voices of 'real people', recorded in various day-to-day situations. For example, in the first film, *Confessions of a Foyer Girl*, two usherettes in a cinema foyer talk about boys and boredom and what they are going to do when they get home from work. The concept of 'Animated Conversations' was developed into a series of five 'Conversation Pieces' (1982-3) for Channel 4, using increasingly sophisticated animation to depict ways in which people succeed - but more often fail - at communication. *On Probation* depicts a group meeting where a tortuous exchange takes place between a young man who needs to visit a member of his family and a probation officer who is trying to negotiate the terms of the visit - with various unhelpful interjections from the other members of the group. The resulting drama is filled with brilliant observation - people tapping pencils, taking off their spectacles, looking edgily at one another - and is ultimately funnier, sadder and far more memorable than if the same small scenario had been presented in live-action.

With their overlapping dialogue, false starts and unfinished sentences, these films have all the hallmarks of fly-on-the-wall TV reportage. This, however, is quite misleading: they are, as Peter Lord puts it, 'almost a documentary but complete fiction!'

There has long been a difference of opinion between animators about what can and cannot be achieved in the medium. There are those who share the view expressed by Halas and Manvell in *The Technique of Film Animation*: 'In all animation, there should never be any doubt that what is being achieved on the screen could only be achieved by this means.' Others hold that any subject matter can be dealt with in animation and, indeed, the Disney studio's move towards making animated films of live-action stories, such as *Pocahontas* and *The Hunchback of Notre Dame*, suggests that audiences are not worried by the distinction. Kihachiro Kawamoto probably spoke for many in the animation

business when he remarked: 'What interests me most in the production of animated film is that the person who creates it is the only one who can express what he feels, like a painter.'

That is certainly what Lord and Sproxton achieved in 'Animated Conversations' and 'Conversation Pieces'. Although the audio-track suggests that the characters on screen have been accurately drawn from life, the truth is more complex since the animation is, in fact, an imaginative interpretation of what is heard. By hearing the dialogue 'performed' by a realistic puppet - who may not bear any resemblance to the real owner of the voice - the words seems more sharply focused and the passing banalities of life take on a new significance.

For example, in *Sales Pitch*, an ever-hopeful door-to-door salesman gets into conversation with an elderly couple who are quite happy to chat, but who have clearly no intention of buying his mops and brushes. The desperation of the salesman - covered though it is by his easy, laughing manner - is painful to watch, and when he packs up his case and turns to go there is a moment where the audience glimpses the unnamed burdens that are weighing on his shoulders. At the same time, *Sales Pitch* is full of delightful comic character animation: the wife, saying little, deferring to the husband who abstractedly cleans out his pipe while the salesman relentlessly continues his pitch; the neighbour in an adjacent house, eavesdropping on the conversation, then accidentally banging her head on the open window; or the dog, seen at the end of the film chewing a sample brush.

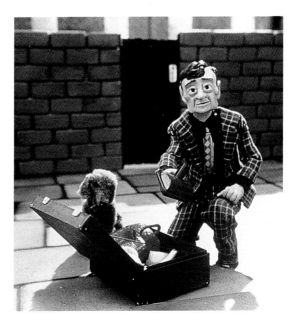

The quiet desperation of the door-to-door salesman in the Lord and Sproxton film *Sales Pitch*, another in the 'Conversation Pieces' series.

One of the other films in this series was a significant departure. *Palmy Days* animated a rambling over-the-tea-cups conversation between several elderly people repeating oft-told tales and laughing politely at unfunny anecdotes. Peter Lord and Dave Sproxton could not, at first, see any value in this material, until they took a leap of the imagination, dressed the old folks in tattered clothes and palm-leaf skirts and placed them in a hut on a tropical island with a crashed plane in the background. By juxtaposing the surreal with the commonplace, *Palmy Days* gained a disturbing subtext that is not a part of the original recording.

The success of these series began to generate commercial work that, in turn, required the employment of more animators. Among those who joined the

studio were Barry Purves, who came from Cosgrove Hall where he had been a director and the character animator for Toad in *The Wind in the Willows*; graphic artist Richard Goleszowski, who joined the studio in 1983, and Nick Park, who was invited to join Aardman in 1985 in order to complete *A Grand Day Out*, a film he had started while a student at the National Film and Television School. Nominated for an Academy Award, *A Grand Day Out* (1989) introduced the world to Wallace, the eccentric, cheese-loving inventor and his faithful dog, Gromit. The story was pure comic-book adventure - building a space rocket and blasting-off to the moon in search of cheese. The characters, however, were strongly delineated: the naive, somewhat inept Wallace (voiced by Peter Sallis) and the real brains behind the partnership, Gromit, whose facial expressions - wide, slightly mournful eyes - quickly register his despair, frustration or total incredulity.

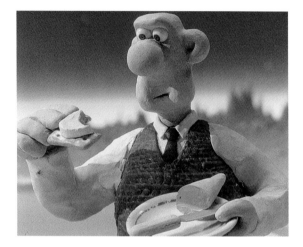

Wallace tastes Moon cheese in *A Grand Day Out* (1989), the first Wallace and Gromit film which Nick Park completed after joining the Aardman studio.

The success of *A Grand Day Out* demanded a sequel, and in 1993 Wallace and Gromit returned in *The Wrong Trousers*, followed two years later by *A Close Shave*, all three films having been commissioned by Colin Rose of the BBC. The later films, both of which won Oscars, have tightly constructed plots involving a villainous penguin disguised as a chicken and a psychopathic mechanical dog. They are packed with visual jokes (Gromit reading a paper carrying the headline 'Dog Reads Paper') and visual puns (Gromit's collection of records by 'Bach'), and there is a proliferation of wacky gadgetry, ranging from the ex-NASA Techno-Trousers to Wallace's Knit-O-Matic machine via a porridge gun and a device that catapults dollops of jam on to a piece of toast as it springs out of a pop-up toaster. Park's films work on many levels. Children respond to the broad character comedy, adults to the more sophisticated elements including the affectionate spoofing of movie genres such as horror films, thrillers, heist pictures, action movies and the deep shadows and crazy camera angles of *film*

Below: A sketch of Gromit for the chase sequence in *A Close Shave* (1995)

noir. The richness of characterisation and the relentlessly paced animation (the model train chase in *The Wrong Trousers* and the motorbike pursuit in *A Close Shave*) have carried clay animation to unprecedented heights.

Between completing *A Grand Day Out* and beginning work on *The Wrong Trousers*, Park contributed to a series of five diverse animated

Compilation of images from
Barry Purves's films *Next*,
Screen Play, *Rigoletto* and
Achilles

films, produced in 1989-90 under the title 'Lip Synch'. The project was devised
to give Peter Lord and three of Aardman's growing staff of animators an
opportunity to experiment with the idea of imaginatively animating real
conversations. 'Lip Synch' was a wry choice of title since, although the dialogue
would be synchronised to the characters' lip movements, the accompanying
images would not necessarily be 'in sync' with the personalities, moods or
settings in the recordings. It was complicated by the fact that two of the
directors took a slightly divergent view and produced films where 'lip syncing'
turned out to be of minimal importance!

A soundtrack of grunts and guttural gabblings accompanied Richard
Goleszowski's *Ident*. As the title suggests, the film is about identity: a grotesque,
phallus-shaped character - pink, bald and naked - is attempting to escape from
a claustrophobic maze where he is constantly expected to conform and wear a
mask. Eventually he finds a way into another world only to discover that, once
more, people attempt to reshape his identity.

Equally idiosyncratic was Barry Purves's film, *Next*, made with puppets (as
opposed to clay) and containing hardly any dialogue apart from the word
'Next!', bellowed from the stalls of a theatre by a bored director who is holding
auditions. The hopeful player who enters the spotlight is William Shakespeare
who, in a *tour de force* of animation, mimes the Complete Works and proves
that 'one man in his time plays many parts'. From a wicker prop-basket, the

Bard produces masks, crowns, swords, items of costuming and a stuffed dummy
which he manipulates as a supporting cast of lovers and corpses. At the
conclusion of the performance, the director (a caricature of Sir Peter Hall)
looks up from a book - having missed the entire audition - and shouts 'Next!'.

Full of surprises, this witty film established Barry Purves's elegant style, seen in
the puppet film which he has made since leaving Aardman Animations: *Screen
Play* (1992), an Oscar-nominated presentation of a Japanese Kabuki-style drama,
performed by ornately clothed puppet-actors on a stage-set which is constantly
being transformed by a complex arrangement of sliding and revolving screens.

Purves went on to produce a darkly sinister visualisation of *Rigoletto* (1993) for
the S4C/BBC series 'Operavox', and in 1995 a homoerotic retelling of the
legend of *Achilles*, a powerful and passionate film with a cast of characters
modelled to look like sculpted figures and enacted in a highly stylised dramatic
form evoking the theatrical conventions of Ancient Greece.

The remaining films in the 'Lip Synch' series followed the convention of the
earlier 'Animated Conversations' and 'Conversation Pieces'. From Peter Lord
came two vastly different films: a charmingly dotty piece of humorous
storytelling, *War Story*, and *Going Equipped*, an intensely focused monologue on
a sombre theme. The fifth film in the series was Nick Park's *Creature Comforts*

(1990), in which zoo animals confess to feelings of depression, claustrophobia and boredom. This film won Nick Park his first Academy Award. The following year saw the start of a series of Heat Electric commercials featuring Frank the Tortoise and Carol the Cat, who became cult figures with British television audiences. The commercials were later released on video, and Frank, Carol and other animal characters also appeared on various items of merchandise. Almost fifteen years later, another collection of *Creature Comforts* would return to the small screen to delight a new generation.

Meanwhile in 1996, the format was adapted for a series of American TV commercials for Chevron. Featuring talking cars, moaning about being tired, having dents in their doors and hearing strange knocking and pinging sounds, these commercials are crammed with visual gags and funny incidental detail.

Aardman Animations had begun making TV commercials in 1984 with an advertising film for Enterprise Computers, in which various competing computers were depicted as clattering fossils given rickety life. More bony animation followed with the Scotch Videotape Skeleton, a jokey character who recalls the skeletal warriors in Ray Harryhausen's *Jason and the Argonauts*. Over the years, Aardman's commercials have given animated life to all manner of inanimate objects from a bottle of Domestos bleach guarding a bathroom to a bottle of Perrier with a pair of dancing straws.

A talking car in a TV commercial for the American company Chevron, as it was visualised in sketch form, above, and in the finished film, below left.

The studio has also specialised in giving human form to a variety of edible products: a singing sausage-man for Bowyers; a *pas de deux* danced by two figures made from Jordan's Crunchy and Chewy bars; a fruit-and-vegetable man for a healthy-eating campaign and - perhaps most memorably - the Lurpak Butterman. Emerging, Morph-like, from a block of butter, 'Douglas' (as he was eventually named) has various adventures - such as snorkeling, rowing, hang-gliding and motorcycling - on a food-laden table. Other ingenious metamorphoses include the bulbous-nosed, porridge-coloured man advertising

Readybrek, who in quick succession becomes a train, an alarm clock and a pop-singer; and, in the commercials for Crunchie, chocolate bars which undergo a rapid series of transformations into chocolate submarines, dancing girls, performing seals, roller-coasters, rocket-ships and rodeo cowboys.

Other innovative commercial work includes the wooden man advocating the use of Cuprinol wood preservative; the Chewits Monster, styled after the popular monstrous-beast-on-the-rampage-movies of the 1940s (with a nod towards Harryhausen's various behemoths); the Polo commercials with their spoof revelations of such inside information as the way in which the mints get their characteristic hole, and a series of stunning Lego advertisements in which heaps of Lego bricks assemble themselves into a pirate and a spaceman who then take on fully animated life.

Douglas the Butterman, who has become something of a star in his own right in the commercials Aardman have made for Lurpak.

All this commercial work has developed alongside the studio's broadcast films in a creative harmony that has allowed each discipline to benefit from the other. The lessons learned in making the 'Lip Synch' series, for example, have been exploited in commercials for a variety of products from Walkers Crisps to the Britannia Building Society. In an expensive medium, it is often the commercial work which not only funds less remunerative ventures, but provides opportunities to develop and experiment.

In 1986 Aardman completed work on *Babylon*, a chilling 15-minute film for Channel 4, set at a conference of arms-dealers where the delegates become increasingly bestial; one grows to gargantuan size before bursting in a torrent of blood and bullets..

In the same year the studio produced a pop video for Peter Gabriel's single, *Sledgehammer*. Directed by Steve Johnson, the film featured lip-synced images of Gabriel's head alternated with likenesses in clay, ice and - courtesy of the Brothers Quay who contributed to the film - bleached wood, rusting metal and assorted fruit and vegetables.

Unlike those studios tied to the name of a specific director or producer, which often tend to narrow audience expectations and limit commercial and creative commissions, Aardman Animations has been able to provide many opportunities for individual artistic expression. In addition to Nick Park, several Aardman animators have been encouraged to produce films which carry their own individual stamp, such as Peter Peake who produced *Pib and Pog* (1996),

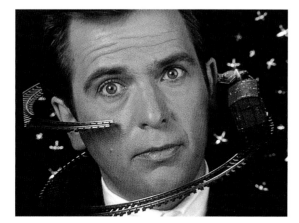

A frame from the Aardman pop video made for Peter Gabriel's single release, *Sledgehammer* (1986). The video was directed by Steve Johnson.

a spoof on TV shows for small children, featuring an enthusiastic lady storyteller and two anarchic characters relentlessly attempting to destroy one another.

In 1991, Richard Goleszowski took a flat modelling clay dog who had appeared in his film *Ident*, called him Rex the Runt, teamed him up with doggy chums Wendy, Bad Bob and Vince and made two short films that led to the BBC commissioning a series of surreal '*Rex the Runt*' stories, beginning with *A Holiday in Vince* in which the gang miniaturise a submarine and take a fantastic voyage through Vince's brain.

Rex was part of an animation genre in the late 1990s that could be described as bizarre-meets-grunge and which included Sarah Ann Kennedy's *Crapston Villas* and Deiniol Morris and Michael Mort's BAFTA Award-winning *Gogs*, featuring an obnoxious family of prehistoric cave-dwellers.

Steve Box, who joined Aardman in 1992 and animated with Nick Park on *The Wrong Trousers* and *A Close Shave*, directed his first film, *Stage Fright*, in 1997. A black comedy, set in a decaying theatre at a time when music hall was giving way to cinema, *Stage Fright's* narrative shifts between present time and flashback while visually alternating between grainy, scratched, black-and-white film images and the sombre colours, harsh stage lighting and deep shadows of the theatre.

'Rex the Runt', Richard Goleszowski's 13-part series, was launched on BBC Television in 1998.

Aardman has continued to push at the boundaries of animation in terms of storytelling and technique as well as in exploring new ways of reaching audiences: hence the arrival in 1999 of *Angry Kid*, featuring a typically obnoxious adolescent with red hair and a fiery temperament. Written, directed and spoken for by Darren Walsh, *Angry Kid* used pixilation, a technique in which a model-animated head is superimposed on a human body and produces an intriguing sense of dislocated reality when a seemingly animated character is seen in live-action environments. While Angry Kid's one-minute misadventures were a bold departure for the studio in that they débuted on the Internet, contained swearing and featured topics not usually found in Aardman films.

The uncertain rediscovery of flight is a major theme in the classic escape movie: *Chicken Run.*

Even as Aardman explore new areas of entertainment, they have consistently held onto the hallmark qualities that have set them apart from other animation studios and first brought them international acclaim.

Peter Lord has continued directing his own films, such as *Wat's Pig* (1996), a medieval fable - told in a split-screen format with minimal dialogue - about two brothers who are parted at birth, one becoming a king, the other a pig-keeper. *Wat's Pig* was nominated for an Academy Award, as was Lord's earlier film *Adam* (1991), in which a human (but also God-like) hand creates and then controls the existence of a little man whom Lord describes as being 'Morph with genitalia'. Having no dialogue, *Adam* works in the universal language of mime, and the film shows the subtlety of acting with clay that is Aardman's particular contribution to this form of animation.

Iin 1998 Peter, in collaboration with Nick Park, embarked on what was, at the time, the studio's most ambitious project: its first feature-length film. Released in 2000, *Chicken Run* was a tirelessly inventive pastiche of classic prisoner-of-war escape movies - enacted by chickens.

The film boasted incomparable model-making, a cunningly contrived plot and a cast of memorable characterisations: from the plucky Ginger, leader of the rebel chickens, and Rocky the American rooster voiced by Mel Gibson who helps hatch an escape plan, to the sinister Mrs Tweedy, gripped by a vision of saving her failing farm by switching from egg-production to the manufacture of chicken pies. The scope of the film, ranging effortlessly from the comic to the dramatic, showed Aardman capable of sustaining and advancing character emotions within the context of a feature-length film.

In 2003, the studio also revisited the format successfully established in Nick Park's Oscar-winning 1989 film, *Creature Comforts*, by launching the first of two new series of shorts in which they put the thoughts and opinions of 'The Great British Public' into the mouths of animals 'interviewed' beside the seaside, at the vet's clinic, back-stage at the circus, down on the farm, in a pet store, or in home and garden. Directed with wit and flair by Richard Goleszowski, the series effortlessly recaptured the essence of the original and a further series devised exclusively for American television viewers was produced in 2007 and screened by CBS.

Nick Park's man-and-dog double-act had enjoyed a long-awaited revival in 2002 with a series of short, three-minute films featuring 'Wallace and Gromit's Cracking Contraptions', directed by Christopher Sadler and Lloyd Price and showcasing a catalogue of zany, havoc-wreaking machines that provided a

In one of the *Cracking Contraptions* episodes Wallace has contrived a snowman maker. Sadly, as with so many of Wallace's inventions, the task is unworthy of the complex genius at work.

prelude to the duo's much-anticipated feature film, Wallace & Gromit: *The Curse of the Were-rabbit* released by DreamWorks Pictures in 2005.

The challenges of the feature-length format were boldly met with a multi-layered storyline involving numerous settings and (unlike the short Wallace and Gromit films) a cast of major and supporting characters such as Lady Tottington, Wallace's first emotional attachment since *A Close Shave's* Wendolene, Lord Victor Quartermaine, a rival suitor for Her Ladyship's affections and an entire village community endeavouring to protect their entries for the annual giant vegetable competition from the devastation of the marauding Were-rabbit.

Written in association with Bob Baker, who had scripted the earlier short films, and directed by Nick Park and Steve Box, *Were-rabbit's* expertly paced and sustained comedy featured various zany new contraptions along with the now-requisite dosage of puns and a series of rich verbal and visual gags inspired by early horror movies.

Four years later (and fourteen after *A Close Shave*) Nick Park directed a fourth short Wallace and Gromit TV film, *A Matter of Loaf and Death*, in which the duo start a bakery business and Wallace is smitten by the amorous attentions of Piella Bakewell before almost becoming her thirteenth victim in her true persona as the 'Cereal Killer'! Whilst the traditional ingredients and the established inventiveness were maintained - and Gromit was permitted a romantic liaison with Piella's poodle, Fluffles - the mood was a good deal darker than any Wallace and Gromit film to date.

In contrast, but showing the extent to which Nick Park's characters had become both a secure part of popular culture and yet adaptable to various audiences, was the successful launch, in 2007, of *Shaun the Sheep*, a children's TV series, directed by Aardman veteran, Richard Goleszowski, and featuring the popular character from *A Close Shave*.

Set on a farm with a flock of sheep, the sheepdog, Bitzer, and Shaun's nemesis, the farm cat, Pidsey, *Shaun the Sheep* was played in pantomime and, to date, has run to two series of 80 7-minute episodes as well as providing the studio with its first spin-off of a spin-off with *Timmy time*, a pre-school TV series created and produced by Jackie Cockle and featuring the youngest member of Shaun's sheep flock along with other young farm and woodland characters who attend a barnyard school where they learn simple life-lessons such as how to share and how to say sorry.

The monster that stalks the gardens, terrorising all who feel pride in their vegetables, in *The Curse of the Were-rabbit*.

Whilst these projects show Aardman's commitment to model animation, they have also followed industry trends in embracing 'computer generated imagery' (or, as it is usually abbreviated, CGI) both as an aid to creating effects in their stop-motion films and as a filmmaking process in its own right.

The progress of computer animation can be tracked across a series of groundbreaking movies from its first usage in *Westworld* (1973) and early experiments such as *Tron* (1982), through to *Starship Troopers* and *Titanic* (both 1997), *Star Wars Episode I: The Phantom Menace* (1999) and *Episode II: Attack of the Clones* (2002).

Film-makers who would once have made use of stop-motion effects artists (such as Phil Tippett, creator of the memorable long-legged AT-AT walkers in *Star Wars: The Empire Strikes Back* (1980) and the robots in the 'Robocop' movies) increasingly turned to the computer. This transition took place within little more than a decade so that only three years after Tippett supervised the stop-motion dinosaurs in *Jurassic Park* (1993), his alien invaders created for Tim Burton's *Mars Attacks!* were abandoned in favour of computer generated extra-terrestrials. Ironically, what is now seen as providing the most effective 3-D animation effects is actually a 2-D medium.

'With films such as *The Matrix* (1999), *Spider-Man* (2002) and *The Hulk* (2003), CGI animation reached the sophistication and Peter Jackson's *The Lord of the Rings* trilogy (beginning in 2001) ultimately demonstrated that the computer...' can create convincing computer-generated characters such as Gollum and scenes peopled by thousands of digital extras as well as simulating the likenesses of real actors to enact impossible scenarios. The 'performance capture' technique pioneered in the *Rings* trilogy was subsequently used in Robert Zemeckis' films *Polar Express* (2004), *Beowulf* (2007) and *A Christmas Carol* (2009) and James Cameron's unparalleled success *Avatar* (2009) all of which featured the added attraction of 3-D effects.

Shaun the Sheep often employs the rest of the flock in many of his schemes; he is just subversive enough to appeal to most children.

The computer's challenge to traditional feature animation was heralded by the instantaneous success of Pixar Animation's *Toy Story* (1995) and with rival studio, DreamWorks' insect movie, *Antz* (1998), released in the same year as Pixar's *A Bug's Life*. The success subsequently achieved by DreamWorks' *Shrek* (2001) and its sequels along with their *Madagascar* and *Kung Fu Panda* movies, Blue Sky Studio's *Ice Age* series (beginning in 2001) and Pixar's *Toy Story 2* and *Toy Story* 3 (1999 and 2010), *Monsters Inc* (2001), *Finding Nemo* (2003), *Cars* (2006), *WALL-E* (2008) and *Up* (2009) seemed to sound a death-knell for cel-animation techniques although Disney bucked the trend in 2010 with the release of its traditionally animated *The Princess and the Frog*.

In 2006, DreamWorks released Aardman's first CGI feature film, *Flushed Away*, directed by David Bowers and Sam Fell. A rom-com set in a community of rats living in the sewers of London (with toads and frogs as the villains), the film was devised and designed in Bristol but animated in Hollywood and went through numerous changes whilst in development. The film's characters were originally modelled in clay so that the CGI animation could capture the plasticity that has always been the hallmark of their creations. The fusion of manual and digital animation was further reinforced by the use of a computer version of the mouth replacements traditionally used in stop-motion.

The studio has also successfully used digital animation in the commercial field, producing a series of advertisements for Polo mints with a retro-futuristic look and for Hershey featuring characters and environments that have the convincing appearance of having been animated in molten chocolate.

In 2008, the studio launched a CGI animated television series with a kung-fu theme, entitled *Chop Socky Chooks*, directed by Aardman animator, Sergio Delfino, and produced with DHX Media and they are currently working on a second CGI feature, to be animated in the Bristol studio.

Despite these diversifications, the studio still holds to the animation principles that originally inspired its founders. 'I always describe puppet animation,' says Peter Lord, 'as being instinctive. You go through it as you go through life: reasonably well informed about what you've just done, with a plan for what you intend to do, but prepared also for an unpleasant surprise at any moment. You hold the puppet in your two hands, and maybe your left hand is holding the shoulders while your thumb lies commandingly on the spine. Your right hand is on the pelvis, ready to move either leg or both at once. So you've got the whole figure under your hand, ready to respond to your instruction. You can feel the movement in it, and the logic as it twists and bends. Often the puppet leads you, you can feel its inner life ...'

It is all very like those ancient creation myths in which a deity takes up a fistful of mud and shapes it into a thing that can hold, within its fragile form, all the passions, ambitions, dreams and despairs that are the lot of humankind - though without any certainty about how that creation will direct its own destiny.

Two of the characters from *Chop Socky Chooks*, a series that Aardman created entirely in CGI; they are the streetwise KO Joe, ready to rumble, and the enigmatic *femme fatale*, Chick P.

basic needs

**Nick Park animating the
family group of polar bears
for *Creature Comforts*.**

**Standard 8 cine camera,
superseded by the Super 8
and now by video.**

The Camera

When you watch a film, or a television programme, or a video, what are you
actually looking at? Everyone knows the answer: freeze-frame the video and
you get a still picture. The moving pictures that we see on our screens are
basically made up of a series of still images in sequence. When these still
images are played back at sufficient speed - normally at the rate of 25 frames
per second (fps) on TV, or 24 in the cinema - our brains stop seeing these
images as separate and static, and instead perceive movement.

This is because of a phenomenon known as persistence of vision which was
first properly identified in 1825, shortly before the invention of photography.
It means that our brain holds onto an image for about one-tenth of a second
after the image has been removed from our sight. This delay in our rate of
perception is enough to allow quickly changing static images (the photographed
frames) to be merged into one another, creating smooth, flowing moving
images.

Compared with ordinary film-makers, who just point their camera at something
moving and shoot it, animators have made life extremely difficult for
themselves, inventing incredibly elaborate and tortuous ways to create moving
images. Instead of capturing something that is already moving, we painstakingly
create each one of the still pictures needed to imitate movement in real life.
Unless we go for a shortcut - for example, by shooting in 'double-frame'
(see below) - we have to create 24-25 separate pictures for every second
of finished film.

Whichever way the still pictures are generated, the same basic equipment
is required: a camera with a lens to focus the image, a system to record
and retain it, and a steady tripod for the camera. But over the last few
years these systems and the way that we use them have changed out
of all recognition. Film, as a medium for capturing images, is almost
entirely dead - at Aardman, we switched entirely to digital capture
after we had completed *The Curse of the Were-rabbit*. It has made a
big difference to the way that we work, and it has also made it a lot
easier for everyone to get started as an animator in their own home.

When they started out many of our longer-serving animators got
themselves Standard 8 or Super 8 cine cameras, with some, like us, even
having their own 16mm film cameras. It is a major advance that it is
technically so much simpler to get started and with that results can be
viewed immediately unlike the days of film, when there were long waits.

Most of Aardman's work is now done with digital single lens reflex (DSLR)

16mm cine camera

CRACKING HINT, GROMIT!

Make sure your tripod is firmly fixed and does not move while the camera is in use. You can weight a tripod by putting weights on the legs and/or suspending a weight from the midpoint beneath the camera. You can fix the legs to the floor or plant them in a triangular spreader which has holes for the legs and stops them slipping sideways. To help prevent the spreader from shifting if someone accidentally knocks against it, weigh down each of its arms with sandbags.

Right: A digital camera in use as Wallace greets the sinister Piella in *A Matter of Loaf and Death.*

cameras, recording onto hard drives. These provide the high quality needed for films that will be shown in cinemas on the big screen. The cost, however, can be in the thousands, and not worth considering for most amateur film-makers. In the professional environment, there are various other aids to accuracy and consistency, but these too are expensive and not at all essential in the early years of a film-making career. There are many more basic skills to be mastered before a DSLR camera has to go to the head of the shopping list.

In recent years there has been an explosion of hardware and software that can help everyone to make stop frame movies. Normal digital cameras are now widely used for stop-frame animation even in professional studios, with Mini DV cameras being perfectly suitable for amateur use when linked to an appropriate computer programme. A web cam on your computer can even be adequate at a very basic level.

Single- and double-frame

Animating in single-frame means you have to animate your model 24 times for one second of completed film. If you do it well, the results are gorgeous. It is, however, a pretty time-consuming method. Fortunately, there is a standard and very acceptable shortcut, which is to take two frames every time you move the model. This is called double-frame, and means you only need to create 12 different images for every second of film. Common sense may tell you that double-frame must look jerkier than single-frame. For now I will only say that we used double-frame for most of Wallace and Gromit's adventures, and they don't look bad. In fact, I prefer to use double-frame whenever possible. Also, you would be crazy to start your animation career working in single-frame. Finally, some further jargon. Single-frame animation is also called 'singles' and 'ones', and double-frame (surprisingly) is called 'doubles' or 'twos'.

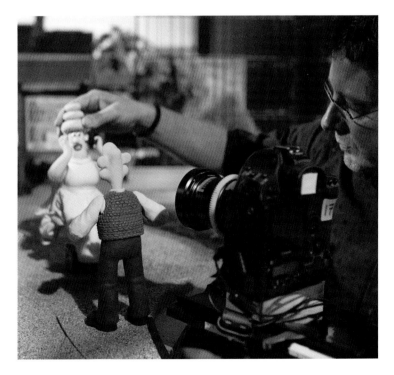

CRACKING HINT, GROMIT!

With a small, light camera buy a lightweight geared head which fits on top of the tripod. The head is equipped with handles which you turn to make a pan or tilt.
To track a camera sideways or on a curve, you only need some kind of wheeled support on to which you can fix the camera. For straight line movements, try a skateboard, guided along between planks. For greater variety you could use a wagon from a model train set, which you then push along a section of rail.

The Digital Image and Motion Control

For professional and amateur alike, digital photography has many advantages over cine film. These include low light exposure, auto exposure, cheapness without film and development costs, good picture quality, and instant replay. The best way to use any of the various forms of digital camera, including digital video cameras is by using a link to a computer software program which can import single frames and replay them. A lot of special effects that used to be done 'in camera' can now be done with a variety of software programs on the computer.

Software is changing all the time, of course, so it is important to keep abreast of developments on the web, or through the press. At Aardman we use a variety of programs, such as Stop Motion Pro, which is a Windows program, or iStop Motion, which is supported by Macs, or Dragon, which is suitable for both platforms. Adobe's Premier is a sophisticated video-editing program that can take in still images and play them out as video.

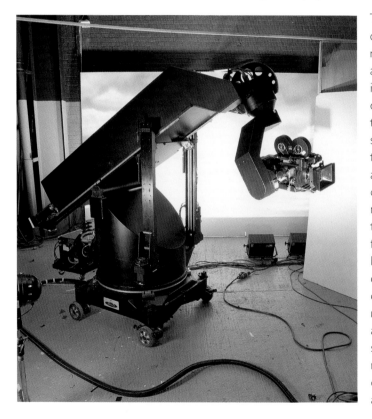

The other important element of camera work is control. There are many tricks that can be used to help at a simple level; the important thing in stop-motion photography is that camera moves have to be timed with the animation, and we have very sophisticated equipment to help us to do that, such as the Milo. If you are working at home, you need to calculate how far the camera should move during a pan or tilt, fix a pointer to the back of the camera head which follows an arc on a piece of cardboard. Basically, you divide the distance the camera has to move by the number of frames the move runs for, but remember that the move needs to accelerate to its full speed and then slow to a stop at the end. On the arc, mark off gradually increasing and decreasing increments for the first and last quarters of the move.

The most common camera moves are pans, where the camera rotates horizontally, and tilts, where it pivots up and down. You can also track a camera, moving the whole thing to one side, or forwards and backwards.

Any movement of the camera must be done smoothly, and there are various devices for controlling the camera as it moves. At the top end of the motion-control field is the Milo, right, a massive rail-mounted electrically driven computer-operated crane, with a boom arm that swivels on a revolving pedestal. This super-versatile rig allows the camera to be moved with optimum smoothness in just about any conceivable direction, its operation controlled by computer. It also repeats movements with extreme accuracy.

Here the Milo is being used to capture a complex action sequence in *The Curse of the Were-rabbit*; it is shown in more detail left being readied to put on tracks. The film cameras are a reminder that 'the Were-rabbit' was the last major project at Aardman to be recorded on film.

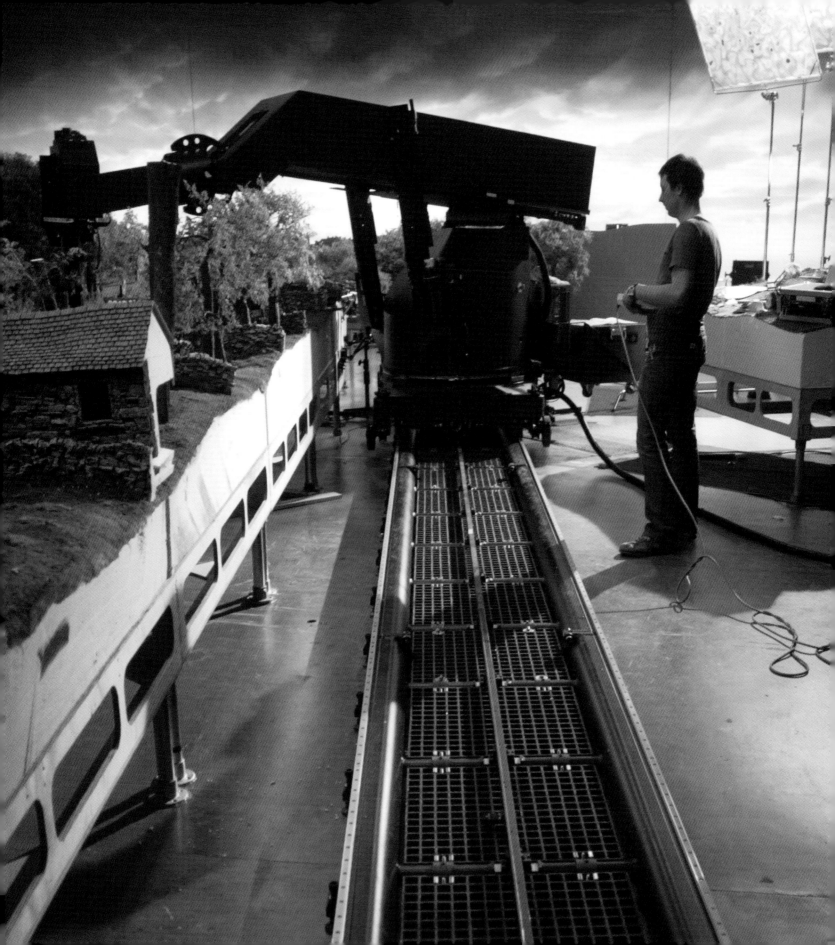

A Simple Studio

Our first studio was the kitchen in Dave's parents' house. Our stage was the kitchen table and our tripod was an old enlarging stand. In later years we moved up-market, first to the spare bedroom and later to his sister's room in the attic (which, I hasten to add, she had vacated). As this suggests, the basic requirements for a model-animation studio are very simple. You need your camera - film or video - and a computer (if that is your chosen method of storing the images). You need a tripod, to support the camera, a flat surface to act as a stage or set, and some lighting to ensure an unchanging level of light while you are animating. And, of course, your character, puppet or whatever.

There is one simple golden rule in the model-animation studio. Nothing should move unless you want it to. When most people start experimenting with animation - and that certainly includes us - the most common fault is that either the set, the shadows from the lights, the camera or the environment itself moves about almost as much as the animated puppet. Any part of your studio which is not firmly fixed down is liable to get knocked or jogged during the hours that you are animating, and every such movement becomes an irritating distraction in your finished film. To avoid this happening, everything possible needs to be fixed down, or otherwise rendered idiot-proof.

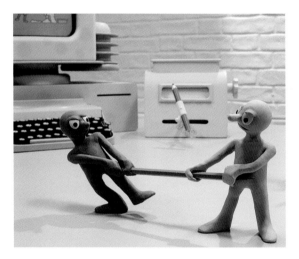

Of course, you have to be careful too. No camera, however sturdily fixed, is going to stay still if you clout it with the full force of your body. I notice that animators, even big clumsy ones, acquire in time great spatial awareness. They become instinctively aware of all the things they must not bump into and manage to avoid them - often without looking - with balletic elegance. Even so, we have to make sure that everything is fixed down.

Morph and his mate Chas, deep in some squabble of huge unimportance. When Morph first appeared on BBC's 'Vision On', our brief was to provide a small blob-like character who would change into various shapes, charge around the table-top, and interact with presenter Tony Hart.

You should be able to tighten your tripod so that the camera cannot slip, even over days. If, as we have already said, you can tape or otherwise fix the tripod legs to the floor, great. If not, try to weight it down so that a glancing blow will not shift it. Sometimes at Aardman we erect barriers - which could simply be ribbon or string - around the tripod, just to keep the animator at a safe distance from it.

Similarly, you do not want your table to start shifting. A succession of gentle nudges will appear like an earthquake in your finished film. The answer is to use

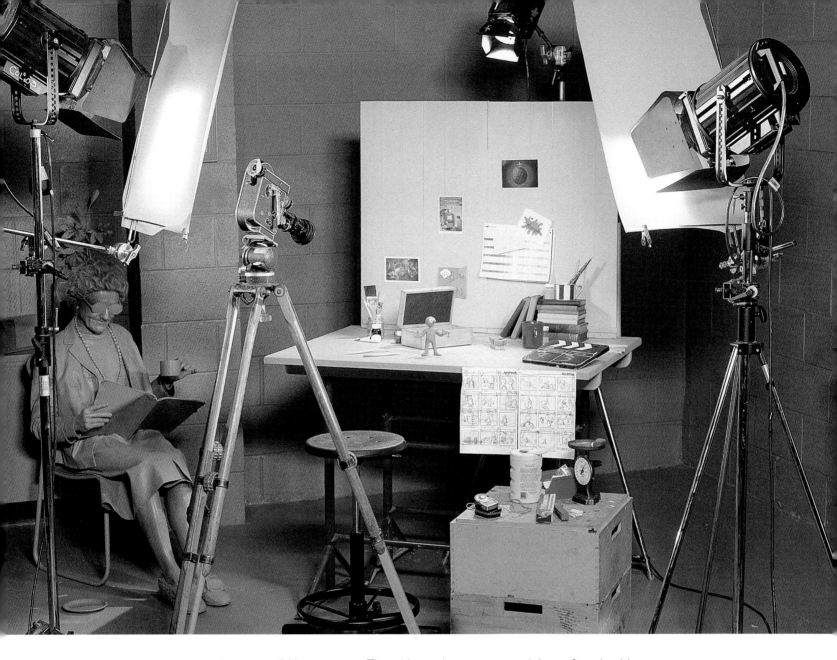

This is how we used to shoot Morph, on 16mm film. These days we use video. Essentials of the scene are: tripod legs firmly secured; camera set well back so the animator has plenty of room; storyboard close by and other props ready to hand - so no need to rummage around later.

the most solid base you can. The table-top is your stage, and the surface should be appropriate. We will see later how models can be fixed to the table to hold their position, and some of these methods are fairly intrusive, involving pins or screws. It may be best not to use the actual table-top but to fix another surface to it. If you decide to do this, thick fibreboard is a good choice. If you follow the Aardman career path and start with clay models, you should be aware that oil and sometimes pigment can seep out of the clay and stain unvarnished wood. You may imagine that clay would stick well to a textured surface, but I found with Morph that he actually stuck best to something smooth and hard, like varnished wood, melamine or formica. If your chosen surface is a board laid on top of an existing table, make sure it is firmly clamped to the table.

A Complex Studio

As you can see, we have moved off the kitchen table. I love the studios at Aardman. I love the fact that they look, and sometimes feel, totally chaotic, though actually they are spaces which have evolved to be the way they are, and this includes being very efficient and businesslike. Even so, I hesitate to show them off to aspiring animators, in case they are discouraged by the complexity and technical sophistication.

Our shooting techniques have always been deliberately cinematic, and that is a feature that has made Aardman's films very successful. As we have moved into large-scale feature films, we have needed to create very complex sets.

In fact, however, the heart of a studio, no matter how complex it may seem, is the same as ever: model, set, camera and lights. Now, however, we have quite complex computing going on as well. The computer allows us to view the shot we are taking and to plan the shot against the previous shots. A big advantage is that this simplifies the real 3-D world into a two-dimensional world on the screen. To help ensure that your puppet is moving smoothly and evenly through the shot, you can draw on the screen with a water-soluble pen. If you trace, for example, the line of the character's back, you quickly find that after a few frames you have a pattern of lines on the screen that should be evenly spaced. Instead of guessing, or remembering how far your puppet has moved each frame, you can clearly see it on the screen.

We also use computers to store the image we have just taken, so that we can compare it with the one we are preparing to shoot. The programme has a slider control so that the animator can mix gently between the two images, checking that every detail is correct. It is also invaluable for checking that nothing in the picture has moved that the animator did not want to move - or, in the case of the animator's worst disaster, when the puppet falls over during the shot, it is possible to replace it in exactly the right position.

Some of the sets for *A Matter of Loaf and Death* were amazingly complex. The view up through his wonderful machinations into the distant attic depths of Wallace's bakery to the scene of Piella's impending assault by flour is especially dramatic: the camera's mount allowing highly controlled movement should also be noted. The street scene (opposite) where Piella pretends to run out of control is another instance of Aardman's loving recreations of the urban landscape.

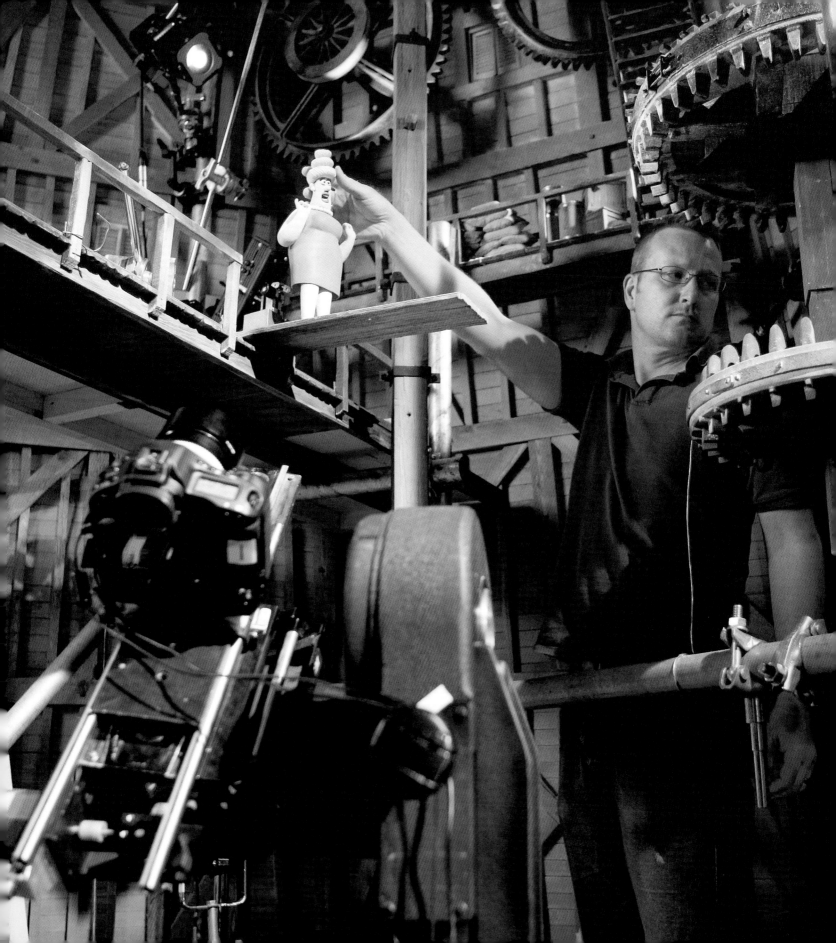

The Power of Lighting

Today we use lighting in just the same way as a conventional film studio, except that we work on a much smaller scale with relatively tiny sets and characters. In order to achieve precise lighting control on such small sets, we use lanterns designed for use in theatres, called 'profile' lamps. These are designed a little like slide projectors and can project a very controlled beam from quite a distance. We are now also using LED lights more and more for these purposes. Lamps positioned some distance from the set can illuminate very small areas of it without 'spill light' falling on other areas.

The amount of light illuminating a set does not have to be huge, even when shooting on film, as we can use long shutter speeds, often between one quarter to a full second. With digital cameras, exposure is much less of a problem and a set can be lit quite adequately with a couple of anglepoise lamps or small domestic LED lights. All digital cameras have automatic exposure control but you may want to overide it and use manual exposure to ensure you get the full effect of the lighting you have set up. Manual mode will also prevent the camera from changing the exposure setting as you step in front of it to alter the positions of your models. Remember to set the camera for tungsten lighting when using normal electric lights, or 'white balance' the camera using a white card held under the lamps you are going to use. This will avoid causing a colour cast to your images and will also allow any coloured lights you might use to have their full effect.

The key light gives the characters their shape, making distinctive and readable shadows. The lamp is often placed to one side of the camera and a little higher than the character to give a 'normal' look. One side of the face will be fully

LED lights are now being manufactured specifically for film making, together with electronic control.

Over the front of the bigger lamps are 'barn doors' which help to control the spread of light and avoid unwanted spillage. Coloured gels can be either clipped to the barn doors (far left) or mounted in a frame that slots into the front of the lamp (third from right).

Lamps can be suspended from an overhead grid, right, or mounted, as below, on floor-mounted lighting stands.

The outer lamps in this group are fitted with Fresnel lenses which allow the beam angle to be adjusted.

Second and third from left are profile spots. Profile lamps give a more controllable beam of light which can be focused to give a hard-edged light or softened for a more subtle effect. Internal shutters can help to control the spread of light. You can also insert a 'gobo' - literally, something which comes between the lamp and the set. We use these to project a defined shape such as a window or a slatted venetian-blind pattern.

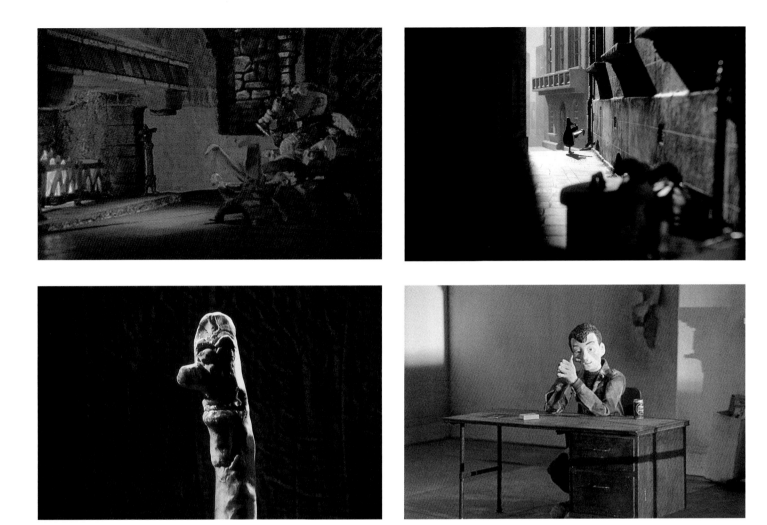

How lighting enhances the action. Clockwise from top left: Warm light from the fire is contrasted with the cold blue moonlight flooding in through the window; from *Wat's Pig*. Film noir suspense with deep shadows and a shaft of bright light in *The Wrong Trousers*. Car lights flash across the wall of the interview room in *Going Equipped*. Back lighting rims the worm/phallus shape of the character in *Ident* and makes him stand out from his background.

illuminated and the other will be in shadow, which will show the character's features well. If there is a window in the set, the key light will come from that direction to suggest that the light is coming through the window and can be coloured to suggest the time of day..

The fill light fills in the shadow side of the subject, keeping a reasonable difference between the two, typically one or two stops (half or one quarter the amount of light coming from the key light) to prevent the shadows going multiple shadows, this light is often a 'soft' light, diffused by tracing paper or similar which is placed over the front of the lamp, or by 'bouncing' the light off a white card to produce a diffused source. Bounced light is very useful, but the light 'falls off' (diminishes in power) very rapidly if the bounce board is too far from the subject.

The back light is used to 'rim' the subject with light, producing a highlight along all the top edges and separating the subject from the background. This is often called giving the subject 'an edge'. This light is placed quite high to the rear of the set pointing towards the camera. Care has to be taken not to have the light

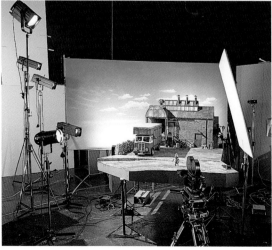

The lighting set-up for an outdoor shot in *A Close Shave*. For this shot the key light (1) assumes the sun position. The shadows are filled by 'bouncing' a narrow-beamed lamp (4) off the large white fill board (6). Three back lights (2,3,5) are used to give emphasis to certain parts of the set, such as the cabin of the truck and details on the rooftop. When positioning these, care is needed not to create secondary shadows from the camera's viewpoint (7).

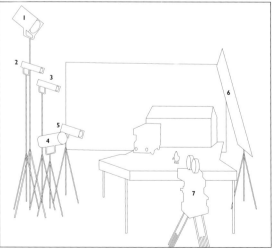

Preston at three times of day. For the daylight shot, left, the scene is keyed from the left as if the main source of light is from a high sun. The fill board to the right of the set bounces a soft light into the shadow areas.

Wiring up the headlight with a wire through the wheel arch. An important element in dressing and lighting night scenes is the use of 'practicals' such as these headlamps (actually torch or flashlight bulbs) which are connected to a low-voltage power supply.

shining directly into the camera lens, so the lens may need to be shielded with a lens hood.

Once your basic lights are in position, you can adjust the amount of light thrown on to the set by various means. First, think what kind of an overall effect you want. Do you want a bright, high-key look with little to no contrast - effectively shadowless - a style often used in comedies or to replicate an outdoor light without sun? Or do you want something more moody and low-key, with high contrast and plenty of shadows, the kind that goes best with thrillers?

The direction of the key light is very important - it is the key. In everyday life, people are usually seen illuminated from above - from the sky - or from lights in the ceilings of buildings, so we read human faces with shadows falling down the face or across it, as from a low sun or as the light comes through a window. A light placed below the face makes it look abnormal and even horrific, especially if the light is coloured! Side lighting brings out the character in the face, emphasising the contours, and side frontal lighting softens the contours and produces a flattering look, as used in shots for glossy magazines.

Soft back light can be produced by placing the lamp beside the camera and directing its beam over the top of the set to bounce off a white or foil-covered board above and behind the set. This gives good rim-lighting effects, but the lamp will need to be quite a bit stronger than the key light to read adequately.

Another good effect is to throw shadows on the wall of a set to look like sunlight pouring in through a window. Cut a window-frame shape out of card and place this close to the set and some distance away from a spotlight, positioning it so that it produces a slanting 'sun beam' across the wall. Putting a light orange filter on the light source will make it even more convincing.

Above left: It is dusk, and the scene is now keyed from the right using a lower light source and an added orange gel (filter) to give the impression of a setting sun. The advent of darkness is further emphasised by having very little frontal fill light and by using practicals such as the headlamps and lights in the building.

Above: The cold quality of night-time is achieved by using a blue gel on the fill light contrasted with a warmer tungsten light source skimming over the building as if emanating from practical light sources.

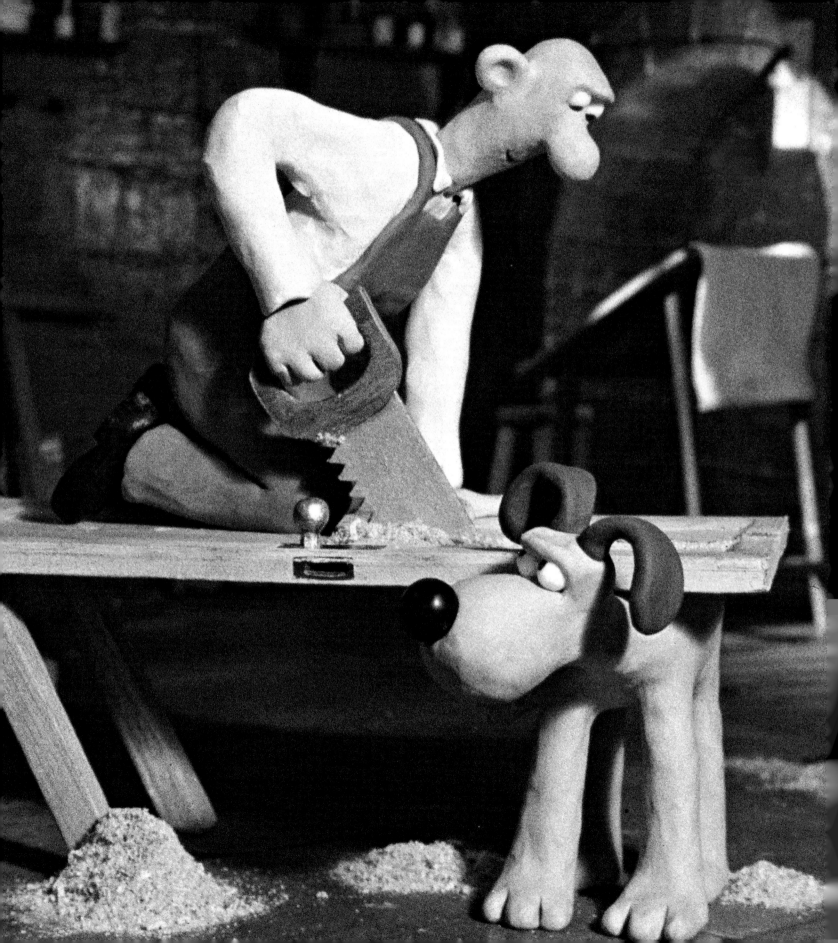

simple techniques

A very early scene featuring Nick Park's Wallace and Gromit; when this was shot, their relationship and their personalities were still being formulated.

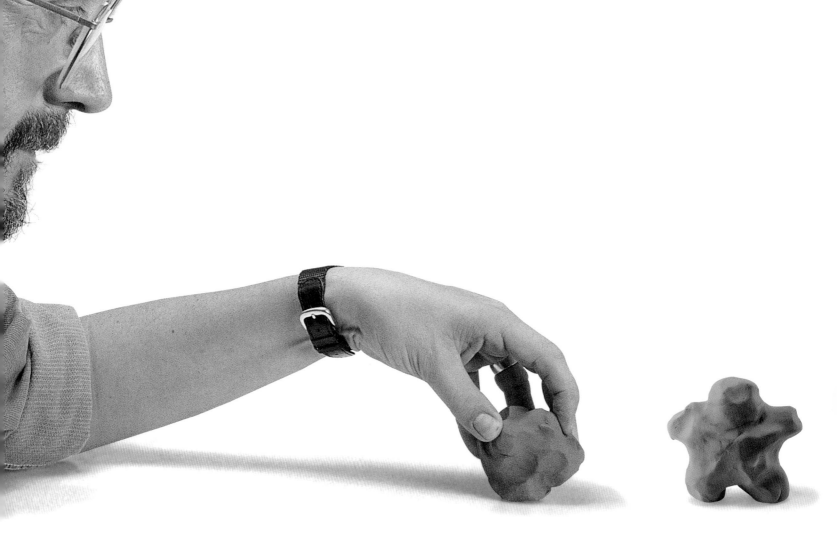

Simple Clay Animation

Working with modelling clay is the perfect way to get started in animation. As a material it is cheap, flexible and instantly ready to use. Within minutes of opening the pack, you can be animating (not necessarily well, it is true, but certainly animating). So where to start? You have a camera, an empty table and a pack of clay. Take a piece of clay and roll it round in your hands to warm it up. Now practise some moves with it - let it stand up and flip over. Divide it into two lumps. Make them rotate around each other. Each time you move one forward, say 0.5in (1.2cm), press down on it a little. As it moves, it flattens itself. Let one piece grow taller. Before you move it, mark its position on the table with a loop of clay, lift it off the set, squeeze it out longer, then put it back on its mark. Look through the camera and check the new position.

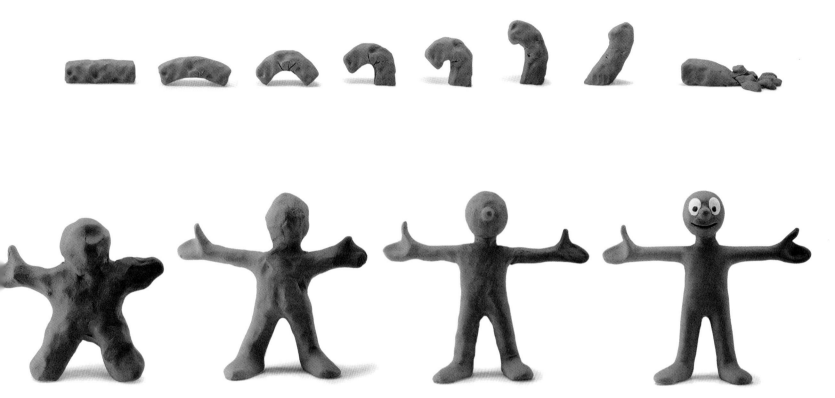

Top: A simple bar of clay, straight from the pack - and never mind the finger-prints! Make it stand up, flip over and break into fragments.

Left: The raw material of clay animation. For filming we use English clay, firmer than the American type which is softer and has brighter colours. Clay is a simple tool, and you need no training to get started. There is nothing to stand between you - the creator - and your ideas.

Try to relax and not be too ambitious at first. Although you could go directly to making a clay figure, a little person or animal, that would be to risk becoming bogged down too soon in detail. Even at this first stage in animation, there are rules and techniques which are simple to follow and will enormously improve the finished result. Never forget that the frame you are animating is one of a sequence. It is not an end in itself. Never lose sight of how slow animation is. If you are working in double-frame, 12 separate moves will only make one second of animation. Time yourself going through a movement to get a sense of how fast your puppet can or should move. How much can you do, how far can you move in one second? If you have a stop-watch, use this to time movements. If not, try saying 'Tick-tock' at a normal rate of speaking; this takes about one second. If you need one second to move, say, 5 ft (1.5m), this means you can film your puppet travelling an equivalent distance - perhaps a complete walk cycle - in 12 frames. Divide up this space into 12 sections or frames to pinpoint each move.

Above: From a blob to a Morph in five moves. This is not so easy, and it would be wise to practise first with the simple sequences on this and the following pages. Have fun with what clay does so well. It is organic and flexible. Each sequence gives you 8-10 phases of movement, or nearly 1 second of film in double-frame (12fps). Put in 3-4 still frames at the beginning to announce your film, and 3-4 at the end to close it.

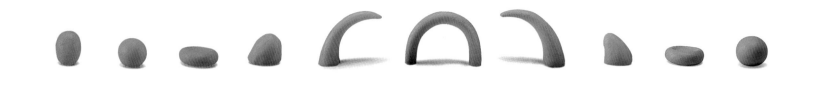

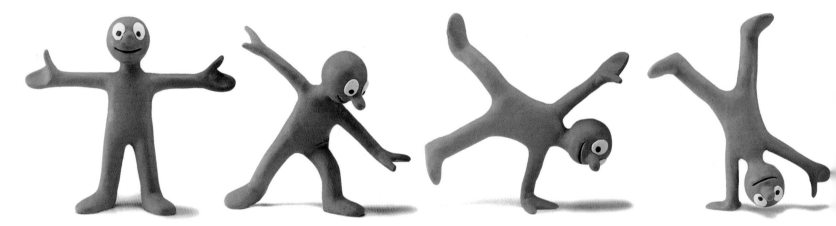

Top: Make an elongated ball and squash it down. Then squeeze it out longer into a horn shape and let it spring over in an arc and revert to its original form.

When this sequence is projected, it will appear that the ball has actually flown through the air.

Above (both pages): Make a smooth sausage shape and bend to make an undulating caterpillar. See how its back arches up to power its movement forward.

CRACKING HINT, GROMIT!

In between shots, clean your hands with baby wipes and rub over the table surface to remove any bits of clay that would show up on your film.

Top: Squeeze out two shapes that rise up, cross over and land in each other's places. Then they form columns, lean inward and intertwine.

Centre (both pages): Cartwheeling Morph. When a clay model is off-balance, support it with fine (invisible) fishing wire suspended out of shot from a rig.

 CRACKING HINT, GROMIT!

Before you animate, use your own body to rehearse the movements and secure a smooth flow from one phase to the next. We call this 'acting through the puppet'.

85

Opposite: Room set ready for the opening shot. Objects such as the jug and glasses, and the base of the anglepoise, will remain in a fixed position throughout. Plan your own film with this in mind, allowing later arrivals enough space to perform their moves. At the beginning of your film, shoot 2-3 seconds of the same frame to establish the scene before everything starts moving, and to freeze it at the end when the action comes to a climactic halt.

Simple Object Animation

Most of this book is concerned with animating models in miniature sets. It is also perfectly possible to animate in the real world, using full-sized objects as props and employing the human body - your own or someone else's - as the puppet. When real people and locations are used, the process is called 'pixilation', the word suggesting the idea of figures jumping about as though bewitched. Because you do not have to build either sets or models, it is a wonderful medium for fast, improvised animation.

These techniques are not part of our mainstream work, but most of us at Aardman have experimented with pixillation early on in our careers, and most of us will jump at the opportunity to do it because it is great fun. While conventional animation requires the animator to work quietly and intensively on his or her own, pixillation is a process in which several people can animate, or be animated, at the same time.

There are masses of things you could animate in a room. They include: an anglepoise lamp; a clothes airer; a glass that fills and empties with liquid; a chest of drawers opening and shutting; curtains and blinds which open and close; a cupboard which opens and the contents jump out; books which change places; toys; things with wheels; counterweighted light fittings, and anything made in several sizes of the same design - weights from scales, saucepans, plates, Russian dolls.

When you lay out your set for object animation, think first of the end point and how to work towards it. Not everything has to be in the opening sequence. Bring some objects in later to create a surprise. Examples from our shots overleaf are: the abacus next to the guitar, the clothes airer, and the dominoes and Lego pieces which jump out of the box. Try to create relationships between the pieces: the clothes airer does not just yaw up and down, it also moves sideways towards the chest, the drawers of which open to allow towels and a scarf to slither out and on to the airer's rails. You need only a minimum of aids to make a room scene work: use tacky putty to hold the rug in position, and suspend the towels and scarf with cotton. As ever, when you move something to animate it, like the jug or glasses, be sure to mark its position with a loop of clay or tacky putty *before* you lift it. When selecting your camera position, choose a viewpoint where everything can be seen clearly and without distortion; in our example the lens is approximately at the eye-level of someone standing.

Above: Frames from our Channel 4 Television logo sequence, made by animating the chest of drawers and the number 4, which squeezes in and out of various drawers. The beach location is an extra bit of surreal fun which makes the chest look more interesting than it would in a room setting.

Now the action starts. On the left, the baseball cap creeps up the wall unit, the cupboard door opens, a poster starts to unravel and the first tennis racquet comes into view. The clothes airer jumps across the room, in the corner there is now an abacus next to the guitar, and more and more cushions arrive on the sofa. In the foreground, the lamp comes on and focuses with rising astonishment on the box and its contents. The dominoes dance off in one direction and the Lego pieces turn themselves into tower blocks. Meanwhile, the glasses fill with orange juice and the jug empties. In the background, the curtains part, the blind slides up and flowers multiply like rabbits.

See how many other animated objects you can find in the pictures. If you make your own film, think about the story behind it all. Perhaps this is what happens every day, when the humans are out of the house and the things come out to play. Run the film backwards, and everything goes back to normal.

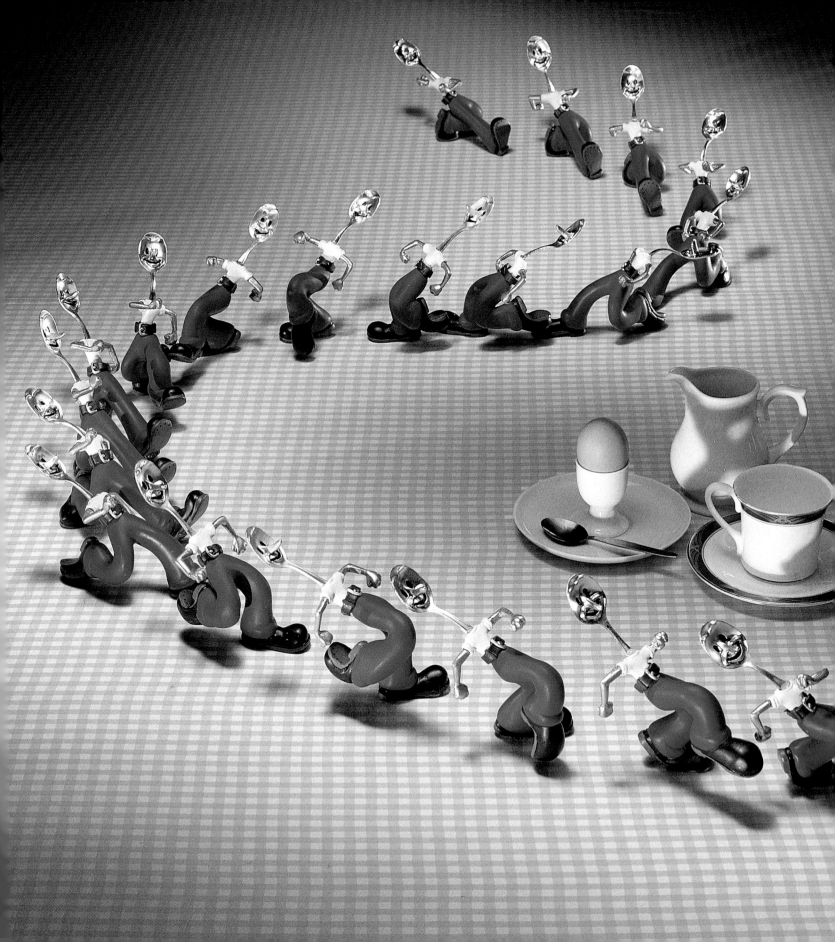

Other Animation Techniques

There is a very particular technique of puppet animation called 'substitution' that I always associate with the Dutch animator George Pal. Although I am sure he did not invent the technique, he raised it to a fine art. Substitution is utterly different from other forms of puppet animation, and actually has more in common with drawn animation. Instead of having one puppet which is repositioned, you use a separate model for each frame of film. Shooting in double-frame, you would need 12 separate models for 1 second of film. We have used the technique only a few times, for TV commercials, and although it is absurdly labour-intensive in the modelmaking department, and expensive, the results can be very satisfying.

Substitution has three main advantages. Firstly, it offers a way of articulating materials that are otherwise very difficult to animate because for some reason they will not bend. For example, a character made out of shiny metal or glass is impossible to animate conventionally (the normal solution today would be to create a computer-generated character). However, you can make a series of models with a chrome finish and shoot them individually.

Secondly, the technique allows the sort of graphic exaggeration that is common in 2-D animation. George Pal used this to great effect in his films. A puppet's walk cycle can include extravagant stretching of the limbs, as demonstrated by the marching figures in the illustrations. With this kind of animation a puppet can change its mass from one frame to the next. Finally, if an action is repeated, it can be quite efficient to build an animation cycle. This is what we did for the Golden Syrup commercial, where all the puppets were required to do was to walk in a repeating cycle.

Substitution need not be the complicated and expensive process that I have outlined. You can make simple and very effective substitution cycles out of clay. This could be as simple as a bouncing-ball sequence, where the clay model shows all the squash and stretch usually associated with 2-D animation. To be a little more complicated, you could make a series of walking figures to show the legs reaching out in an exaggerated way. When you work with this technique, you can emphasise the importance of bodyweight in motion, letting the character almost sag into the ground and spring upward with each step, like a human bouncing ball.

Marching figures animated by substitution, also for the Golden Syrup commercial. The bread is from a giant loaf baked specially for us. The baker cut it in slices and we put these in plywood formers to go stale, so the slices would stay in the required shape during filming.

models and modelmaking

Stage Fright made great
demands on both animators
and model-makers, since the
theatre is populated with a
full audience, all of whom
react to the events on stage.

Basic Principles

You have got your storyboard, at least in outline, and perhaps a few sketches of the character you want to make. Now is the time to think in some detail about the nature of the model and what you want it to do. Think about its size, shape, weight, and the kind of movements you need it to perform.

How big should you build it? If it is too small, there will not be room to accommodate the mechanical skeleton, known as an armature, which allows the model to be posed and to hold its position. The advantage of a larger model is that you can give it plenty of detail. On the other hand, the larger the model the larger the set has to be, and that can present its own problems. For many of our films we make the human-shaped characters about 8-10in (20-25cm) tall, and construct everything else to fit round this scale.

Morph has always been hand-made. To check that we always used the same amount of clay, we weighed him on these old scales.

Weight, too, can be a problem. Say you have a character with a big head. Even if you use a hollow head, it will still need special support. How much support? Will a simple wire skeleton be enough, or will it need a tougher rod-and-joint armature? As ever, it is a balancing act between the artistic requirements of how big the head must be, and the practical question of how you can make that shape work.

Armatures for Wallace and Gromit. These mechanical skeletons are precisely designed and built from detailed drawings of the character (see page 99). You can make them yourself, though most amateur animators get theirs from specialist suppliers.

Outwardly, Morph and Adam may look very similar. Both are human-shaped figures made of clay. In construction, though, they are quite different. While Morph is fairly earthbound, moving about over a horizontal surface, Adam has to be far more athletic, able to stand on one leg and bring off other balancing feats that Morph normally never has to. Morph can thus be made of solid clay, but Adam has to have ball-and-socket joints in the legs so he can keep his balance.

In his quiet way, Morph also has his moments, as demonstrated in the flick-through sequence at bottom right on pages 7-61. When a clay model has to be tilted off-balance, there are lots of cunning ways to stop him falling over - with a pin through the foot, magnets, a carefully disguised blob of stickyback (wax), a rod in the back which the camera cannot see, or very fine fishing wire suspended from a rig above the model. For further tips, look at the sequences on pages 78-81, and see also page 98.

One of the early traps is to think, 'I am a beginner, so I should use basic, clay-only models.' That may be fine for the very early days, but most people will then want to broaden out, and rightly so. You need to test the other options. Quite soon you will also

Building a wire-based figure - one of the troupe of chihuahuas featured in *Stage Fright*. Wire figures are easier to animate than clay models, and cheaper to make than armatured characters, but tend to snap if too much is demanded of them.

discover that unsupported clay is not all that easy to animate. It smudges and gets dirty, and you have to clean it and resculpt every two or three shots. Because of its weight, it is also relatively inflexible.

You might do better to go for a wire-based figure which has its rigid parts, such as the head, made of balsa wood or fibreglass to cut down on weight, and its skeleton covered with foam or cloth. A figure made like this will last longer and let you do more with it. It will also, by keeping its shape, retain the essentials of the character. This is important. With clay, you can shave off so many bits between shots, or unintentionally pull it so far out of shape, that you end up with a different-looking character. This will not endear you to audiences, who need to identify with a character that remains consistent and recognisable.

Don't be afraid to experiment. The more you do, the more you will build up an armoury of different solutions which you can apply in different contexts. At Aardman, in the course of designing and building a single character, we will look at dozens of different materials. In modelmaking there is no neat set of perfect answers. Every character calls for a different way of working.

Sometimes you do not need to build a whole character for a particular sequence. For a head-and-shoulders shot, it can be enough to build the top half of the body and put it on a central pole. As long as the character is held stable for the shot, it does not need to have legs as well.

Think also about the character's focus of interest. If a character has expressive hands, these will probably need a special armature. In *Loves Me ... Loves Me Not*, the character has to have long-fingered, extra-flexible hands so he can perform the delicate task of plucking individual petals off a flower. Hands break easily, by the way, so with a character like that you will need to make several replacement hands which can then be pegged on to the arm as required. To do this, you need to allow for a hole at the end of the arm when you design the basic figure.

As you can see, there is a lot of planning involved. It is a bit like cooking, really. You have to put in all the ingredients to get the right result. And in modelmaking, of course, you have to write the recipe as well.

The compulsive petal-plucking hero of *Loves Me ... Loves Me Not*. Because of the delicacy of his hand movements, and the amount of times he repeats the action, special armatures were made for his hands.

Wallace makes vain shooing
noises at the horde of sheep
happily camped out in his
living room. Even though
these sheep may seem to
be mere extras, the detailing
on them is precise. Necks
and heads move about, and
also give the modelmaker
clues about how the model
should be constructed.

Making a Sheep

In modelmaking terms, there are three types of sheep in *A Close Shave*, which
we broadly categorised as Normal Sheep, Stunt Sheep and Thin Sheep. Thin
Sheep were required for the scene in the wool shop when they run between
Wallace and Wendolene, and we needed to show a mass of different woolly
shapes going past while Wallace and Wendolene are still holding hands over
their heads. They, obviously, had much narrower bodies than the normal type.
Stunt Sheep were used for the shot where they plunge through the small
trapdoor in Wallace's house, and when Shaun emerges shivering from the Knit-
O-Matic. They had to be different again, with a lighter and more squashy build,
and had skeletons made of mesh and coiled wire. Normal sheep were really
quite complex, and had a variety of options built into their basic armature.
This was made of K&S square-section metal tubing, and had two sets of holes

Right: Sketch of Shaun the
Sheep as he swings to the
rescue on board the anvil.
Drawings such as this help
the animator to see the shot
in advance, and also give
the modelmaker clues
about how the model
should be constructed.

in each corner so that the sheep's legs could either come
out vertically (for the normal standing position) or out at
the sides for the pyramid scene when the sheep are on
Wallace's motorbike. Again, there were special holes to allow the
neck to fit into the body at different points, depending on the shot.
When the sheep form a tower outside the prison (while Shaun saws through
the bars and rescues Gromit), their heads are naturally forced downwards by
the weight of the sheep on top, and so their necks had to be set lower on the
body. In the usual standing position, the head was set higher up on the body.

On the following pages we show the various construction stages for a Normal
Sheep. These involve a bewildering array of materials which we have learned
about through experience (also known as trial and error), ranging from the
K&S armature down to tiny details like the glass-bead eyes with painted pupils.

Left-hand column: Legs are made from lengths of twisted aluminium wire.

The feet are steel discs with holes for the leg and for a pin in case the leg needs extra support.

The leg is covered in mesh which is cut to size and squeezed round the aluminium wire.

The head is made of fast-cast resin. Once out of the mould, the holes and slots for eyes and ears are drilled to shape with an electric drill.

Right-hand column: The first stage completed, with pieces of K&S square-section tubing added last to join the legs to the body.

The eyes are white glass beads with pupils painted on using a paint brush and enamel paint. First, the glass bead is placed on a cocktail stick, then put in a drill and clamped with a vice. The drill is turned on to run slowly while the pupil is painted.

A covering of Plastazote - a hard, foam-like material - is put over the metal armature and trimmed with a scalpel, leaving the various holes clear for fitting the legs, neck and tail.

The ears are made of aluminium wire which is twisted to leave a loop at one end. Over the loop goes a piece of mesh, and over this goes the outer covering of maxi-plast rubber, which is sculpted and baked in an oven to retain its shape.

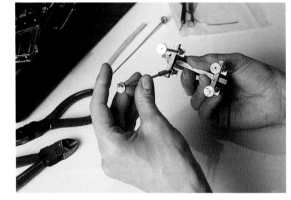

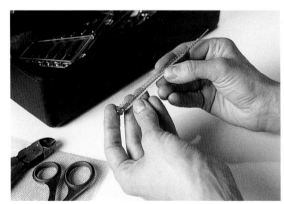

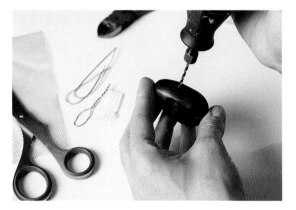

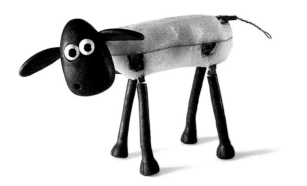

Left-hand column: The second stage completed, with Plastazote body and legs made of maxi-plast rubber which has been sculpted and baked.

Next, the body and tail are covered with a square of foam, which is trimmed to shape with scissors.

Right-hand column: Fur fabric, the final covering, is starched to make it lie down properly and avoid flickering on film. It is then trimmed from its backing, top, and glued over the foam layer, as shown in the next picture.

Eyelids are cast in coloured resin and then trimmed to shape. When the head is finally assembled, the ears and neck are glued into the head with epoxy-resin glue. The eyes, however, are bedded into a type of sticky wax which holds them in place but allows movement.

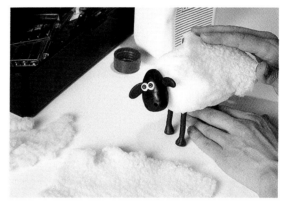

★ CRACKING HINT, GROMIT!

Wear a mask when you handle epoxy-resin glue.

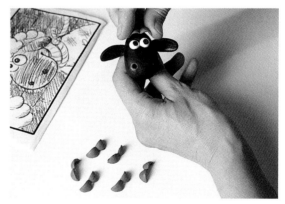

Gromit Construction

In their progress from *A Grand Day Out* to *A Close Shave*, the Wallace and Gromit puppets have undergone a considerable evolution and are now much more rounded and three-dimensional than they used to be. Wallace had a much flatter face when he was building the rocket in the cellar in *A Grand Day Out*. At first he did not speak much, but when he did he suddenly developed cheeks and his brow got bigger. Now he is much fuller in the face with quite rounded cheeks, and his mouth expands quite enormously in a sideways direction when he speaks 'ee' sounds, especially in words like 'cheese', mention of which tends to make him grin as well. In the same way, Gromit's brow was much smaller in the beginning, and is now quite big. His nose or muzzle has meanwhile become shorter, and is less pear-shaped and more stubby. At first he was to have been a talking dog, with a mouth, but this idea was dropped when it became clear how expressive he could be just through small movements of the eyes, ears and brow.

Not all Gromit figures are the same. The one shown here is a standard Gromit standing on four legs. In other scenes where he is required to sit down, say in an armchair or at the controls of the rocket, he has to have a very different kind of ball-and-socket armature. This other type is much more human-looking, simply because our joints are not in the same places as those of dogs.

This Gromit consists basically of a ball-and-socket armature and a body made of fast-cast resin. Plastazote could also be used for the core of the body, which needs to be hard enough to be drilled for fixing the puppet's limbs to it. The body is then built up with modelling clay. In general it is a good idea to begin by adding clay to the armatured parts, since these tend to give off black metallic flakes and oil which makes the clay dirty. We block out the whole figure first, and then sculpt it to its final form, working the surfaces until they get smoother and smoother. Water is used to skim off clay, or lighter fluid, though this eats away at surfaces and is best reserved for tiny detailed parts.

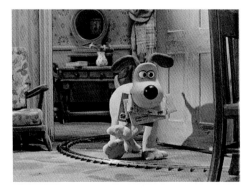

Gromit brings in the papers, ears raised on the alert.

Character sketches to work out the angles of head to body, the position of the eyes for looking up, down or sideways, and how the paws change from being conventional paw or hoof-like things, for walking on, to human-style hands with four stubby fingers.

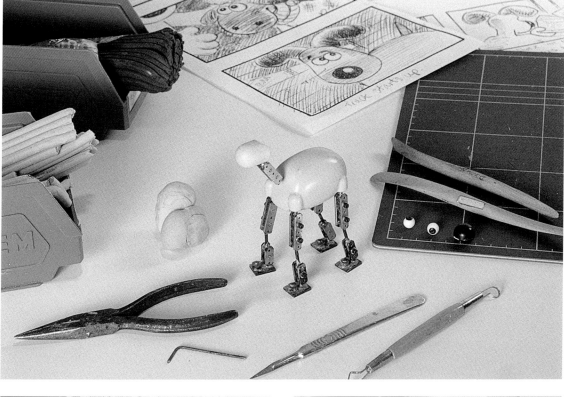

Starting with the armature and fast-cast resin parts for the head and body, the **Gromit** shape is blocked out in clay and gradually smoothed down with a modelling tool. Then the final details can be added - the eyes, nose, ears and tail.

The eyes, like those of the sheep (see previous pages) are glass beads with painted-on pupils. The noses were mass-produced for something else, but when we saw they were just right for **Gromit**, we bought a bagful. The ears and tail are made from a wire twist. This can be coated with cotton, string or pipe-cleaners to help key on the clay, which is then added and smoothed into shape.

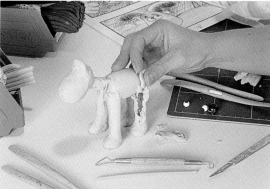

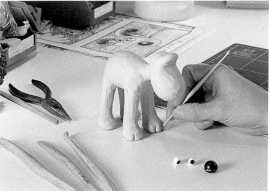

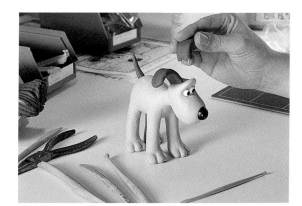

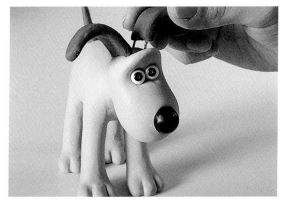

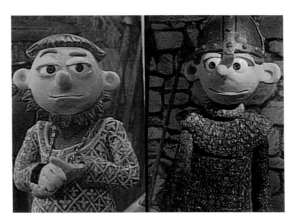

Wat and his brother, shown
in split screen, essentially
two characters cast from the
same mould.

Wat Construction

Wat and his brother, in *Wat's Pig*, are good examples
of the human-type everyman figure. When planning
the model, we knew that he would have to move
fluidly and often, and make a lot of emphatic
gestures. The solution was to keep his build fairly
spindly, as the drawing opposite shows. Basically, the head consists of a solid
core covered with clay and sculpted, and the hands are also made of clay. The
rest of the body is made of foam applied sparingly over a metal armature.

Construction falls into several main stages. It begins with the storyboard, where
the film-maker can give real purpose to any previous sketches he may have
made of the character. Once the story is working properly, the character's

design can be finalised and drawn up. The figure is then sculpted in
clay and a design drawing made for the armature. This shows in
detail how the armature will be built and how it fits inside the
character. When the armature is made, it is wrapped in plumber's
tape to make a better bond with the latex covering. The clay
sculpture is broken down into its component parts, such as the
torso, and these are cast in plaster. This produces a plaster mould in
which the armature is placed and coated with foam latex. The
mould is baked and the finished torso (or whatever) is removed
ready for colouring and assembly with the head, legs and hands.

Making the armature is a
delicate and specialist task,
nothing less than engineering
in miniature. This picture
shows the modelmaker
surrounded by the tools of
his trade: in the foreground,
vernier calipers, allen
keys, assorted pliers and
a hacksaw.

A mobile model such as this needs good built-in stability to help it stand up
when its weight is not in the vertical plane. There are various ways to achieve
this, the best being to fit a three-part footplate to the armature, as shown in
the skeleton on the right. These footplates spread the weight of the model over
a broad area and allow the animator to move the foot in a convincing way
when the model itself is in motion. Other solutions to the stability problem are
to hammer a pin into the foot and hide it with a blob of clay, suitably coloured.
Alternatively, use a stickyback, a small blob of wax, which you can mix with clay
to disguise it, and then apply it to stick down the foot at the appropriate point.
Another option is to use a pair of magnets: one is fixed in the foot and the
other is placed on the underside of the stage. If these solutions are not
enough, as when the model is standing on one leg or leaning or holding
something, you can put a piece of stout wire in its back to act as a prop, and
then anchor this in a blob of clay behind the figure, where it will be out of sight
of the camera. To make your model tilt over, or fall or fly, put fine fishing wire
around the waist and neck and hang the figure from a rig positioned out of
shot. Against a white background the wire will probably be invisible. If not, hide
it by spraying it in a colour that matches the background.

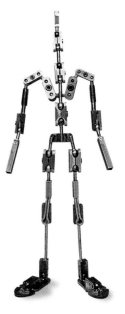

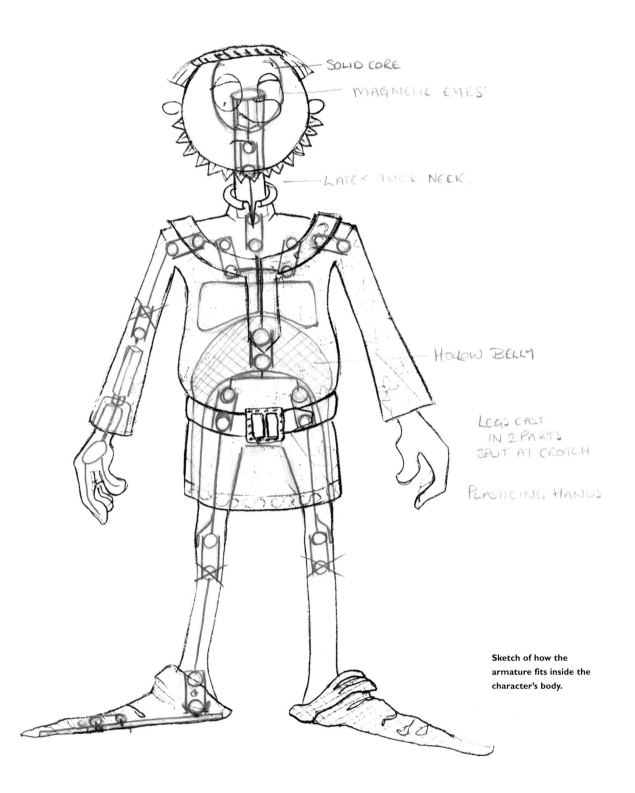

SOLID CORE

MAGNETIC EYES

LATEX TUBE NECK.

HOLLOW BELLY

LEGS CAST
IN 2 PARTS
SPLIT AT CROTCH

PLASTICING HANDS

Sketch of how the
armature fits inside the
character's body.

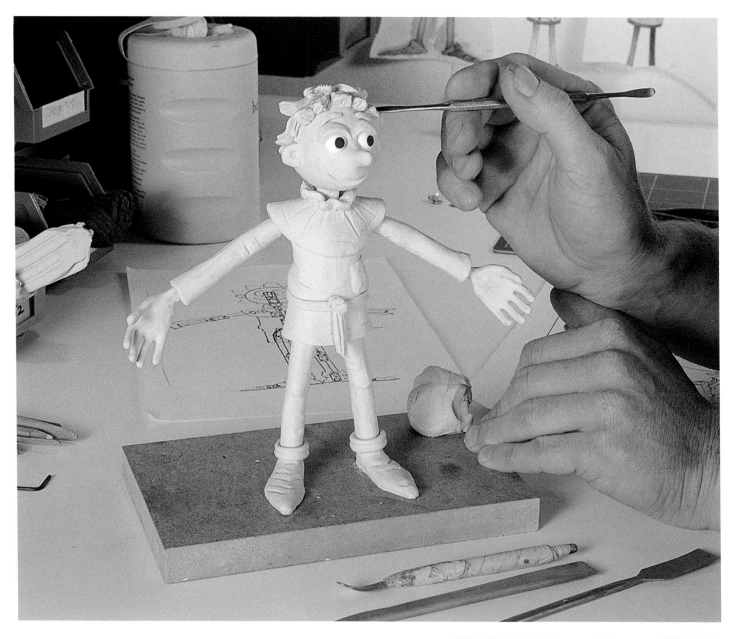

The original Wat figure is sculpted in modelling clay on a simple wire armature. This has brass square-section fittings so that all the component parts can easily be taken apart.

The clay torso is laid up, ready to be cast in plaster.

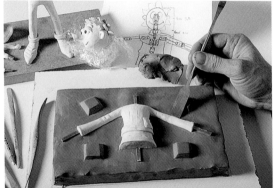

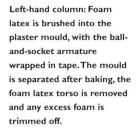

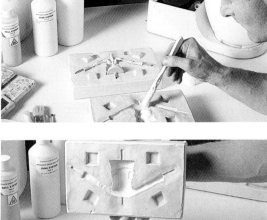

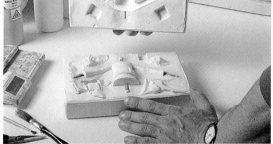

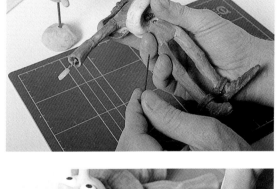

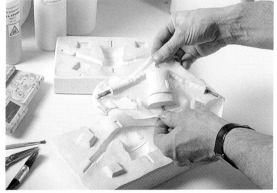

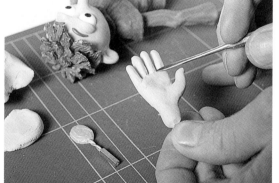

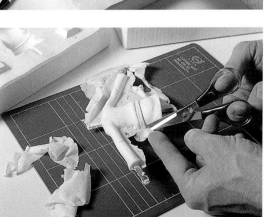

Left-hand column: Foam latex is brushed into the plaster mould, with the ball-and-socket armature wrapped in tape. The mould is separated after baking, the foam latex torso is removed and any excess foam is trimmed off.

Right-hand column: Colouring the torso with a diluted latex mixture. To colour figures, you can either spray the whole torso with the main colour and then hand-paint details such as the belt, or you can mask out the parts you do not want covered and spray the rest.

Assembling the puppet after painting.

Sculpting the hands in clay. A character such as Wat will use a lot of hand gestures in the course of a film, which means the hands will need replacing from time to time with new ones.

Rex Construction

Rex the Runt and the main characters in his series of adventures are flattish, not unlike gingerbread men. Their shape, and the way they are made, comes from the special way the series is filmed. This is the so-called 2-D technique of shooting the characters on an angled sheet of glass, often with a painted or photographic background positioned behind the glass so that the two elements can be combined in a single shot. Rex and the others - Wendy, Bad Bob and Vince - are not completely two-dimensional (even a gingerbread man has a certain minimal depth) but the way they can be used is very different from a fully rounded, three-dimensional character.

There are three main advantages to shooting on glass. Firstly, you do not need the complex armatures which have to be built for most of our conventional 3-D characters, such as Wallace and Gromit. Secondly, the characters are not bound by gravity and can be animated to jump or fly around the scene, more like they do in cel animation. Thirdly, the animator can sit in reasonable comfort at the sheet of glass, which is fixed at the angle of a drawing-board, with the camera shooting over the animator's shoulder.

Rex and Vince, ready for the camera. Once the basic figure is sprung from the press mould, the eyes, noses and clothing are added. The eyes consist of simple white beads with small holes in the pupil so the eye can be moved around expressively. Noses are made of solid resin, and Rex's mouth is a loop of clay.

In the course of making a series, we get through several hundred main characters. Obviously, it is important that each one should look the same as its predecessors. At the same time, they have to be as simple as possible to make. The solution for us is to use press-moulds. The process begins, as ever, with a model drawing, which is then sculpted in clay. We then cast the character in rubber.

When the clay is removed, it leaves an impression that gives us the press mould. This is then surrounded by a plaster jacket to stop the mould distorting. The mould can be reused throughout the production to turn out new characters when they are needed.

Animating on glass. The characters are set up on the angled glass, often with a suitable background placed behind it, then filmed from a position over the animator's shoulder.

Once the mould is ready for use, the first step is to dust it with talcum powder to prevent the clay from sticking to it. Then a thin layer of clay is rolled out and pressed into the mould. This is followed by more clay, pushed in carefully to make sure it works its way into all the detailing of the figure. The top surface is finally flattened out with a rolling pin. To extract the completed character from the mould, the trick is to bend it slowly and at just the right angle for it to pop out. The character is then ready for the usual finishing work - adding the eyes, nose, mouth and any other special features, such as Bad Bob's eye patch.

Above: A complete impression of the figure lies in the rubber mould after casting, while the modelmaker rolls out a thin layer of clay.

Centre left: Layers of clay are pressed into the mould and pushed into all the details of the figure.

Centre right: When the mould is full, it is flattened with a rolling pin.

Below: The rubber mould is separated from its plaster jacket and then gently bent to release the new figure.

Preston

Preston is the evil dog in *A Close Shave* who first appears as the thuggish sheep-rustler who rules the roost in Wendolene's blighted household. At the film's climax, he is transformed into a metallic monster, receives his just desserts and ends up as a crippled robotic wreck. He is thus seen in three completely different versions - the brutal but recognisably doggy dog, the gleaming robo-dog and the trembling has-been.

John Wright, who specialises in 'engineered' models, made the original armature for the basic Preston, which was then modelled in clay and dressed with the character's special spiked collar and wrist bands. The other, mechanical versions are much more elaborate and were made in John Wright's workshop in Bristol. He recalls, 'What was interesting about the robot Preston was that his armature was on the outside and became part of his villainous character.'

The arms and legs are in fact part of a basic armature, with the visible parts dressed with extra screws and piping to make them look more mechanical and threatening. The body was machined in a chemical-wood material called Modelling Board and painted with a steel-finish paint. This was then dirtied up around the rivets to make it look as if it had been knocked about. On the chest (see main picture, right) is a miniature tape recorder, also specially made. The other main feature of this model is a hinge at the back of the head which allows the top of the head to lift back and reveal a mouth horrifically full of cogs, gears and piping.

Finally, after his disastrous experience in the Mutton-O-Matic, the crippled Preston is a mere shadow of his former brute self. The body is essentially the same, though tipped over into the horizontal, but in place of his fierce armature-legs he now stands on four much more spindly supports, made to look like wall units for a shelving system and mounted on pram wheels. For added pathos he sports a bandage wrapped round his forehead.

The three ages of Preston, in which the villainous bully dog is transformed into a metal robot clad in spikes, pipes and rivets, and later, after meeting a machine which is even bigger than he is, emerges a beaten-up, bandaged wreck gliding about on pram wheels.

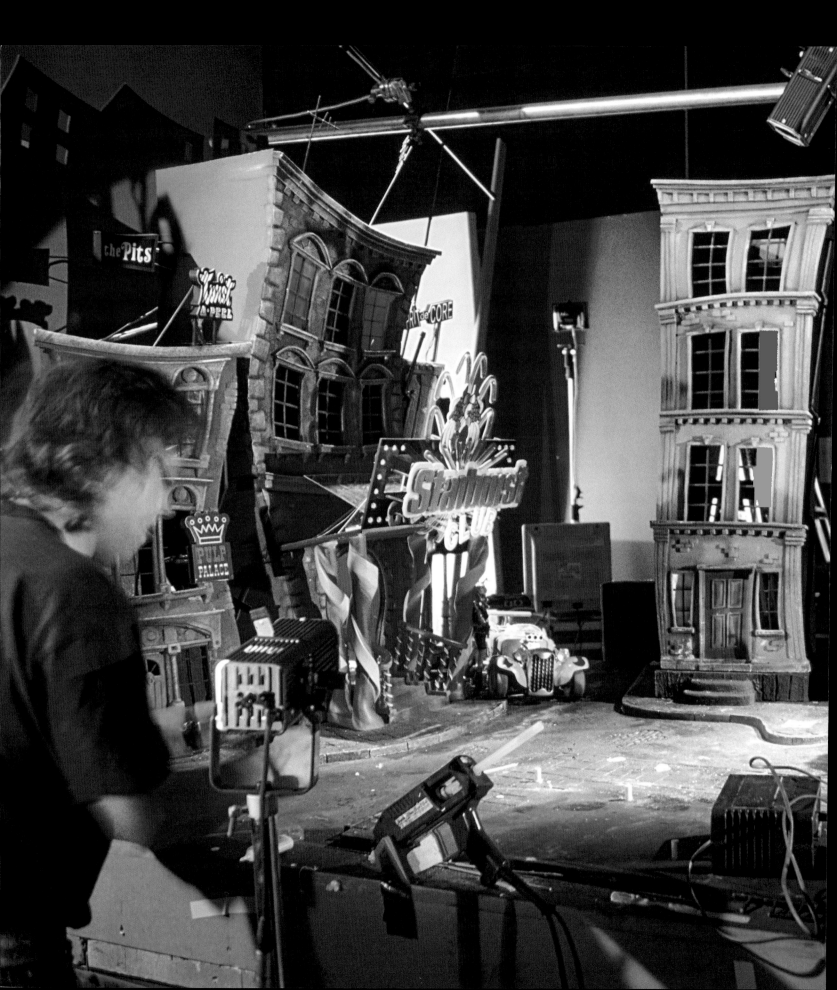

set design and making

Imaginative set design and construction can convey a lot of the message, as in this elaborate set for a Starburst commercial.

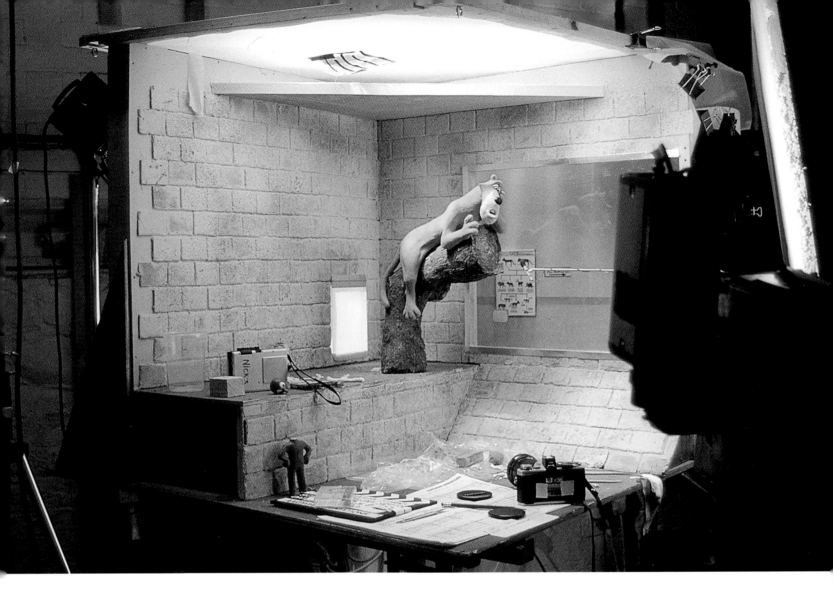

The Jaguar mourns the
lack of space in his simple
brick enclosure; from
Creature Comforts.

Planning a Set

For about the first ten years of our career, Dave and I never had a set with
more than three walls in it. That really is all you need at first, just something
that neatly contains the miniature world you are filming.

Every set has to have a firm base which does not move. Even though your
basic stage or tabletop may be solid and flat, it is a good idea to build each
set with its own floor. It will then be completely transportable and can be
stored out of the way when you do not need it, and brought back for use in
another film. Also, your basic stage will soon get mucky and stop being very
flat if it has to be host to a succession of different sets. Use a sheet of
hardboard or plywood as the platform and colour it with emulsion paint.

As you design your set, think about where you will want to bring in the
camera. In relative scale, the camera is about as big as a double-decker bus,

so you have to make plenty of allowance for it. Think, too, about how you will light your set and leave enough space to get in and animate your characters, whether from the front, the side or by moving in over the top. Try to avoid situations where you risk brushing against, and moving, any part of the set. This is easier said than done, but if you move something and do not put it back exactly where it was, the shift will show up on your film.

Try to keep your first sets indoors, and confine everything within a space of about 4ft × 4ft (1.2m × 1.2m). For a simple room set, build two side walls and a back wall from foamboard or thick card. Cut out a window in a side or rear wall to give yourself extra lighting and shadow options. Hold the walls upright with supports glued on to the back, and fix the walls to the floor with blobs of tacky putty. If you need to take out a wall to shoot from a different angle, be sure to mark its position before you lift it.

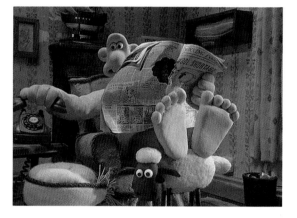

The furniture and other props need not be elaborate. Add simple chairs and a table if this fits the plot of your story. Look around local toy and model shops for ready-made pieces, or make everything yourself from simple materials such as balsa wood. Glue the parts together and colour them. Later you can move on to scenic artist's paints, but for now any water-based paint will do. If you want a tree to be visible outside the window, make the trunk and branches from a frame of twisted aluminium wire, cover it with masking tape and paint it. Cut leaves from coloured paper and glue them on to small frames of fine mesh, of the kind used to patch holes in the bodywork of cars.

Wallace in his sitting room, basically a simple three-walled set with a window on one side, through which different lighting effects could be used to suggest changes in the weather or time of day.

Bear in mind that props should be more or less in scale with your characters, and that most human-shaped puppets are 8-10in (20-25cm) tall. Remember, too, that nothing has to be spot-on realistic. You are operating in a world populated by small clay creatures, and the important thing is that their chairs, their TV sets, cars and other worldly goods should look appropriate to them.

A Straightforward Set

From an entry-level set with just three walls, it is not such a big jump to Wallace and Gromit's sitting-room. The basic structure is the same, even though it is made with greater expertise and has more elaborate furniture and décor.

Our conventional room sets are free-standing table units. The whole structure has to be strong and solid enough not to move under temperature and

atmospheric changes. The floors are usually made of perforated steel, which is strong enough not to bend and thin enough for magnets positioned underneath to hold and draw the puppets as they move around the set. The actual room finish - in the form of floorboards, carpet and so on - is fixed over the floor. The room walls are usually made of plywood and fixed in position by means of dowels - like pack-flat furniture - so they can be lifted out easily when shots need to be taken through the space they are occupying.

You can apply the same techniques to other more complicated sets such as a staircase and landing. Here, it is important to leave sufficient space under the stairs for the animators to get in and reposition the magnets - and to do so many times during the course of a sequence.

Outdoor and Landscape Sets

Outdoor sets are generally bigger and more difficult because you have different layers from front to back, and this all takes up a lot more space than a room set. In *Wat's Pig*, for

Set drawing for *Wat's Pig*, with Wat outside his hovel and the ground sloping up and away towards the castle. Opposite, a frame from the film shows the same scene.

example, we had a landscape set with three layers, and a track running through it. First was the foreground which sloped upwards from a flat plain that the characters could stand on. This was about 8ft (2.4m) deep. Then the land appeared to fall away - in fact it was a gap with nothing at all there - and

Below is the same landscape seen from side-on. From the platform on the far right, where the characters stand, the ground rolls away in layers towards the horizon and painted sky.

behind that we had the next layer of hills, which was about 2ft (60cm) from front to back. However, the track appeared much narrower so the audience would understand that it was much farther away. Behind this was the third layer of hills with the castle perched on top.

These hills were painted in paler colours to make them recede, and in the far background was a painted sky. It was all very graphic rather than realistic, but it suited the context of a fabled medieval world inhabited by peasants, warriors, a power-mad baron and a kindly smiling pig.

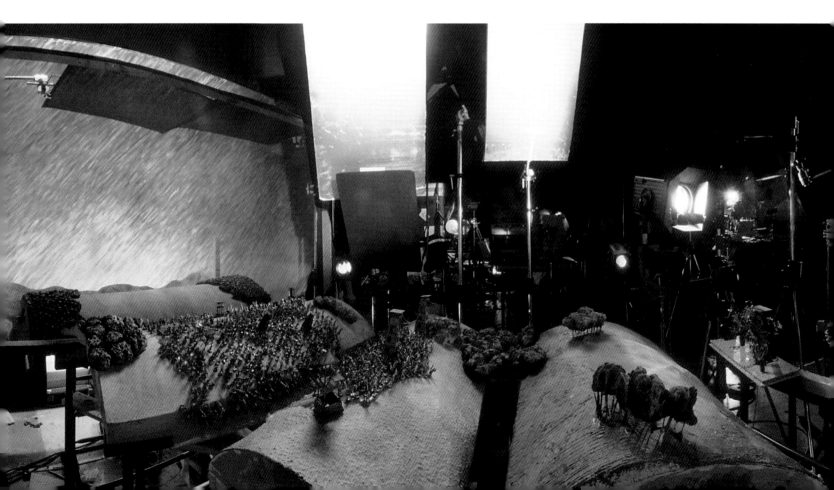

Matching Sets to Products

When the function of a set is to help advertise a product, it will tend to look more highly finished than usual. This is particularly true of scenes where the product itself is presented in some form. Clients want their product to look good, and sometimes the tone of a commercial is worked out from that point.

This by no means applies to all commercials, many of which take place in a complete fantasy land which is geared to promoting some idea about the product or special quality that the advertising agency has chosen to emphasise - its great taste, for example, or the fact that it is made of real fruit. However, when the product appears in the story, it will probably be handled straight, pretty much as you would see it in real life or in a brochure. In our commercials for Burger King, we peopled the set with a colourful mob of clay puppets, but the burgers, buns, chips, etc were handled in a realistic manner.

To make such items is specialist work, and here the boundaries become blurred between modelmaking and set-building. Whoever does the work, the important thing is to get the right blend between the animated models and the backgrounds against which they move. This can be seen in the Polo commercials, where the sturdy shape of the mints, with their chunky embossed lettering, seems to express a sympathetic bond with the shiny metal machines in the Factory of the Future (courtesy of 1930s Hollywood) which is obviously dedicated to production of the ultimate mint, and where every surface is studded with Polo-like rivets.

In our Chevron commercials, we were dealing with a product which is virtually impossible to show - petrol. To resolve this, we created a range of vehicles which run on Chevron (and others that do not) and made them into central figures. They are strong characters with expressive features: the headlights are eyes, which swivel this way and that, their radiator grilles are mouths and their wipers act as highly mobile eyebrows. The sets were then matched to the cars, right down to the last

High-finish factory sets for the Polo commercials, crammed with glass and metal surfaces held together by Polo-shaped rivets.

Wide-eyed and expressive, with wiper eyebrows and radiator mouths: two cars from the Chevron series.

Drawing for a Polo factory set, which by featuring an impressive length of conveyor belt, moving in a bold diagonal across the set and surrounded by machines, goes far beyond the conventional three-walled space of most 3-D animation sets.

petrol pump and telegraph pole, so that everything had the same graphic 'cartoon' quality. In other words, we built a believable world for those characters to inhabit.

Many advertisements finish by cutting to a pack shot of the product. You may see the company name and logo as well as the product, or just the product by itself. For this we often make a special larger version, it being much easier to make something look good if you make it bigger than life-size and build up its inherent textures. These packs may even be more perfect than the ones on sale in the supermarket. We can do this by taking off the bar code, for example, or some tiny detail such as a copyright line.

Then the pack has to sit perfectly in its setting, on a velvet cushion or surrounded by petals, each of which has to be exquisite and just right. All this adds a sense of high quality, hence desirability, which the client naturally wants people to associate with this particular product.

A Complex Set

The film *Stage Fright* started off as the story of an entertainer who passed through all the showbiz eras of this century. Beginning as a dog-juggler in music hall, he went into silent movies, then he tried talkies, and so on, and each time he failed in some dreadful way to make a go of it. As the planning went on, we could see it would be possible to make almost the entire film in a single music-hall setting, and this encouraged us to invest heavily in building one big set.

The theatre is based on the Bristol Old Vic, and we show it in two periods. One belongs to the cheerful past, when it was a proper music hall, and the other to the present after it has become a virtual ruin. To do this we built the theatre in its prime, decorated with shimmering gilt ornament and gas lamps, and filmed all the sequences relating to that period. Then we wrecked it, smashed the plasterwork and ripped up the seats until we had the right air of ultimate mournful decay.

Right, top: the auditorium in its distressed state, after we had trashed it to show the old music hall in its time of decay.

Right, below left: The theatre during construction, from which you can get an idea of its relatively huge scale for an animation film. Below right is the second proscenium arch where we filmed on-stage scenes to save time while the main auditorium was in use.

Set drawing for *Stage Fright*, the stalls and galleries filled with 80-90 characters. In some shots every one of them had to be animated, especially when they were applauding or jeering.

On the right is a plan view of the auditorium, showing the boxes near the stage which swung open like doors so that between shots the animators could move in and animate the characters.

It was a big set, measuring about 10ft (3m) from front to back, 6ft (1.8m) high and 6ft (1.8m) wide, and consisted of about thirty separate pieces. Fitting it all together was like doing a 3-D jigsaw puzzle. Along the side walls of the auditorium we had little boxes for members of the audience. We built these side parts as big doors which could be opened out on hinges. The animators could then go in, animate the figures in the audience, including those in the boxes, then close the door ready for the next shot. The hinges were disguised under architectural columns which looked like part of the theatre's design. We also built a second proscenium arch and front-stage area so we could film on-stage shots at the same time as the more complicated sequences were being photographed in the main theatre.

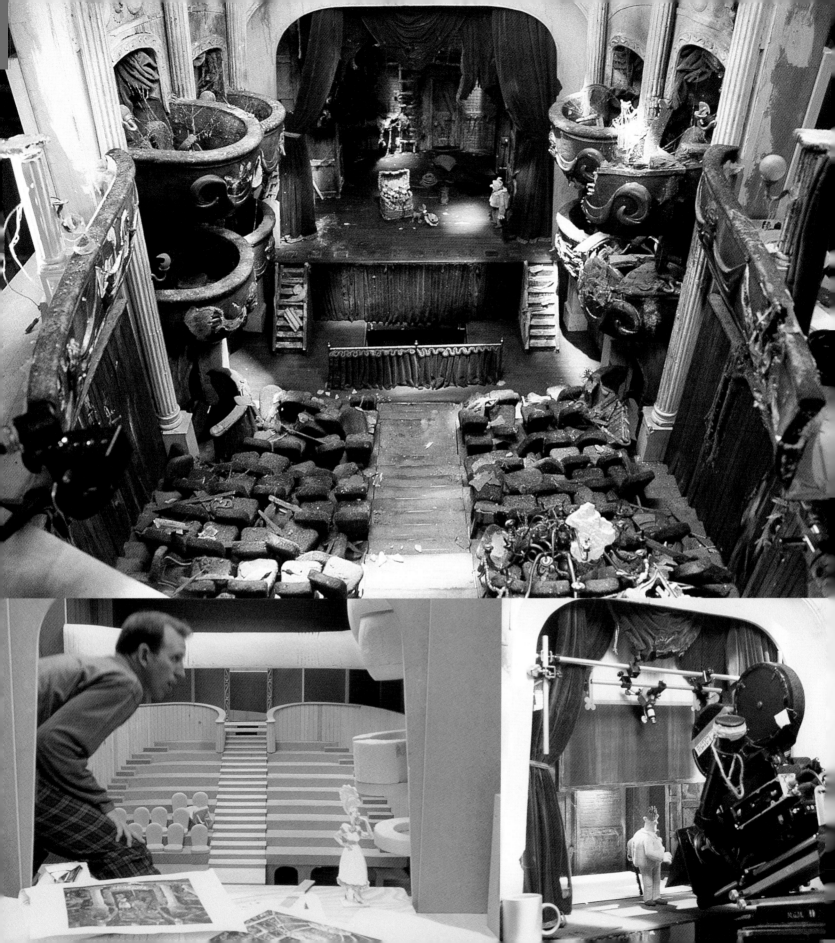

Below: The hand next to this display of Wallace's tool-kit gives an idea of how minute such props have to be. To compare the real-life scale of the saw in this group with the saw as it actually appears in the film frame, look at the picture on page 76.

Ingenuity and Props

Because we work in miniature, all our props are small. Some, however, are very small. Many of these are hand-held items - a toaster, a tea set, a hair-drier, a plate of burger and chips. All these things have to be made in the same scale as the hands that will hold or carry them, although that is not necessarily the same as the scale of the set. Hands are often made disproportionately large to cope with all the work they have to do, so if the same prop was held up to the character's head it would look ridiculous. To get over this, you probably have to make a smaller version of the prop. Close-ups, on the other hand, look better with a larger version. These are just some of the complications that our prop-makers have to bear in mind as they search for ingenious ways to convey the essence of an object. Over the years they acquire an extraordinary mental directory of solutions to cover anything from a tiny submarine to an electric fire that actually glows.

As ever, there are no fixed rules about materials or methods of construction. For fine or detailed work, prop-makers sometimes use rather finer materials than basic modelling clay. Products such as Fimo, Milliput and Sculpy are easier to model than standard modelling clay; the sculpted object can then be baked in an oven and hand-painted. Items of clothing are often sculpted in modelling clay, then a plaster mould is made and filled with latex which has lengths of wire inside it. If you want, for example, an apron or a coat that will flap in the wind, the wire helps it to hold its position. When several versions of the same prop are needed, such as shoes or hats, it may be best to use fast-cast resin and a silicone mould.

Graphic items such as newspapers or Wallace's travel and cheese magazines can usually be produced on the computer and reduced down. The same goes for posters, wall-signs and notices on shop-fronts. If a character needs to hold a newspaper while reading it, you can back the paper with heavy-duty foil to hold it firm while in shot. Household decorations, such as the pictures on the wall, the wallpaper and carpets in Wallace's living room are all hand-painted. You could make these by photocopying, but usually directors prefer things to have a home-made feel. We have also included a number of glass objects in our films. These are made for us by a professional glassblower.

A Moon rocket no taller than a paint-brush, from *A Grand Day Out,* and a flying toaster made for an episode of Morph.

Right: Gromit flies round on the end of a miniature power drill; from *A Grand Day Out.*

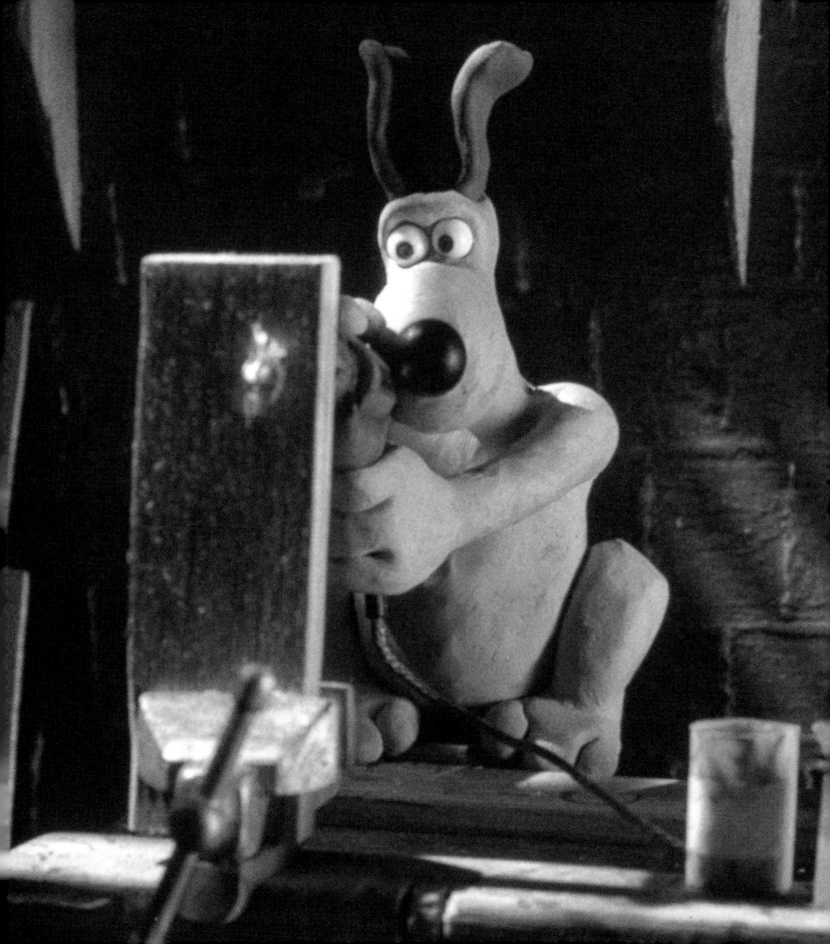

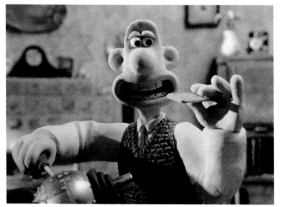

Prop-making for small worlds.

This page, from top: Making Wallace's favourite crackers, and the packets too.

Mocking up newspapers and other paper items. These may be needed for a character to hold and read, or for display in a newsagent's window, as shown. Newspaper props are backed with heavy-duty foil so they hold their position during shooting.

In the glassblower's workshop, where all manner of glass objects are made, including the milk bottles which feature at the end of the chase sequence in *The Wrong Trousers*.

Wallace's hair-drier with an action frame from *The Wrong Trousers*.

Opposite: A parade of objects to demonstrate the invention and artistry of the prop-makers. They include the submarine that journeyed through Vince's brain in the 'Rex the Runt' series, and the basket used by Tiny, the dog-juggler in *Stage Fright*.

Left to right: Ancient exhibits from the museum in *The Wrong Trousers*; Contemporary table and lamp from *Not Without My Handbag*; fantastic creatures from the *Rex the Runt* series, an animated dustbin featured in *Morph*, and tiny instruments for Rex's band. Though beautifully crafted, some of these props were only seen for a fleeting second in the final film.

Miniature engineering from John Wright's workshop. Wallace's motor-bike is engineered like a real motor-bike, with welded parts and steel frames. Even the wheel spokes are individually stitched with wire and drilled into the wheel frame. The tyres are rubber, like real ones. Working parts such as the exhaust and engine are made of steel and chrome and heated to make them look scorched.

Big machines, like the Mutton-O-Matic, are made using foundry-cast brass parts. With such pieces, it is good to put everything on them, as for an all-round view, with all the rivets showing. When you are making the model, you never know which camera angle will finally be chosen.

He's leaving home. For this rain scene in *The Wrong Trousers,* we superimposed live-action rain. The water running down Gromit's cape was actually tiny blobs of glycerine which were animated frame by frame.

Right: Ghost effect in *Stage Fright,* basically achieved by double exposure.

Special Effects

Some special effects are made principally with the camera. Others rely on physical factors such as the use of glass to lend invisible support, or artfully chosen props and materials which can be made to pass off as something else. Usually, though, a successful effect is a blend of both. How you light your scene is also important.

Double exposure For double exposures, or superimpositions, which can be applied to produce ghost effects, you need a camera with a windback facility. First, expose your main scene, then wind back the film by the number of frames in which you want your ghost to appear. If you then expose this figure against a black background, it will show through on

Top: The secret of pouring tea is to use rolls of squashed-up brown Cellophane. This catches the light and makes it look as if it is moving; from *Palmy Days*.

Centre: Beads of sweat fly off the anxious Penguin's brow in *The Wrong Trousers*. The sweat was made by animating tiny perspex drops across the window in front of the character.

Bottom: Washing windows with a foam of white hair wax dotted with different-sized glass beads; from *A Close Shave*. As with all new solutions, once you have made the wonderful discovery that foam = white hair wax + added glass beads, you can apply the formula to other situations to make, say, shaving foam or bubble-bath.

the first exposure and be transparent, like a ghost. Black velvet is best for the background, because it reflects less light than black paper. You can extend this trick to other kinds of apparition, as the Victorian photographers did with their scenes of 'The soldier's dream of his loved-ones' and 'The fairies' dell', etc.

Mattes The simplest form is the split screen. Here you mask off one side of the picture and shoot the action that fits into the unmasked half. You rewind the film, swap the mask over and shoot the action for the other side. This process can be further developed by using a sheet of glass in front of the camera, on which an area of the image is masked off with black paint - for example, the action to be seen inside the windows of a miniature space-ship. The ship is shot with the window areas painted out on the glass. Then the film is rewound, the clear area painted black and the previously painted area scraped clear, and finally the action for the window is set up in front of the camera and shot.

Water and rain effects Water and other liquids are difficult to simulate, and animators have tried out various ways to convey the illusion. A classic method for flat water, say a lake or river, is to cut a perspex sheet to size and spray it with the colours you want, adding ripple effects and so on.

For the rain effect in *The Wrong Trousers,* we put little blobs of glycerine on glass and animated them by blowing them, frame by frame, down the glass. Then, every so often, we put in a random splash effect, a tiny winged object that looked like a very small butterfly and was made out of cel. We stuck this on Gromit's raincoat and on the ground, just for one frame, then took it off. In another scene in *The Wrong Trousers,* the Penguin is outside the museum window during the robbery, and beads of sweat fly off him. Again, we animated small perspex drops across the glass away from him. For the foam in the window-washing sequence in *A Close Shave,* we came up with a combination of white hair wax dotted with glass beads to represent the bubbles. To suggest bubbles bursting and new ones forming, we took beads out and put in new ones.

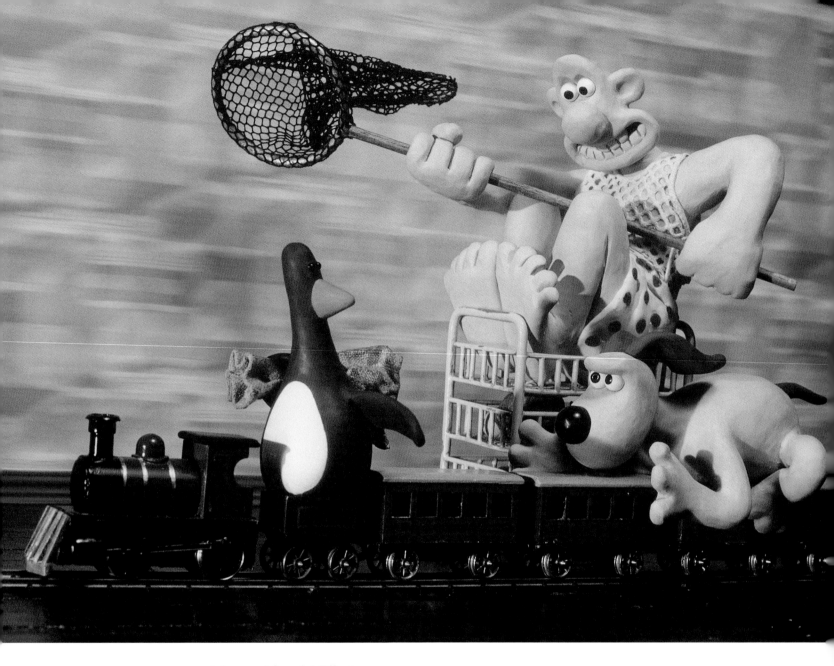

Advanced Special Effects

There are some special effects you cannot easily achieve with model animation. For example, it is difficult to convey the illusion of high-speed motion. If you animate objects moving fast across the screen, you often get jerky, 'strobing' movement because the distance between the positions of the models from one frame to another is too great for the brain to smooth out. The problem is exacerbated by the sharp images created by photographing static objects.

When shot as live-action film, fast-moving objects create a blurred image on each frame of the film because they are moving during the relatively long exposure made by the live-action camera. These blurred, indistinct images are more easily smoothed over by the brain than the hard-edged, sharp images

Left: The train chase scene in *The Wrong Trousers*. By moving the train and the camera together during a two-second exposure, it and the characters on board come out sharply defined, whereas the wallpaper background is blurred.

created by stop-frame animation. To avoid the jerky effects of fast-moving objects in animation, you have to create blurred images. In the train chase in *The Wrong Trousers* and the lorry chase in *A Close Shave,* we blurred the background by using long exposures (one or two seconds) and by physically moving the camera during the exposure.

To take the train example, the train on its track was attached to the camera, which was mounted on a dolly. For each frame, we pushed the dolly about 3-4in (8-10cm) and this carried the train along with it. At the same time we pressed the button to expose the film. The characters on the train come out sharply defined because they are moving with the camera, but in the course of the two-second exposure the camera moves fractionally past the wallpaper in the background, and this comes out blurred.

Blue-screen This process is used a great deal in films today. It is a way of putting difficult foreground action against a realistic background - for example, to show people falling out of a building. We use the technique frequently when we want to put animated characters into a live-action background. First, the foreground action (the people falling) is shot against a blue background. The blue is then electronically replaced by the chosen background (the building) using a sophisticated computer graphics system (it used to be done in the film laboratories, but this is rare nowadays). This has the effect of merging the two elements of the scene. Naturally, you have to be careful to match the lighting, perspective and camera angles, otherwise it can look like cut-out images stuck on another picture!

Douglas the Lurpak Butter man, filmed by the blue-screen process. First he is shot against a blue background, then the blue is electronically replaced by the table-top scene. We use blue as the background colour because human faces do not usually have much blue in them. Any strong colour will do, such as lime green, but it is important to ensure that the colour does not appear in the surrounding scene because it will also be removed in the process.

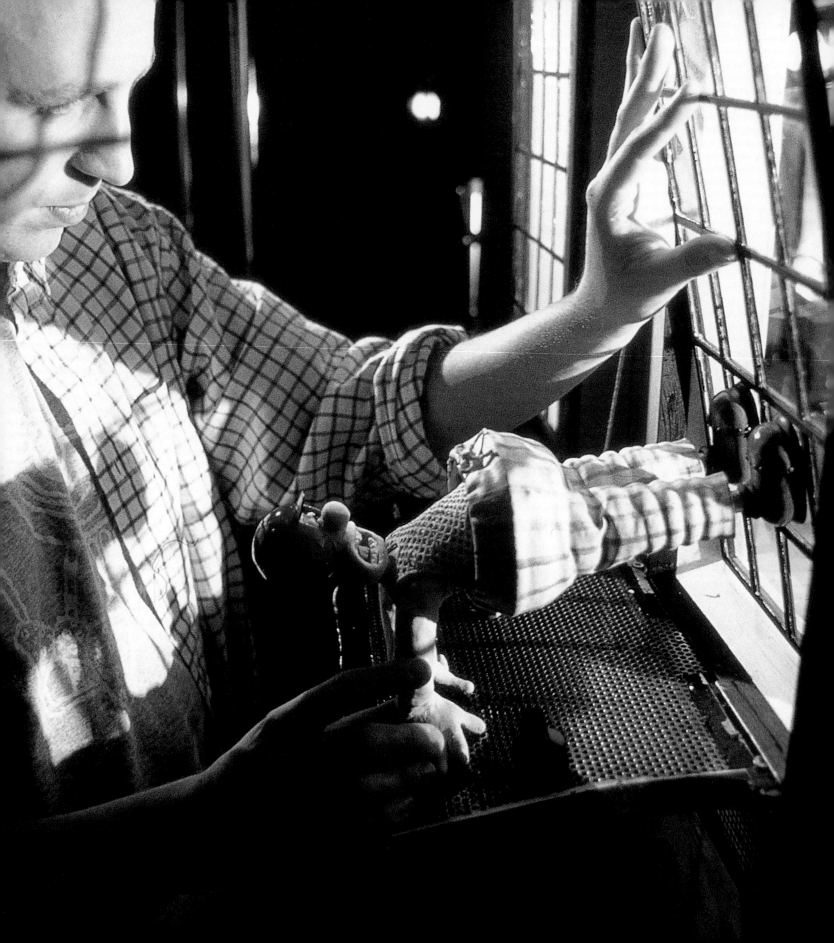

animation and performance

Wallace's alarm and helplessness call on the animator's art for expression as his rebellious trousers take over.

Movement

Like actors, animators communicate through the language of movement. We create characters, convey emotions and make people laugh through the movements, gestures and facial expressions of our puppets.

People often say that our work is naturalistic, which I think is meant as a compliment because the best model animation is regularly praised for its

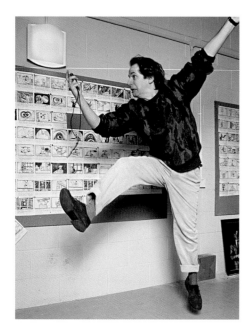

smooth and 'natural' movement. But in fact our work is not realistic at all. It is - and it should be - exaggerated. All the animated movements that we do, however understated or natural they may appear, are bigger, bolder and simpler than 'real life'. Real movement, the sort of thing you would see if you analysed film of a live actor, always looks weak and bland when it is closely imitated in an animated version. Some animators use previously shot live-action footage as reference material, or even copy it slavishly frame by frame to create their own animated performance. At Aardman we rarely do this. We prefer to act out the animation ourselves, so that we really understand it, then add our own degree of caricature and stylisation. The important thing is that the audience should be able to understand what the puppet character is doing and thinking, no matter how broad or subtle the style of animation. What we love doing is producing *performances* with our puppets that feel 'natural' because in some way they feel true. By simplifying and exaggerating gestures, we try to distil the essence of a particular movement or sequence of movements. This is far more important than copying from real life. When we get this right, it gives the audience a great sense of recognition. They think, 'Yes, that's exactly how people react or behave,' and they believe that what they have seen is uncannily natural.

Nick Park, stopwatch in hand, uses his own body to work through the jerky, exaggerated movements of *The Wrong Trousers* (seen right in action). Once he knows exactly how long it takes to get from **A** to **B** in a particular phase, he can plan how to animate the model within this timespan.

Posing the Character Obviously, animation is about movement. But few really expressive sequences are carried out through *continuous* movement. One of the classic symptoms of our earliest work is that the characters shift about constantly and restlesslessly, never daring to be still. Later we realised that the time between movements, when the puppet is still, often conveys far more character than the same number of seconds of elaborate animation.

We talk of 'poses' and 'holds'. A pose is pretty obvious - a still position that conveys a lot of information about

mood and emotion. A hold is the moment when the action stops - though it seldom freezes completely - and it can last for anything from a quarter of a second to half a minute. During these holds, the audience can see and understand far more than when the character is continually moving. The point to remember is that your puppet is never *just* sitting or standing or leaning - it should always be expressive in face and body. You should always know what your character is thinking and feeling - if you don't, who does? - and in the poses, you make it clear to the audience.

To be sure, I certainly do not mean that the pose has to be like some magnificent melodramatic gesture from a Victorian painting. Audiences are very sophisticated, and the pose can be as subtle, or as corny, as you can make it. If your puppet is frightened, he does not have to be cringing and quaking in extravagant terror. The fear can be communicated in the angle of the head, the tension in the shoulders and arms and the smallest obsessive gesture with one hand.

Remember that these holds should not be totally static. Watch television with the sound off, or watch people in the street. You often see people sit or stand for several minutes at a time, doing virtually nothing. However, they are moving in slight ways, and they *are* alive. If your puppet goes into a hold, keep it alive, don't let it freeze, and look on this as an opportunity to let the audience see what he or she is thinking and feeling.

Changing the Pace Of course, different actions happen at different speeds. Building a house of cards is a slow and careful business, whereas trying to extract a lighted cigarette from inside your clothing is going to be pretty frenetic. But whatever the speed of the sequence, try to vary the pace of individual parts of your animation. Try to avoid falling into a too-regular rhythm of move-hold-move-hold. Remember too that different parts of the body can move at different speeds. A thief may creep carefully through an empty house, but his head and eyes can move quickly and sharply.

★ CRACKING HINT, GROMIT!

In the animated sequences on the following pages, we show key frames to illustrate the essence of a movement. In a full sequence, there would be other, intervening frames.

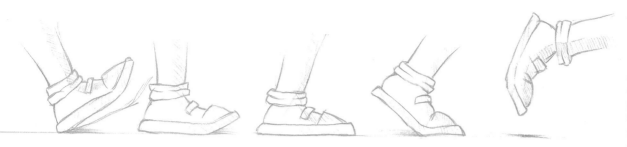

When a hand or a foot - or a bottom or a nose - comes into contact with the ground, make it look as if it is firmly set. Make it lie flat and contact the ground at all points, so that no line of light is visible underneath. This makes the puppet feel larger and heavier.

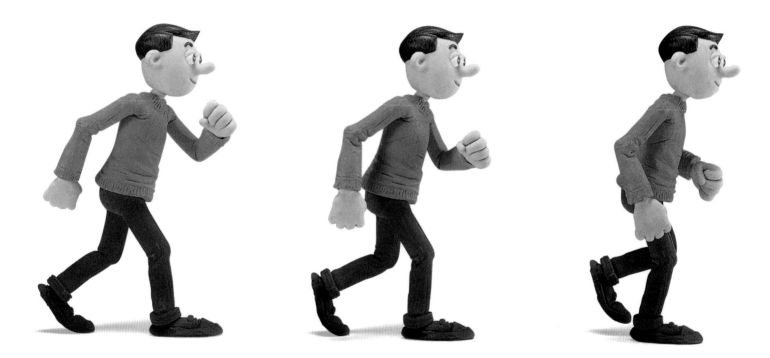

Remember that your puppet has a centre of gravity, and needs to stay well balanced. Standing with his weight equally on both feet, you want him to step forward on to his right foot. To do this, he must first shift his body weight over his supporting foot, the left. The best demonstration is to try it yourself. Start with your

feet very close together, and step forward on to your right foot. As you start, you move very slightly to the left. Starting with your feet a metre apart, you are forced to move a long way to the left before you can go forward. Now try moving off without shifting left and see how unnatural it feels.

Right: Everything about this puppet is downcast. His feet barely leave the ground, his head bounces slowly as if he has not got the strength to hold it up, and his arms swing heavily in small arcs.

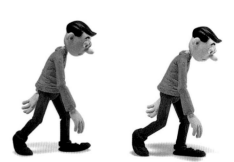

Every step we take starts at the hip joint. Your puppet should do the same. When he prepares to move off, the supporting hip drops down as the body's weight is transferred on to it. The pelvis swivels and the stepping foot is released.

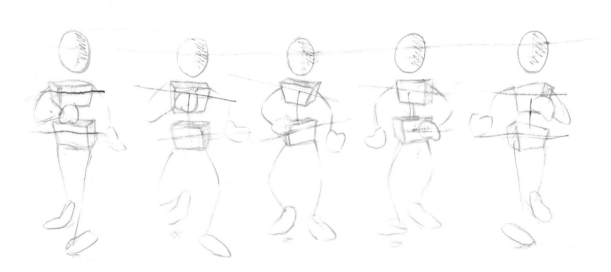

Adam
Adam is so dejected, his whole body hangs heavily. As he plods slowly uphill, his arms barely swing.

Wallace
The Wrong Trousers take Wallace for a walk. The trousers move with an extreme mechanical step, which causes Wallace's hands and head to wave about in panic.

Loves Me ... Loves Me Not
As the puppet tangoes across the floor, his legs smooth out the action like shock absorbers.

Wat
In most 'real' walks, the head is kept quite still. In this scene Wat moves with exaggerated effort and his head bobs up and down wearily.

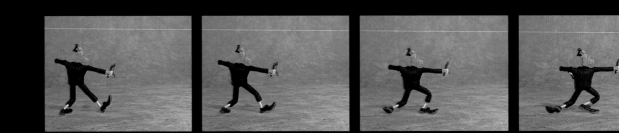

Substitution
The substitution technique allows us to create lovely smooth lines in the legs and feet, and gives extra stretch as the front foot reaches forward.

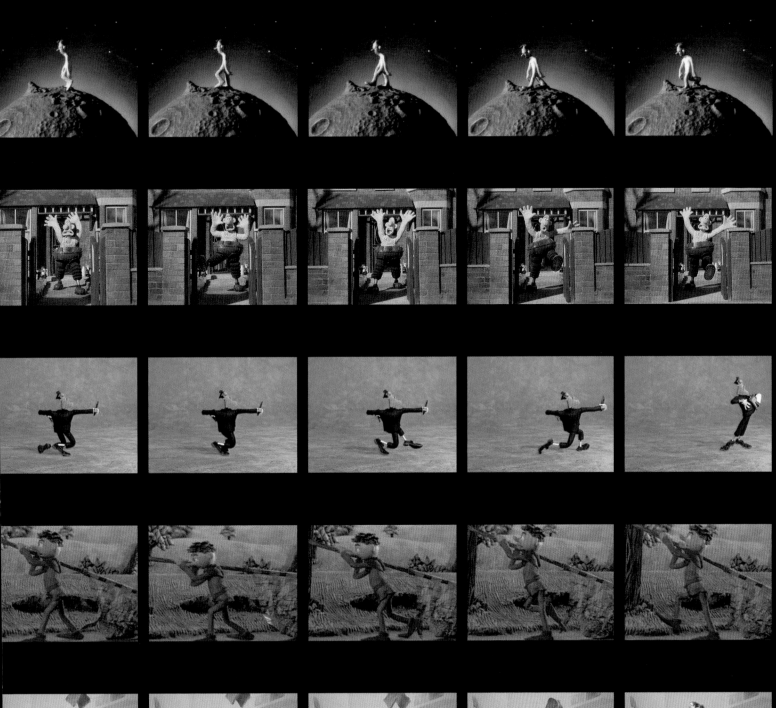

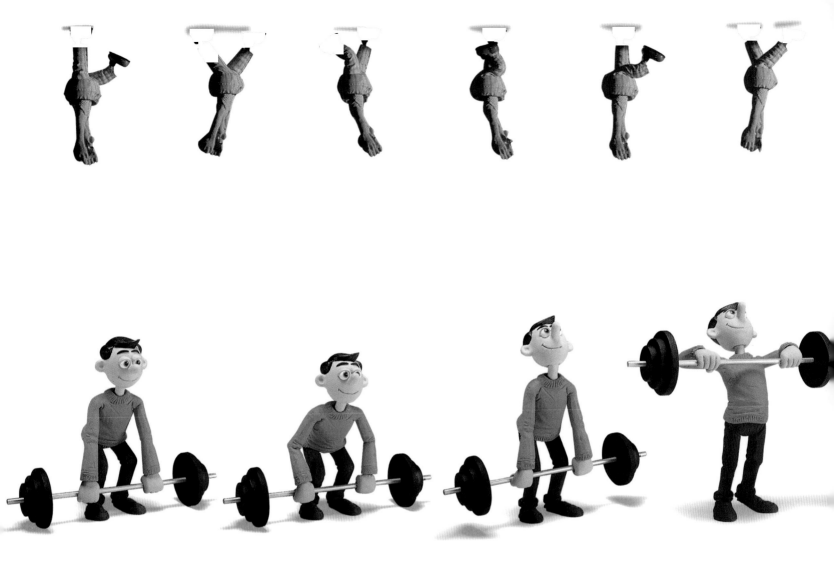

Making Movement Believable

Anticipation Before an animated figure starts moving in one direction, we usually anticipate the action by moving it the opposite way. This is not so strange when you think about it. If you want to jump up in the air, you first crouch down; if you want to throw a ball forward, the first thing your arm does is go back. Anticipation is 'realistic', and it also works well in film because the moment of anticipation prepares the audience for the action which is going to follow. This is why, in cartoon films, the anticipation is often stronger than the action itself.

Weight We make our characters more believable by making them look heavy. The weightlifter, above, nicely demonstrates this as he struggles to lift a barbell which only weighs a couple of ounces. The animator plans and rehearses the movement, miming it to understand how it works. Then he tries to make the puppet do the hard work. In stage 3 for example, he has just started to lift by pushing his legs and back straight, and stretching his arms. At stage 4, he has hauled the barbell as high as he can, it hangs in the air for a moment before it

Most of the principles that make up good animation have something to do with the transference of weight and the animator's ability to make it believable.

Characters in animation are not bound by the Laws of Gravity. If you want to, you can make an elephant flit around as weightlessly as a butterfly. However, in nearly all our animation, we work hard to create the illusion that our puppets are earthbound. I often think that modelling clay lends itself best to creating solid, heavy-looking characters.

Above: Think about the weightlifter's speed through the lift. Most of the action is quite slow, but at stage 4 he suddenly snatches up the weight, and at 5 he quickly gets his hands and arms below the barbell.

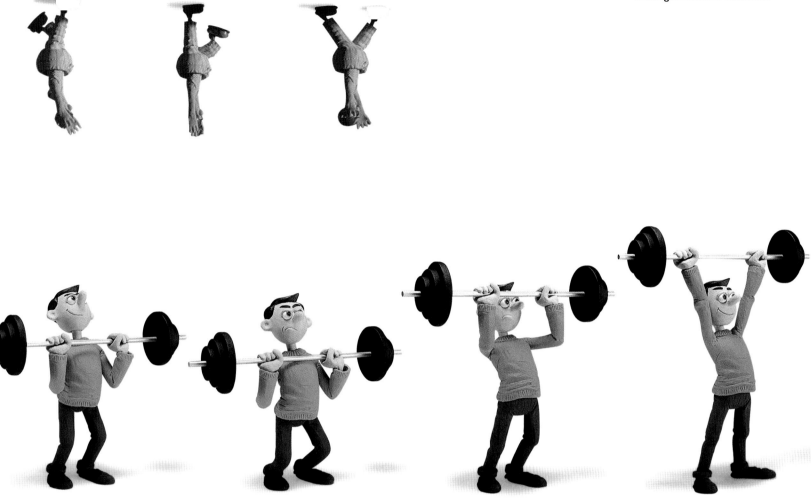

Top: Wallace walks across the museum ceiling in *The Wrong Trousers,* his leg movements controlled by Feathers McGraw from outside the window. The way he moves reflects both the character and his plight. The Penguin, mindful of the risks he is taking, moves the Trousers with exaggerated care. The knees come up high and the feet are planted with great caution, to make sure they stick. Inside the Trousers, Wallace moves to a linked but different pattern.

falls, and in that time he quickly gets his hands and body underneath it. When he finally holds the weight aloft in triumph, see how his arms and legs are locked straight. If they were not, the audience would not believe he could support a heavy weight.

Momentum Remember that, like the barbell, your head, body and limbs are also heavy. Because of this, they should not stop moving too quickly once they start. Try sprinting as fast as you can, then stopping. When your feet finally stop, thanks to friction, your head and body will want to carry on, tipping you forward. In animation, we often exaggerate this natural effect.

Acceleration and Deceleration Except in extreme cases, objects and people do not suddenly start or stop moving at full speed. They normally accelerate and decelerate. This is pretty obvious in the case of a sprinter running from the starting blocks, but it applies equally to small actions such as lifting your hand to scratch your ear. Remember that your hand and arm have weight, and have to be brought up to speed.

See how his arms swing like a pendulum, but always behind the movement of the feet. When a foot is forward, the arms swing helplessly back, then swing forward again as the next stride begins.

Very little human movement happens in straight lines. It can usually be broken down into a series of arcs. If you trace the path of the batter's foot, hand or hip, you should see a pattern of overlapping curves.

The sequences here show a mix of all the animation principles mentioned in the previous pages. Swinging a baseball bat is a good example because the whole process is about storing up and using energy.

Stage 1 shows the batter poised to receive the ball. In 2 and 3 he moves back, anticipating the main action which will be forward. His shoulders rotate, storing energy, and his weight is entirely on the back foot, allowing him to raise the left

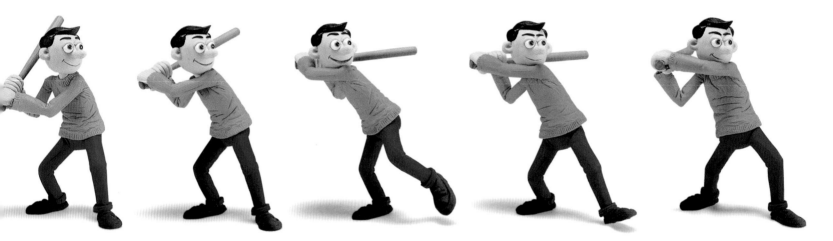

All the sequences on these pages demonstrate how movement flows through a gesture. I think of it as a wave that runs through the body from the first thing that moves to the last. Swinging the bat starts when the foot steps forward, followed by the knee, hip, chest, shoulder, elbow, hand and finally the bat.

Right: The force of the flying ball catches the man's hand and pulls him along in a sequence that runs from his hand down to his feet.

foot. He steps forward on to his front foot, and by 5 has started to unwind his shoulders. As he accelerates, the bat moves a greater distance in each frame.

The bat has weight and is swinging in a big arc, so in 6 and 7 it is moving farther than anything else. All his weight is pushing on to the front foot, and his whole body is unwinding so that maximum force and speed are brought to bear on the ball at stage 7. At 8, the power which started in the hips and shoulders has now been transferred to the bat which is almost pulling him round in his follow-through. In a more 'cartoony' version, his bat would carry on and get wrapped round behind his head.

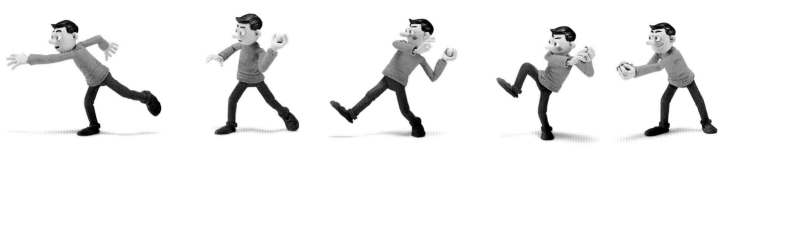

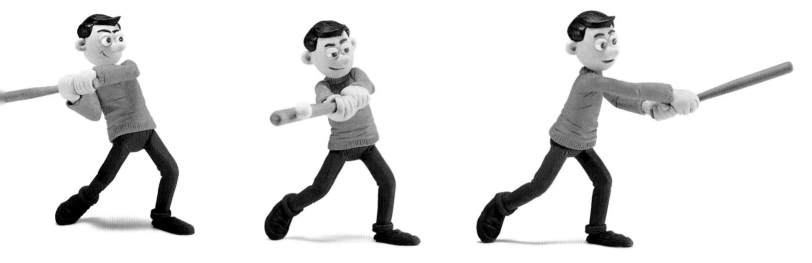

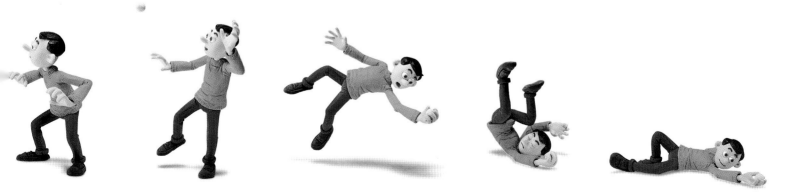

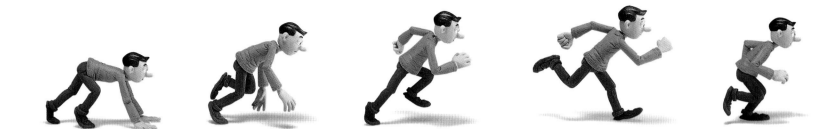

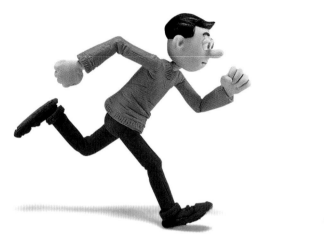

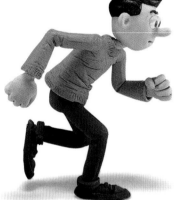

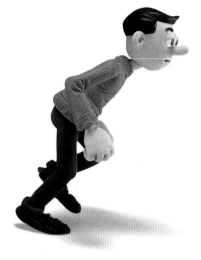

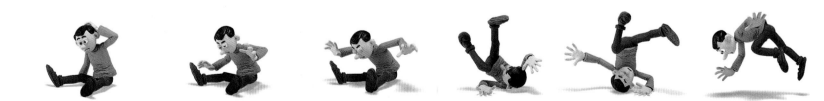

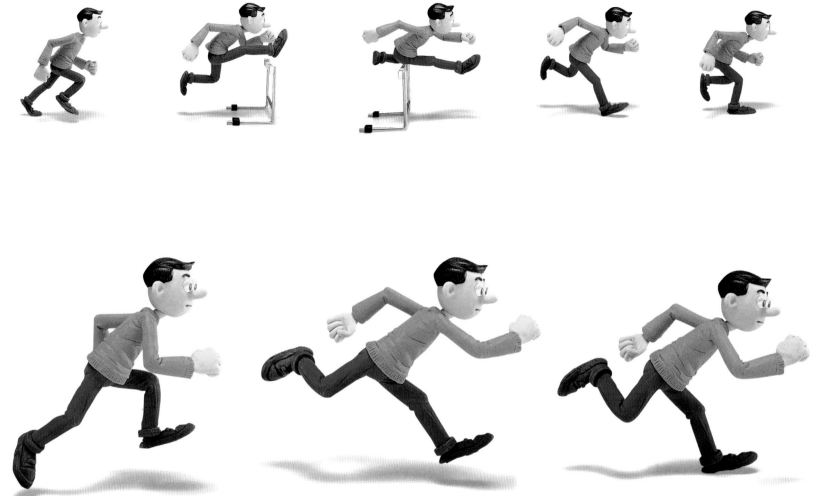

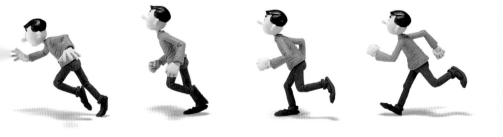

Running is notoriously difficult in model animation. Because the movement is fast, the gaps between frames are large. This means that although the effect is energetic, it is seldom smooth.
Left: The tumbling character demonstrates the effect of momentum. When he trips, his feet stop moving but his head keeps going forward (4). In turn, his tumbling body pulls his feet after him (6). When his head contacts the ground, the feet - still full of energy - carry on past (7) until they finally settle on the ground (8). If he was running faster, he would carry on tumbling longer.

Action and Reaction

Porridge Power
The impact of the flying blob of porridge knocks Wallace back in his chair. Just as he recovers to an upright position, the action is repeated.

Pib Shoots Pog
Pib reels back from the recoil of the gun and Pog under the force of the projectile. They sway back into an upright stance, and Pog turns to reveal a very large bullet hole.

Carpet Trick
The boy's whirling legs ruck the carpet into extravagantly huge ridges. In classic cartoon style, when his legs touch the ground, they zoom off first, followed a moment later by the body and head.

Bungee Effect
Gromit's legs, helmet and bucket tell the story. In frame 3, when his body has stopped falling, his legs are the last things to stop. When he finds himself pulled up again (6), his legs are the last thing to start moving.

Adam Takes Strike
A study in anticipation as Adam coils himself up to strike. See how in frame 7 he has started to unwind into the stroke from his foot to the shoulder, but the pack is still in a state of anticipation - it has not yet moved.

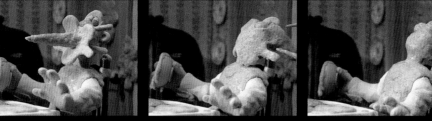

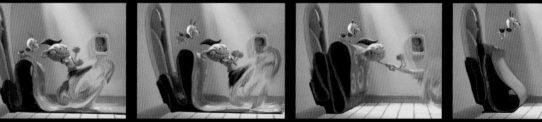
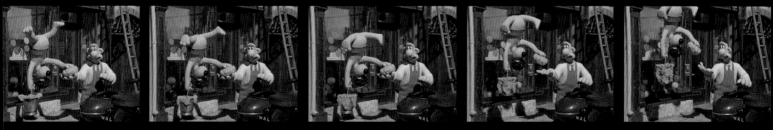

Special Movement Effects

We are often asked how the Penguin got into the bottle in *The Wrong Trousers*. In fact this was a relatively straightforward thing to do, relying on a quick substitution of both character and bottle. The sequence, illustrated below, begins with the empty milk bottle wobbling and vibrating after Gromit has crashed into the cupboard. Then it falls off the unit and Gromit catches it. Up till then we used an ordinary model bottle. For the next frames we had a thin replacement Penguin who is first seen entering the bottle before he becomes inescapably jammed up to the neck inside it. This was a different bottle, vacuum-formed and supplied in two halves. We pushed the thin clay Penguin against the side of one half and then sealed him in, hiding the join when we positioned the bottle to camera.

Another difficult part of this sequence was animating the Penguin after he has been shot up in the air and then falls to earth against a background of sky and clouds. Rather than try to show the Penguin in motion against a fixed background, we photographed him on glass with a parallel sky positioned behind him. In the following frames the Penguin is largely still, though from time to time we altered the position of his feet and the sack across his shoulder. The illusion of falling comes mainly from the sky itself, which we moved from side to side during a series of long exposures. This was a variant on the blurred-wallpaper effect which occurs earlier in the train chase (described on page 131).

Again, while shooting *Adam,* we had to go to great lengths of ingenuity to show him running round the circumference of the world. For most of the film, Adam stands on top of his globe, which was supported on the end of a scaffolding pole. This was fixed through the far side of the globe and so always remained out of shot. The pole also ran through a hole in the night-sky picture which was our backdrop. For the running sequence, it would have been incredibly painful to animate Adam by holding him on strings and changing their position after each shot, so we came up with another solution.

First we turned the globe-pole-sky unit on its side, through 90 degrees. Then we measured the circumference of the globe and cut a circular hole in a large

The Penguin falls to earth in *The Wrong Trousers*. The illusion of falling was mainly achieved by pulling the painted background from side to side during a series of long exposures.

How the Penguin got into the bottle. This was a two-bottle and two-Penguin trick. When the Penguin began entering the bottle, his body was exchanged for a special thin Penguin. The receiving bottle was also different - it came in two halves and was clamped round the Penguin between shots.

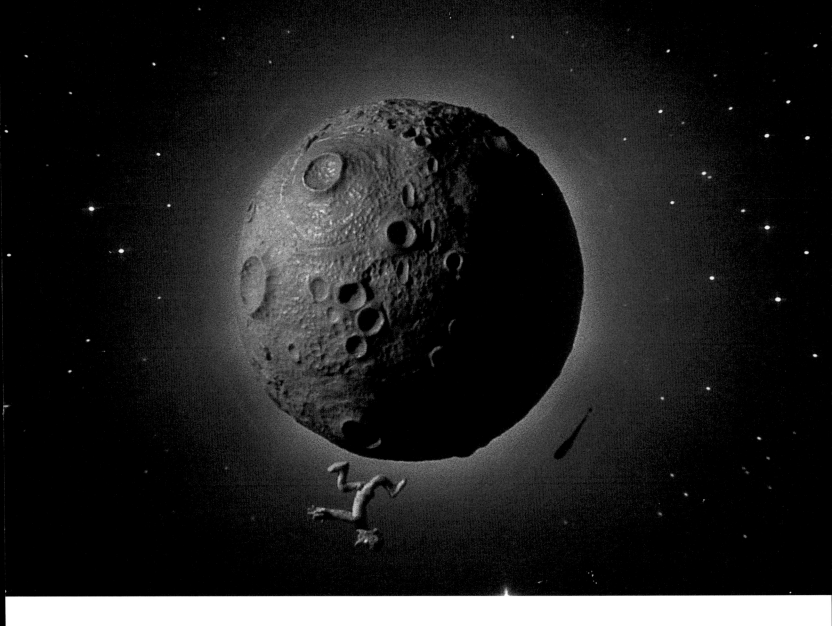

When Adam ran round the circumference of the globe, we shot him on glass. With one hip and one shoulder resting against the glass, he was far easier to animate than if we had tried somehow to suspend him on wires.

sheet of glass which fitted exactly round the globe on a north-south axis. So now, because everything was turned, we had the camera up in the roof shooting downward. After that, it was relatively easy to film Adam running round the world because he was lying with one shoulder and one hip flat on the glass.

If you should try something like that yourself, there are two snags: extra colour from the glass, and reflections. A sheet of glass may have some colour in it, and this is likely to show up when you move from the previous scene, which has no glass in it, into your with-glass scene, and similarly when you move out of it into the next scene. To avoid this, shoot a whole group of scenes with a sheet of glass in them, whether they need it or not, and the transition will not show up. To avoid picking up reflections thrown by the puppet lying on its side, shoot directly at 90 degrees to the glass. There may still be some reflection, but this should be minimal.

Expressions and Gestures

Arnold, the bully figure from *Stage Fright,* and some of the replacement mouths that helped to keep fame and fortune at a distance in his career as an entertainer.

His short pointy teeth, allied to fierce eyes and alarming carroty hair, give him a powerful expressive range. Think of this when deciding on the kind of facial effects you want your character to produce.

Although we spend a lot of time on mouths, working with dope sheets to synchronise speech and mouth movements, and yet more time making this work by constantly sculpting and resculpting mouths, or fitting replacement mouths, this part of the face is by no means the most expressive. The mouth is of course crucial to speech, but perhaps supplies only 5-10 per cent of a character's performance.

Those moments that really make you believe that this clay person is talking are all done with the eyes, eyebrows and gestures involving the face - nods, nose-scratching, stroking the cheek while thinking something over, and so on. Bear in mind, too, that a character can be highly expressive without speaking a single word. Gromit is a good example of this: almost all his expressiveness comes from the way his eyes are positioned. Many of our models' eyes are made of glass beads with a painted-on pupil, which has a hole at its centre. To move the eyes around, and make them look up, down or sideways, the animator inserts a cocktail stick into the hole in the pupil and swivels the eye to the desired position. Eyebrows are used to enhance certain facial expressions - surprise, for example - and eyelids, often made of fast-cast resin, are added if the character is required to blink, fall asleep or wake up.

Hand and arm gestures are also important in their own right, whether they involve touching the face or not. The amount they can be used will naturally depend on the build of the character. As Nick Park found while making *Creature Comforts,* not all animals are designed with the kind of front paws that can be waved about expressively: 'It was fine for the Jaguar and the Polar Bears, because they had these front legs and paws, but some animals did not have anything I could work with. The young Hippopotamus just had two cloven front hooves, which he needed to support himself while sitting up, and the Armadillo was even more limited. With the Bush Baby, it was enough to have her clinging on to the branch to bring out her insecurity. I also made her lift her glasses off, so people could see those two little timid eyes beneath.'

CRACKING HINT, GROMIT!

Clay faces and hands get dirty very quickly. The best way to clean them is very gently to scrape off the top layer. The important thing is to keep a constant balance between the tones of a model's face and any separate pieces, such as mouths and eyelids, that you may fix to it.

The more you scrape away, the more you have to add new bits of clay, and here too you can get differences in tone. Eventually, you reach a stage where you cannot get the dirt out of the face, and then you have to make a new one.

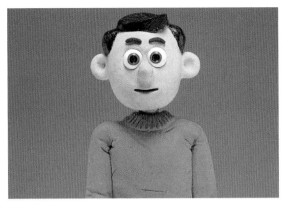

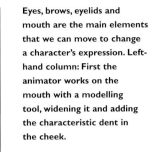

Eyes, brows, eyelids and mouth are the main elements that we can move to change a character's expression. Left-hand column: First the animator works on the mouth with a modelling tool, widening it and adding the characteristic dent in the cheek.

The eyes are turned by inserting a cocktail stick in the pre-drilled hole at the centre of the pupil and swivelling the eye (in reality a glass bead) to the required position.

Right hand column: Next the eyelids are pushed into place and carefully modelled in to make sure that everything has the same skin tone. The eyebrows are moved to create further expression. See how much the character's expression has changed since the first frame.

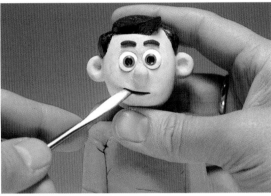

Faces and Expressions

In Going Equipped, the characterisation is exaggerated but basically realistic.

Gromit shows expression through his eyes and particularly through Nick Park's trademark animated brow - from inquiry to determination to despair.

Dark moods and uncertainty in the faces of the stars of *Stage Fright*.

Pib and Pog accompany the extreme violence of their actions with obvious, 'cartoony' facial expressions to show, as here, perplexity, sly triumph, dismay and wicked glee.

Right and opposite: Sprawled across his tree perch, the Jaguar is free to gesture massively at the unreasonable fate which has befallen him.

 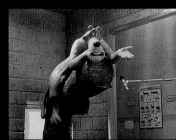

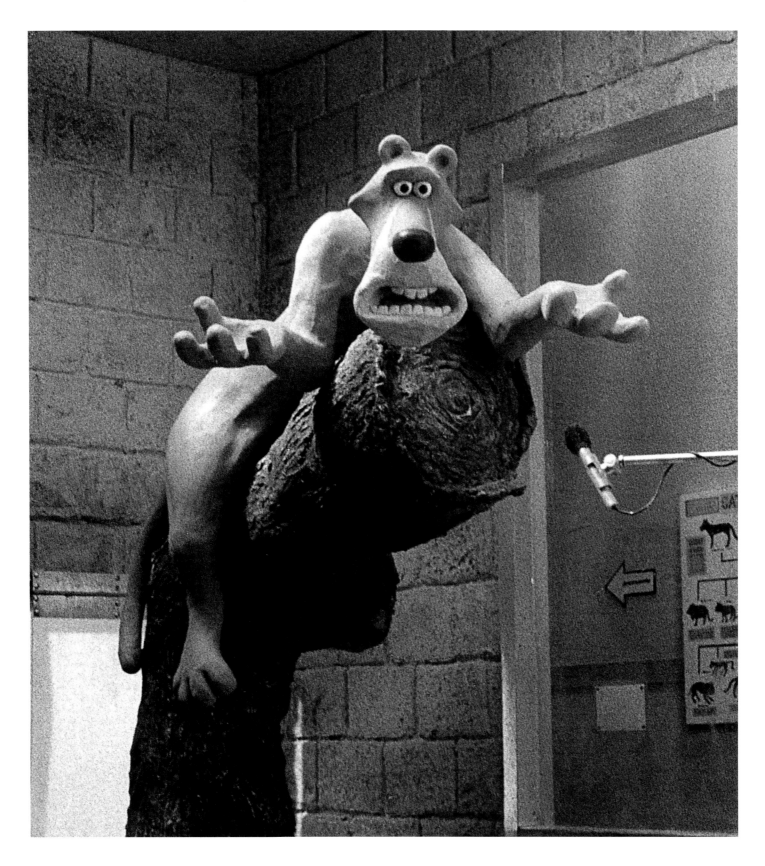

Speech and Lip-sync

We match voices to lip movements by a somewhat ancient method which has become traditional in the company. First, an editor marks all the syllables on the magnetic tape of the dialogue recording. Then he or she transfers all this to a bar chart, in which each bar covers a second of film (or 1ft of 35mm), so the animator can see exactly where each syllable starts and finishes. With the word 'Me', for example, the chart will show the 'M'-sound lasting for two frames, or whatever, and the longer 'eeeee' sound lasting for nine frames. If there is pre-recorded music, as there might be for a film which is set round a tune or song, this will also be sketched in, to show where the beats fall, or a particular run of notes which are important for the animator's timing.

The chart goes to the animator, who then copies the information on to a traditional animation dope sheet. There are 96 lines to a page, one line for each frame, covering 4 seconds, and the lines run vertically down the sheet. On the dope sheet you have more space to put other information, and that is the essential difference. Instead of having just a tiny gap per frame, as on the bar chart, here the animator has a whole line.

Now you have your own personal map of the sounds, and the gaps between them, and can begin to devise a performance for your character. From listening to the sound, you know when the voice goes up higher - which might indicate a questioning expression, with raised eyebrows. In *War Story*, the old man says

Nick Park and Steve Box prepare Wendolene for her next scene in *A Close Shave*, matching gesture to storyboard.

Below is a chart of Wendolene sounds, each one pinpointing the position of the mouth.

Opposite, below, is a sample dope sheet, which provides the animator with an accurate map of the sounds a character will make, and how many frames each one will occupy. This is matched, top, with the face the audience sees while hearing the sounds on the soundtrack.

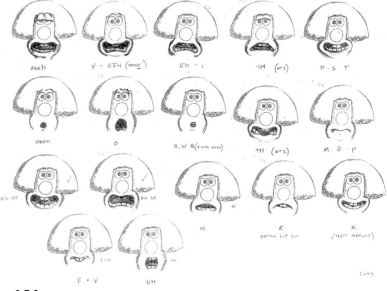

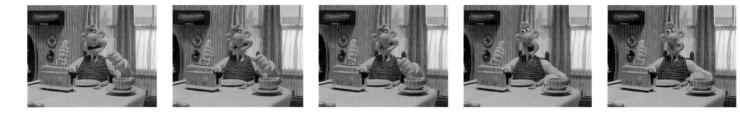

to his interviewer, 'I was out at the BAC, see, Pete?' You listen to that, and try to work out when he should raise his eyebrows, or tilt his head. Typically you listen over and over again, repeating it to yourself, copying the accent and intonation, trying to sense the right moment for the character to react. You can hear that he pauses after 'BAC', so you choose that as the moment. The dope sheet, meanwhile, tells you the exact space between 'C' and 'see' is 18 frames. This is the essential information you need both to plan ahead, and to animate.

How much an animator actually notes down on the dope sheet is a matter of personal choice. You could write down every detail, but with experience you tend to write less. Alongside our sample piece of speech, you might mark in certain movements, e.g. 'blink ... blink ... starts to raise hand to face - 18 frames (during that time, starts to tilt head to left) . . . tilts head to left - 12 frames'. And so on. Sometimes it can be deadening to analyse a movement too closely, fragment by fragment. Today I tend to write down just the key moments, where the timing is essential, and leave the rest to inspiration when we shoot. On the other hand, some gestures are so specific that it can be helpful to note down all the separate movements, of hands, eyebrows, angle of head, etc., to make sure you include them all and that they blend together.

One important tip is to look ahead at all times. It is too easy to develop a kind of tunnel vision with the frame you are working on, and then you can forget to start another movement in time, or you find that your character is out of position and cannot make the expressive move you want him to.

As for marrying the sounds to lip movements, a character can either have its own set of replacement mouths, each corresponding to a particular sound or group of sounds, or you can decide to resculpt the face itself each frame - what we call 'animating through'. Even with replacement mouths, you still have to do a certain amount of remodelling to clean up the face and sculpt in the new mouth so it fits perfectly.

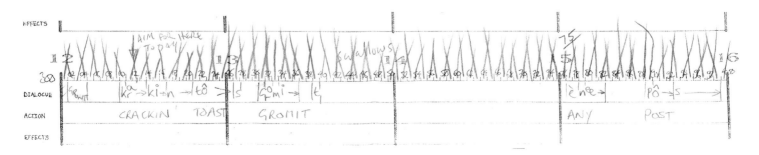

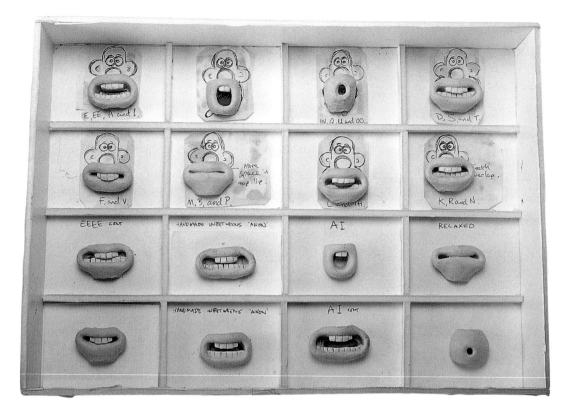

The labels visible on the mouth models include:

Top row: E, EE, A and I. / IN, O, U and OO. / D, S, and T.

Second row: F and V. / M, B, and P. — More space in top lip. / L and TH. / K, R and N. — Teeth overlap.

Third row: EEEE cont / HANDMADE INBETWEENS 'ANON' / A I / RELAXED

Bottom row: HANDMADE INBETWEENS 'ANON' / A I cont

A box of Wallace's mouths, showing some of the sounds and expressions he can make with them, including the all-important 'relaxed' when he does not say anything at all or goes into listening mode.

Talking Heads The idea of making up a set of replacement mouths for a character was conceived as a way of saving time. Because everything in animation takes so long, any time-saving device is to be welcomed. In theory, it should be quicker for the animator just to exchange one mouth for another, model it in to make sure the joins do not show, and shoot the next frame. Also, a replacement mouth has the advantage that it can be used a number of times, whereas if you reanimate a fixed mouth you lose that advantage. For all that, some animators still prefer the old-fashioned way, finding it more satisfactory to work with a head that remains a unified entity, and probably has less variation in skin tone, than with something that always consists of two halves that have to be constantly reunited.

Whichever way you choose, you have to be prepared to do a lot of cleaning and remodelling. If you have a mouth which you will only need for two or three frames, then this is not so important. But if it is a mouth you are going to use when the face comes to rest, and will be needed for a long sequence of frames, then you have to be sure that it is clean and that it tones in with the face.

The best cleaning liquid for clay is water. You can try lighter fluid, but this tends to strip away the whole surface of the face, leaving it sticky and more difficult to handle. For the best results, use water and gently scrape away at those parts you want to clean or remove.

156

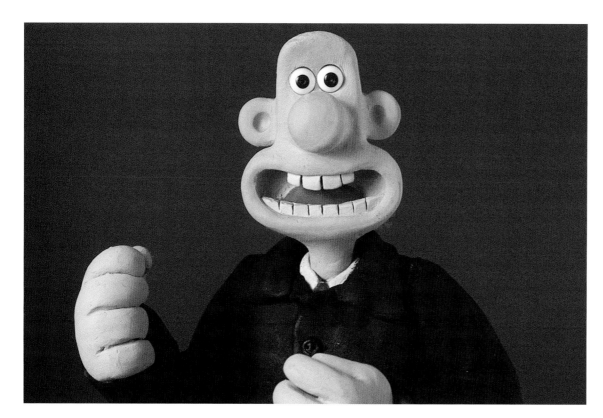

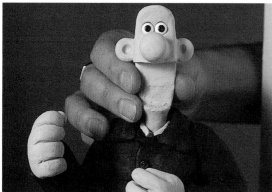

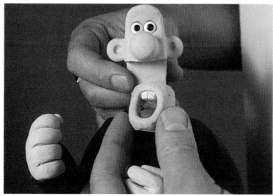

In this sequence, Wallace's 'ee' mouth is taken off and the new mouth which says 'o' is slid into place. The animator uses a modelling tool to mask the join and smooth down the new face.

CGI-computer generated imagery

Modelling Figures and Sets
Rigging
Animation
Lighting and Rendering

In the right hands, CGI can create convincing surfaces that move in three dimensions, such as this couple, skilfully sculpted in gleaming chocolate in a commercial for Hershey's.

Modelling Figures and Sets

CGI is the most powerful force in animation since the movie camera, and those of us that love to animate, and love to watch skilful animation, need to become as familiar with this tool as with the pencil and paper or lump of modelling clay. Animation artists are dedicated to bringing works of art to life, and our work has always involved creating a character or an object in two or three dimensions that we can enjoy visually, and then making it move. Ultimately, we want to make it move in a way that engages the audience and tells a story or delivers a message. CGI changes none of those things; what it offers are new and exciting ways to do them.

Our first step in CGI is the same as it would be on paper or in clay: we need to create a character. Just as with clay, this process is described as modelling. Just as in clay, too, the first step is to think about what we want the character to do, and how we want him to look. Some of us in the modelling section work straight into the computer, because we can see what we want and how to fashion the character, but mostly we will start with drawings, just as we would in other media.

As you start out, think of yourself as an artist/craftsman, because that is what you are. You are sculpting in a virtual space, creating something in three-dimensions within the environment that the program (in our case Maya) creates for you. The program and the computer it runs on are your tools, and sometime it is worthwhile just to think for a moment of all the many man hours that have gone into creating these tools in as friendly a way as possible. Sometimes the programs produce

CGI is powerful as a tool, but it is the artistry of the user that is most important. In this highly successful commercial for McVitie's, a family of wheat is seen acting out a scene in the animation frames, left. The injection of life and personality into the plants is masterful, while the creation of the fully rendered scene, above, is filled with the light and air of a summer's day even though it is created entirely in the computer.

Characters in CGI must
be convincing in three
dimensions, so one drawing
is often not enough to be
sure that you have the
character properly defined.
Here is the original drawing
for our character Ike,
showing his appearance
from front and side, and the
modelled character
matching the drawings.

glitches and problems, but so do other tools. And remember that if you make a mistake fashioning a piece of wood, there is usually no going back, but in CGI you can rework until everything feels right.

So, how do you begin? It is often said that when you begin you find yourself in a void, because there are no fixed points. This is true, of course, but it is just as true of a blank piece of paper: when you want to depict a landscape you have to create fixed points, such as the horizon or a figure. You have first to decide where such fixed points will go on the paper or canvas, and then everything else relates to that.

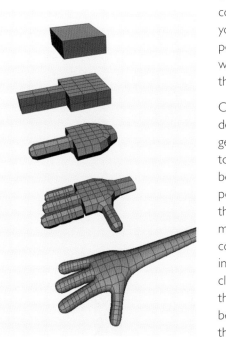

Creating anything in CGI, whether it is a character or a piano, depends on the creation and definition of the surface geometry, and this is what the program is designed to help you to do. There are several ways in which programmes have been devised to do this and you will come across NURBS and polygons as two of the methods for defining the surfaces, and there are others. The key point is that the surfaces can be manipulated just like a material by pulling and pushing at control points. The whole process can be likened to modelling in clay: clay is added and then smoothed into shape; excess clay is removed in processes that are intuitive after a while. In this environment, too, the process of sculpting and moulding becomes intuitive - you just become accustomed to the tools that the program provides.

Although they only have four
digits, the hands for Ike will
be quite important since he
is going to play the piano.
Here you can see the five
stages in polygon modelling,
starting from a generic
primitive box. Part of this is
extruded to form the first
finger. Further surfaces are
added to shape the edges of
the box and the finger into
more curvilinear forms. The
single digit can be copied
and pasted until the four
digits are present. The
resulting shapes are then
smoothed by the program.

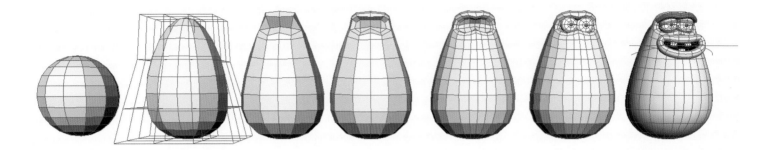

Seven phases in the creation of Ike's simple body shape. The first phase is just the introduction of a primitive sphere; this is then deformed into an ovoid shape - notice the use of an external lattice, which allow you to deform shapes uniformly; the brow is added and is then reinforced so that it can be animated; eye sockets are formed; the eyes are added as two spheres, which can be separately animated; finally, the face parts such as eyelids and mouth are added and the lifeless shape immediately takes on a character.

Ike with arms and legs added, ready for the rigging process.

All props and sets must also be modelled. The piano that Ike will play is shown here in a wireframe view and as a greyscale model.

The first item is to create a character, purely for demonstration purposes. On these pages you will see a deliberately simple character being built who is eventually going to sit to play the piano. We don't need him to be complicated: he needs to relate to the audience and to be able to sit and play. All the characters and objects you create can begin with the simplest of shapes. Most programmes have ready-built simple shapes, called primitives, such as spheres or cubes that you can click on. Our character is initially based on a sphere, and as you can see, the shape is transformed over several steps into the body shape we require. The important thing in working with a modelling program is to remember to make the tool assist you in making a character that is full of life: the tool serves the art, not the other way round.

A room setting showing the ways in which surfaces need to be defined, as the wireframe view shows clearly. Above is the same set when it has been rendered and lit: each surface has to be thought through separately, just as if you were building a set for live action and needed to address each surface in turn to create a convincing effect.

Ike's rigging shows that the control points are mainly concentrated on the face and the limbs, the body does not need a lot of movement.

Rigging

Perhaps the best way to think about rigging is to think of building a wooden string puppet, and the problems that you need to think through to make a puppet do as the puppeteer (who is really the first ever animator) might want. The way that the puppet moves is determined by three things: the position and movement of the joints; the position of the strings as they join the parts of the puppet, and gravity. In the virtual world of CGI, gravity has disappeared, though it can be replaced as an 'ambient condition', just as other constant forces, like the wind, can be. The joints are still needed, however, to create convincing and consistent movement, and the puppeteer's strings are replaced with highly sophisticated instructions that mimic live movement, or animate.

Another important comparison to make is with the armature that is used inside a clay body, as shown on page 103. The rigging is, in many ways, a highly sophisticated, virtual armature, but instead of the body being built physically around the skeleton, the armature is inserted into a pre-modelled body. The rig creates articulation and control that is similar to the articulation that nature provides for animals through their skeleton. A skeleton articulates the body by connecting to tissue, and in the same way the rig has to be connected to the figure that surrounds it, since it is the animators' instructions to the rig that create the animation, and this is an important principle to grasp. The way that each control function, or node as it is called in Maya, operates on the body around it can be adjusted by the program. This means that the rigger can intensify or nullify the effect of the control on different areas of the external figure, which is very important to create smooth control of the movements.

Even the simplest shapes require rigging to create the controls for the animator: this simple rectangular block has the simplest of rigs inside it with just four control points. Simple rigging like this is needed for limbless creatures such as the character from the BBC3 ident, bottom left.

Below: The rigging for the boy from the highly successful Hershey commercials, together with a wireframe view showing the controls for movement, and a greyscale model; a frame from the final commercial is shown right.

It is possible to create generic rigs like these two below for a human and animal form, and reuse them with amendments in new characters, just as there are generic armatures in clay modeling. The program itself will often provide some very simple examples.

The way in which the tools that the riggers create for the animators operate is like the strings on the puppet, but can be made far, far more complex. To make the work of the animator easier, the rigger can group together several movements to create 'attributes' at a particular point, like a smile on a mouth, or a raised eyebrow, that the animator can use a slide tool to increase or decrease: the sliders can then be colour coded to make them easier to use.

At Aardman, as in most larger studios, we ask different artists to work on different aspects of CGI, so there is a specialist rigger. Any successful rigger needs to understand both animation and programming skills. It is useful to have experience in both areas, since the rigger needs to anticipate the intentions of the animator and work closely with the modeller in the creation of the figure always bearing in mind its role in the film.

If the hands are important, as they are for Ike at the piano for instance, they need to be able to do more than if they are just needed for hitting things. The program also allows the rigger to imitate and build in reflexive actions, like the way that a dog's ears will flap as it runs, so that the animator can concentrate on the run cycle for the dog, and only check that the ear flapping is appropriate to the run.

So the ability to foresee the way that the animator will need the figure to move is essential to the rigger's work. But the process by which the movements and the attributes are then built into the figure needs an understanding of the way to build instructions into the program. This is a fiercely logical, but enjoyable task, and, clearly, the rigger needs to be able to think both creatively and logically at the same time, which is just the way we all need to think when we are solving puzzles and games.

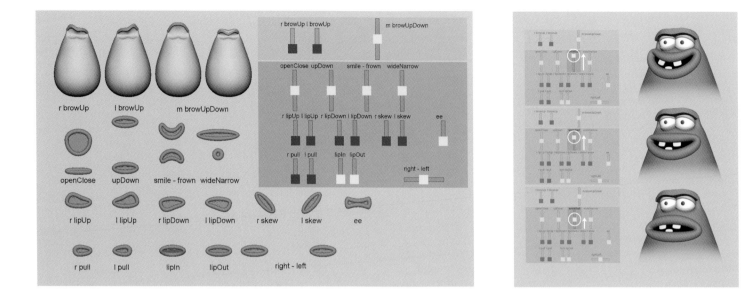

Animation

On page156, you saw the way that Wallace's mouth shapes are stored for use in different speech patterns and expressions, and in CGI we create facial patterns in just the same way. Then, during animation, the animator can turn on a particular mouth - it might be an 'ooo' shape, and can use what is called a slider to make it vary from an 'oh' shape to a full 'oooooo'. The slider just controls the rate and extent of the mouth shape's influence on the face, and makes control a lot easier. Sliders can also mix these shapes together tweaking and creating new expressions.

In the illustration on the right a slider is being used to change Ike's happy smiling mouth to one that expresses alarm.

The principles that apply to bringing clay to life apply just as well in the other form of 3-D animation, CGI. At Aardman we can produce work in both media, and sometimes we even combine them. It is the same understanding of movement that applies, the same need to look in the mirror to catch a change of expression, the same 'acting out' often using our own bodies as the testing ground.

But the tools are different, of course. It may be the same skills needed to imitate life in another form, but the manipulation of images on a computer screen is a very different activity to the manipulation of clay with your fingers and wooden tools. Of course, we use very sophisticated computer programs that have been developed to help us create a virtual world, and in this book it is not possible to go into the details of the programs. Fortunately, there are simpler and cheaper ones available for people starting out or studying, but once the program is learnt it is what you do with it that counts: using the program to make things move is one thing, understanding movement is another.

There are lots of ways that a computer program can help you as an animator, and we can mention just a few examples. Scenes can be blocked out using minimal animation just to get a feel for the timing and composition of shots. This blocking can then be built on, or you can even leave a reference low-resolution character in the scene as a guide for the final version. Scenes can be set-up and returned to easily, with no set-up of practical cameras or lights as would be the case with stop motion.

Animation can be run through backwards and forwards whenever you need to, so tweaks and changes can be made. A walk cycle, for instance, can be perfected and such things as eye blinks can be inserted at a later time:

something a clay animator can't possibly do. This ability to return and animate other things within a scene, almost to layer animation, is a crucial difference that the computer brings, and so is the ability to ask the program to repeat poses and animation again and again, as in walk-cycles, for instance. Some other reflex motions can be set automatically to respond to a character's movements, like the way a dog's ears or a character's clothing will move as it runs, things that in clay require a lot of time. The program can handle these things automatically by the use of 'dynamics', which can then free the animator to concentrate on performance. A character's eyes can be fixed on an object in the virtual world, too, no matter what other movements are happening, and this is something that is really difficult in clay.

But look out! The things a program does can sometimes make things too easy, and you start to let the program make decisions for you. For example, the program can create the in-between stages in a limb movement automatically once the animator has set the start and end point, but if you don't look out, the movement can be robotic or 'floaty' and lifeless, so you may often need to tweak it. And some things are much easier in a virtual world, like flying, since objects can hang anywhere in virtual space and don't need support as they do in the physical world. This is a great advantage, but the animator has to remember what gravity does all the time, because it only exits in the animator's mind, not in the virtual world.

The animator's task is always the same: to understand weight, movement, momentum and character, and the computer is just another tool to help you bring your expertise to life.

Above is one of the frames from the animation of Ike playing the piano.

The demonstration frame, left, shows the effect of the rigging in making the entire are flexible. It also shows the considerable range of expression that can be achieved with this simple figure.

The walk cycle for Ike, once animated to the animator's satisfaction can be recorded by the animation program and used in repeated cycles, although the program also allows the animator to intervene and adjust the cycle as desired.

To light Ike at the piano, the program create virtual lights that perform just the same tasks as those described on stop motion sets on pages 78-79. They are the key light from the top left, the fill light opposing the key light from the bottom right, and the back light, or rim light framing the subject from top right.

Ambient lighting, the light that surrounds us in our normal environment, is difficult to recreate in CGI. In the natural world captured in a camera, light is bouncing and reflecting from every surface in a way that might feel random, but is in fact determined by a multitude of factors. To reproduce these factors a reflective sphere is introduced to an environment like the one you are creating virtually (in Ike's case a white 'cove' or photographer's background). The sphere is then photographed and the image is opened out to make a 2-D image, which is the mapped onto the inside of a virtual sphere that surrounds the scene that you are animating. The sphere then acts to reflect that light back into the scene, and most importantly, wherever you are in the virtual sphere, and wherever you point a virtual camera, the ambient light remains the same. It is a complicated but crucial way of creating a natural effect.

Lighting and Rendering

The final phase in CGI is lighting and rendering. What you have so far done is create figures and the world in which they move, rigged the figures so that they can be animated, and animated them. You have created a range of moving surfaces and brought them to life. Now it is necessary, as it were, to paint them, to make them look as they would in the scene. You can think of this purely in terms of the mysteries of light.

We see because our eyes are sensitive to various qualities of light such as intensity, colour, diffusion, as it is reflected from the surfaces of objects in the world around us. The way that light is reflected depends on the surface and on the intensity and directionality of the light source or sources, and it is these factors that the program is constructed to mimic in a process called rendering. In this process, the program calculates for each tiny area of the surface the effects of the surface texture and the light.

But in order to light and render your scene, you can work with the program without knowing how it is operating. You need to think like a painter as you select colours and textures, and to think as a movie director and lighting cameraman would do as you select the camera angle and arrange the lighting. When you are thinking as a painter, you are trying to create surfaces that match your overall vision, whether that is a

As Ike sits at the piano he is lit in turn by the ambient light only (top left), then the key light is added (top right), followed by the rim light creating starker outlines (bottom left), and finally the fill light filling out the shadows (bottom right).

169

As the lighting and rendering of a scene is worked on in CGI, it is usually broken down into component layers that can then be worked on individually before being put back together to make the composite image shown opposite. Each layer shows the rendering artist a different quality of the way surfaces they have created are behaving under different lighting.

Here are seven such 'passes' that together make up the final scene. At the bottom is an 'occlusion' pass that shows the shadowing that occurs, as it were, naturally from the ambient light. The effects of this ambient light are shown isolated in the 'environment' pass (top row, left). The 'depth' pass (top row, right) allows the artist to see the depth of focus effect he is getting, and that he can vary. The 'diffuse' pass allows the artist to examine the colours as they are affected by direct lighting, say from the key light (second row, left). The 'reflection' pass (second row, right) shows the way that surfaces designated as reflective are behaving in reaction to the environment and other elements within the scene. An 'ID' pass is used to create mattes for specific objects, so that they can be worked on individually, as the aeroplane will be here, without affecting other areas (third row, left). A 'specular' pass (third row, right) shows the highlights created by direct lighting.

naturalistic vision or an illustrative vision. You might want to match a comic book character and the heightened effect of comic-book printing, or you might want to represent a creature as realistically as possible, say if you are working on a nature program. Just like Vermeer or Picasso, you are creating surfaces that create an illusion: the key difference is that these surfaces will move.

The lighting formulations in CGI have been adopted from cinematographic techniques: it is the artificial lights of the cinema studio that the program imitates. This gives you control that you can vary for mood or clarity, just as a lighting cameraman would do when shooting. Lighting can thus be thought out in just the same way as you learnt with stop motion on pages 78 and 79. This method gives you a lot of control and allows you to direct the eye and shape the reaction of the audience, just as you would as a photographer or a director.

There are, of course, many different possibilities at this stage in the film-making, but just as with all the work that you do in CGI, the most important thing is to gain confidence in using the tools through experimentation, so that the tool can begin to fulfil your vision. Try to avoid the trap of doing things because the program makes them possible rather than because your original creative vision demands it - make the machine work for you.

Many of the animators at Aardman have worked in both clay and CGI: they all agree that both methods have strengths. If you want to animate, it is clearly best to try out your creativity and experiment with both media. It is finding the best vehicle to express your ideas that counts.

This is a scene from a remarkable commercial created for Polo. The director began from his own amused obsession with mechanical tin toys, and devised an amusement park ride for a Polo mint through what feels like a boy's bedroom in the 1940s, only to arrive back at the start and continue a loop that is emphasised in the final copy line, and reflects the nature of the Polo.

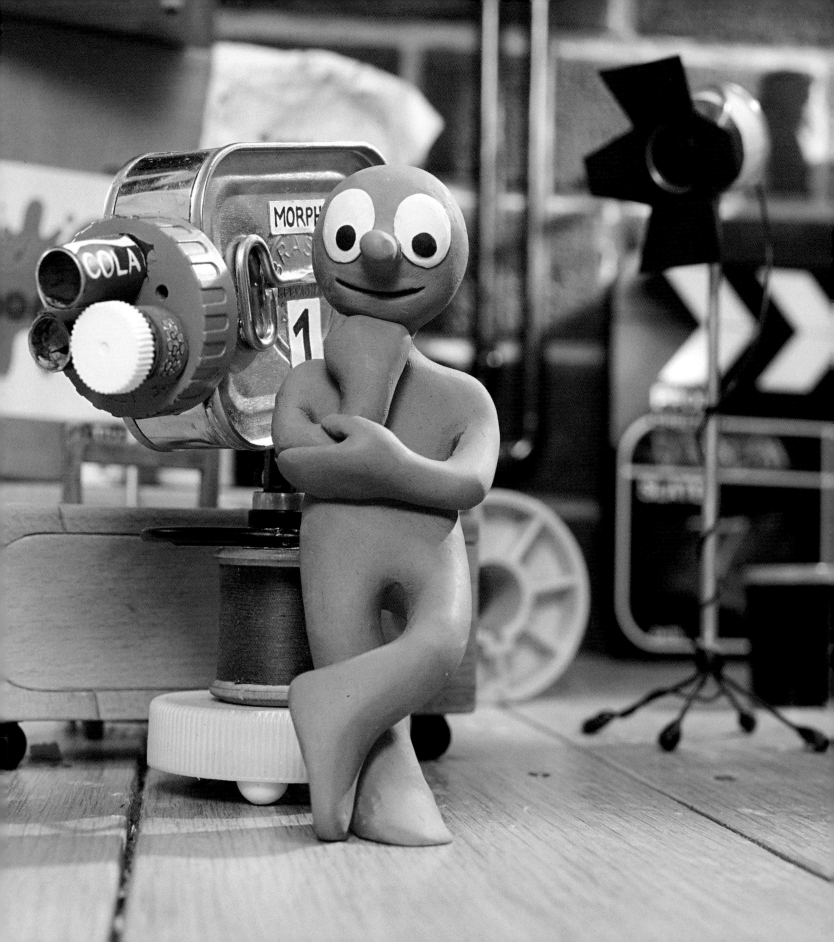

making a film

**A nonchalant Morph
stands by one of the more
interesting cameras from
his BBC days.**

173

The Role of the Producer David Sproxton

It has never been easier to make some sort of film or movie, whether animated or live action. Simply by using a mobile phone you can put a sequence of images or shots together to tell some sort of story. You can even get the world to see it by posting it on any number of web-sites like YouTube. Indeed, the Internet is saturated with movies of all sorts from all over the world, made by all sorts of people about all sorts of things. Most of them don't merit watching and most of them don't get watched.

So what makes a film stand out, and how do you get people to see it? These are the two key questions that all movie producers face, regardless of the type of film they are planning to make. A short film can be as hard to fund and find an audience for as a feature film. If you are a young filmmaker wanting to make your first film you need to think like a producer as well a director. You may find a friend or colleague who is willing to take on this role, but whether it is one or two people, you need complimentary skills so that the roles are not competing against each other. Both director and producer should be working to make the film project as good as it can be.

In the world of professional movie making, a good partnership of director and producer is essential and many directors will work with one producer for much of their career simply because they work well as a team and compliment each other. Put simply, the director's role is to hold the creative vision while the producer's is to organize the resources that enable that vision to come to fruition. They are both creative roles, but the producer is thinking in a more entrepreneurial and managerial way. On any film project there is never enough time or money available from the director's point of view. From the producer's point of view, there are distinctly limited resources available and the skill is to enable the right compromises to be made so that the project is made with what is available. Once both parties have come to understand this equation, they find life a great deal easier!

The still emerging mobile phone market suits short films with strong, simple story lines. An internal competition was held at Aardman to encourage creative thinking in this area for films that were no more than two minutes long, aimed at a young, male audience. The winner was a neat piece of stop animation called *Stuff versus Stuff* that then became a series of films showing combat between household objects. It uses object animation, just as shown on pages 86-89.

The first question that any producer needs to ask is what kind of film should it be, and this, of course, will depend on the idea behind the film. Is the idea something that will make a successful short film that can be viewed on the Internet? Is it a short that explores a character or situation that could then be developed into a series for TV? Both Angry Kid and Big Jeff started as

Big Jeff is a larger-than-life 'Aussie with no Cozzie', who has a great following on the web despite his state of undress. This was one of Aardman's first ventures into Flash and its simple (and memory efficient) form of 2-D animation. Although limited, Flash is a great way to get started on your own animation.

characters in one-off short film ideas, which later developed into a series of shorts.

Perhaps the idea will run to a longer piece that can stand alone, like a TV special, or could even be developed into a feature film. The Wallace and Gromit films sit in this category, starting as one-off 30-minute TV specials. Eventually the duo became strong enough as characters to justify developing a feature film script around them. Other ideas may be developed as TV series from the outset, as *Shaun the Sheep* and *Timmy time* have been.

Of course there are other options but this gives you some idea of the range of possibilities. One of the great things about Aardman is that we work in so many of these formats, from advertisements to shorts, to feature films, and all these films need both creativity and production control. They all need to be made knowing how they are likely to be viewed and reach their audience. This is especially true since there are now so many ways to view movie material from mobile phones to cinema screens.

In this section of the book we are exploring making films of all these different types. From this you can see that it is essential that this first question of format is answered so that everyone knows what they are aiming for in making the film. What all Aardman films have in common, we believe, is strong stories and engaging characters.

In the early stages of anyone's film-making career keeping things short is good idea. Developing strong story-lines for longer films is a very difficult thing to do if you haven't tackled a number of shorter ideas first; people often make the mistake of thinking that they have to make a feature film if they want to be regarded as a credible film-maker, but the odds are stacked against success. It is

The ability to convey emotion with the simplest of body forms is one of the animator's secret arts. Purple and Brown is a successful sequence of one-minute films built around the two characters on the right. They are clearly alarmed by the arrival of the angry blue guy, but their more normal demeanour in the films is shared laughter over minor incidents, particularly those that reflect bodily functions. The great secret of Purple and Brown is that they manage to create a strong story line in just one minute, and always share the joke.

Pib and Pog, written and directed by Peter Peake in 1994 has proved popular as a short film in a wide variety of markets. The two characters are portrayed inventing ever more savage ways in which to hurt each other, while the soft-voiced female commentator, clearly an echo of television for infants in the fifties, remains totally oblivious to the murder and mayhem on screen. Pib is about to be impaled on a bed of nails as Pog watches gleefully, but the glee is all Pib's when he manages to trap Pog's head in a bucket filled with sulphuric acid. Meanwhile the commentary tells us what nice little chaps they are.

generally thought that it takes about ten years of producing shorts (which can include TV work) before a director is ready to tackle a feature film with any chance of success, and the statistics seems to bear this out.

Having decided what sort of film the idea merits, the producer and director will then work together to develop the script to the best of their ability. At the professional level script-writers will be engaged at this stage and it will be producer's job to brief writers and to contract them. The producer may also offer advice and criticism to the writer alongside the director, and will certainly have an eye on the practicalities of the script in terms of resources available. Even for a 90-second film ensuring a strong script will make it stand out from most competitors.

Aardman helps to sponsor the DepicT.org web-site for short-film competition, and anyone can take a look at the site to get an idea of how strong, simple ideas can be turned into short films with real impact. There are many other micro-film competitions like Depict.org and they offer the opportunity to practice your film making skills and to be judged against others at a very high level. Some of the competitions have truly worthwhile prizes, and they can open doors to further film-making opportunities.

At a professional level, the producer needs to answer major questions about the markets and the potential earnings for the film and the funding. In the early stages of film-making, however, it's unlikely you will be chasing big budgets, in fact you will probably be embarked on a 'no-budget' project but with the intention of getting the right sort of people to see the finished work. So the key questions become who are those people and where can they be found?

If you just want some sort of audience reaction, putting the film on the Internet may satisfy that requirement. If you are after bigger and better

Chop Socky Chooks is a series of shorts developed by Sergio Delfino, and was one of our first explorations of the medium of CGI outside commercials. The idea of martial arts comedy for kids was given extra impetus by the freedom of movement that is so much easier in CGI than in clay animation. When gravity is something you can apply or not, the leaps and flights of martial arts require no complicated rigging. The films use interactions between a number of strong characters: clockwise from above, they are Dr Wasabi, Bubba and Chuckie Chan.

opportunities and are using this film as a kind of calling card, the short film festivals and TV commissioning editors become your target.

If your film is targeted at a specific market area such as a children's TV series, or is meant to be a series of funny short pieces aimed at a more adult market, you will need to do some research to find out who commissions this sort of work. These could be in Television or they could be people who run the various web-sites that carry this sort of work, or they could even run short films in cinemas, as festivals perhaps.

Regardless of the area you are focused on, it is worth reminding yourself that there will be many others out there doing the same thing, so your task is make the film stand out. You will need to present yourselves as strong, ideas driven people that other people want to work with. This is all about marketing yourself and your ideas, and having a plan on how you are going to market any film you make will be critical to its success and your career.

Many people get carried away with the technology of film-making at the expense of developing good ideas. These days the tools for film-making are so accessible and so user friendly that discussing the merits of one system against another is a futile exercise. Cameras, edit systems, animation packages, etc, etc are changing every week, and generally getting better and are great value for money.

High Definition is rapidly becoming the standard for production with various file formats being derived from the original depending on the distribution system being used - television, DVD, Internet, mobile phone, etc. A real convergence of all the production systems is underway, which is good for everybody. You can now shoot both high quality stills (as Aardman does for its stop frame work) as well as cinema quality video footage on the same digital stills cameras. Photo-chemical film is in its death throes as the world moves towards an all digital, tapeless production environment.

The message is more important than the medium, so don't get hung up on technology, get out there, generate some great ideas and get producing the stuff!

Thinking about a Script

Whole stories do not fall ready-made from the sky. The best ones usually evolve slowly and take a huge amount of effort. Dave and I learned our trade in storytelling when we made films for 'Vision On' and 'Take Hart'. Those early films were very short - no more than sketches, really - but many of the same basic rules that we discovered then, apply equally to much longer and more complicated stories.

A story is usually about something, meaning that there is more to the story than simply what happens. Morph stories are usually about sibling rivalry, jealousy, pomposity pricked - things like that. But the seed from which the story grows may be very simple. It may be enough to think of a single gag, an absurd situation, an animation idea that you would love to try.

Morph, Chas and a computer keyboard - all the ingredients you need for a short sharp conflict. When we began making Morph films for the 'Vision On' series, our goal was to tell a story in under a minute - not a bad target for anyone setting out in animation.

When we were writing sketches for Morph, we had the freedom to choose any subject. For example, we might decide it would be fun to animate him as if he were on ice. That is not a story, but it is the seed from which the story grows. It is a situation that will be fun to do and will challenge the character. Now we need to work out how to simulate ice on Morph's table-top. He could invent an ice-making machine, or receive one through the post, like Wile E Coyote, or we could send him to the North Pole. Or we might decide that all this is much too complicated. Instead, Morph's alter ego Chas has polished the floor so hard that it becomes as slippery as ice. But Chas, being incredibly lazy, would never have polished the floor voluntarily. So he needs a reason that is funny and in character. The simplest reason is good old malice. Chas has booby-trapped the floor, and now lies in wait to watch the fun. Starting with an animation idea, a story is already forming.

All this is the set-up for the main part of the story, in which Morph tries to achieve something, and is constantly thwarted by the slippery floor. I am shy of giving rules, but we often found that you had to try three variations on a predicament to make it effective. In this case, discovering the slippery floor and falling over a few times is not enough. You have to invent *variations* on him falling over. Why does he do it, how does he avoid it, what are the consequences? And while he is falling over, while he is in conflict with Chas, we must not forget to have visual fun with Morph skating around. Finally, we need a punchline, an ending, a resolution. Knowing Morph, he eventually discovers that Chas is responsible and takes some terrible kind of revenge which leaves the audience with a feeling that justice has been done.

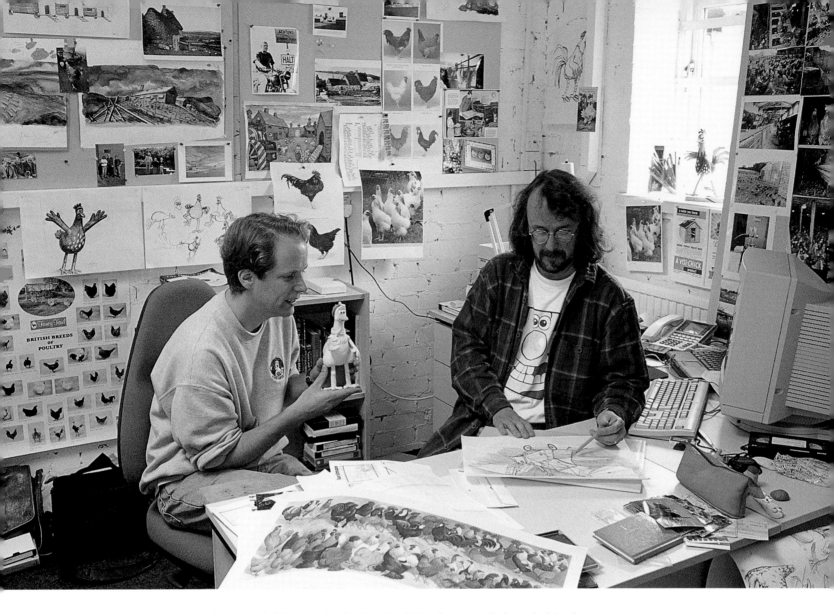

Nick Park and Peter Lord think chickens - devising the shape, look and individual characteristics of the stars of Chicken Run.

On a much bigger scale, the idea for *Wat's Pig* came during a holiday in France. I was in the Dordogne, where you can see these huge medieval castles standing in full view of one another. I thought, how difficult to have been a peasant in the middle of this lot, caught up in the intrigues of warring barons who held the key to everything you did in life. That was the starting-point. As we developed our plot, we settled on one particular castle rather than have two facing each other. Later came the idea of the twins who were separated by a thief who stole one of them. After that began the real job of knocking it all into a complete story, which took months of work.

Story-writing is like solving a great puzzle made up of dozens of elements. Think of Rubik's Cube. You twist the sides around to see if a given combination will work, then you twist it again, and again, until it comes out right. Along the way, you probably have to discard a few things as well, and that can be the hardest part.

The welcoming screen for Webbliworld. We created a lot of colourful assets, as we call them to attract and hold a child's imagination: we have given personalities to many of the assets so as to make interactions more immediate. Initial drawings, on the right, began to shape the webbli maker, the central feature of the opening screen.

Flash Animation and the Web

The web is so fast evolving that it is difficult to pin down developments at any time. You are reading this in an illustrated book, which is an old technology - many centuries old - that does some of the things that a web-site can do. It does some things better, some worse, but a printed book is caught in time in a way that the web is not, because the web is constantly updating, so Aardman's web-related activities are constantly changing and growing. Animation is a key factor on the web, and as one of the leading creators of animation in the world we know that we have to be involved.

We now have, for instance, a creative partnership with Webbliworld; this is a site that was dreamed up as a place where children can safely go to create their own characters and interact. It is a place where they can be stimulated into thinking about the environment, but still remains a constantly interesting and entertaining virtual place to go on the web and meet other kids. We provide the visual ideas behind the site, and, of course, the animation. For instance, each visitor to the site is invited to create their own character, or avatar, so we came up with a wacky animated machine that allows the visitor to choose the style and colour of each body part and then pull the lever to make their very own character. Their character can then interact with the other visitors in Webbliworld. The animation is all done in Flash, which makes it very immediate and simple.

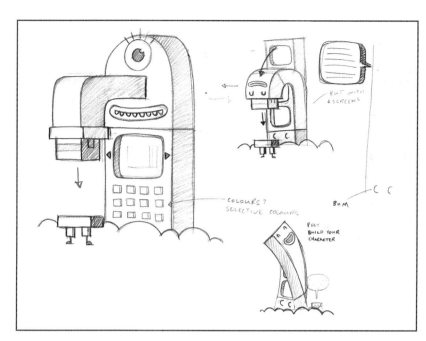

Join in. Make your Webbli

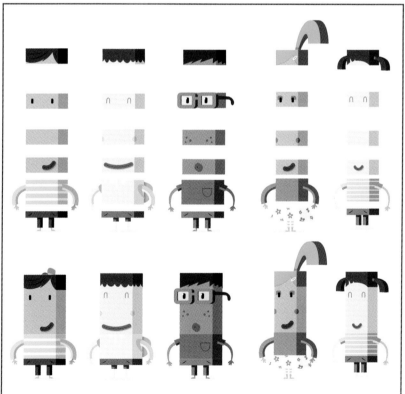

Above are the rough animation sketches for the action of the Webbli maker. Flash allows you to animate in rough form before dressing and finishing the moving surfaces. The machine offers a menu of choices of parts of your Webbli, from head to foot, and when the lever is pressed, Presto! The machine bends and drops the Webbli part by part until it is assembled, as is shown on the left.

There are vast ranges of choices, so each child can make a character of their own. Aardman brings skilful animation and characterisation to the process.

Home Sheep Home is a relatively simple game of problem solving, but it is the use of well-known Aardman characters Shaun and Timmy that have resulted in the game becoming an immediate hit. The rendering of the characters in Flash means that they have to simplified considerably, while still maintaining the essence of 'Shaun-ness' and 'Timmy-ness' and this is a demanding brief for any animator.

Online Games

Games are a major feature on the web that Aardman's digital department is becoming more and more involved with, both on our own site and on others. Developing interactive games at the level that is appropriate to each site is a great creative challenge. We are especially active in creating games that link with our movies and TV series, of course. Television producers can be very demanding: they know that for young audiences the possibility of playing a game on line that meshes with the programmes they are watching is very important, since the one format reinforces the entertainment value of the other.

Most online computer games involve animation so Aardman is really well placed to create them. They can be seen as a specialist extension of our movie making and the thinking and creative development involved has much in common. The process is different, of course, because although all games ultimately tell a story, the story is not linear but contingent: it relies on interactions with the player. But notice that Aardman's insistence on strong story lines and characterisation is still important.

A good example of the games that we generate is Home Sheep Home, a game for the young enthusiasts for Shaun and Timmy. The object is to find a way for Shaun, Shirley and Timmy to overcome barriers by moving things, pressing buttons and so on. The trickiness of the game lies in the problem solving: the

The creation of each level in the game demands the construction of different challenges and the planning of the obstacle to be overcome and the unique route to the solution. For level twelve of the game a seesaw is arranged so that the right selection of jumpers enable one of the characters to be catapulted over and switch a drawbridge into place for everyone to cross. The three phases of creating and testing are shown here, as the appearance and operation of various elements is explored and defined.

game's writers have cleverly used the differing size, weight and strength of the three characters so that the player needs to deploy the right character in the right order with the right task.

To create a game, just as with movie-making, we start with a script that describes the situation and the possible moves that a player might make, including, of course, those that are ultimately successful. From the script, visualisations are prepared on the one hand, while simultaneously there is what we call a 'grey box' test of the parameters of the game to prove that it can play out, even at a rough level. The twin processes of visual creation and animation, and the testing of the game then continue until we are happy with the player's experience: the crucial test for all games. A game's learning curve is important: we all know that games need to entertain, satisfy and frustrate the player.

We have three stages of testing in the development of a game as the characters or props and backgrounds (these are called the game's assets) are developed: Alpha, Beta and Gold. The animation is, of course, made dependent on the player's actions, so, for instance, Timmy needs to be able to jump, walk and push, and affect other assets only in so far as his diminutive stature will allow. This is all built in to the game's software, and relates to keyboard actions. You can see that the testing is very important, but once we reach the Gold level we know that we are ready, after the addition of sound effects and any other 'post-production' elements to launch the game.

Home Sheep Home was placed on just four sites in a process called seeding, but within days it had migrated to many others and been played many millions of times!

Creating a Storyboard for *Adam*

With only one location, two characters and no dialogue, *Adam* is a very simple film. Even so, storyboarding it was not easy. At the ideas stage, I had come up with a dozen or more situations that Adam would face - the effect of gravity, loneliness, a temper tantrum, etc. The job was then to put the sequences in the best order. so that the story unfolded in the right way to an audience. I drew up each short sequence very swiftly and roughly - to capture the ideas in my head. Then, with hundreds of scratchy little drawings on separate sheets of paper, it was easy to shuffle them around to try out different ways of structuring the film. The storyboard drawings did not need to convey anything to anybody else about the look of the film. What they did convey to me was the spirit of each sequence, and also whether or not a gag was working.

So, along with body posture and facial expression, the most important thing the storyboard told me was the size and shape of the shot. Is loneliness conveyed better in a soulful close-up, or in a wide shot which shows that there is nobody and nothing else around? Or both? And in which order? It seems to me that such questions - half artistic and half practical - are the main business of storyboarding.

Peter Lord, seen on the right animating his character Adam, planned the film by drawing up the main sequences in a series of rough sketches like those shown below. By shuffling these around, he was able to organise the film's structure, and also check whether he had captured the spirit of each individual sequence.

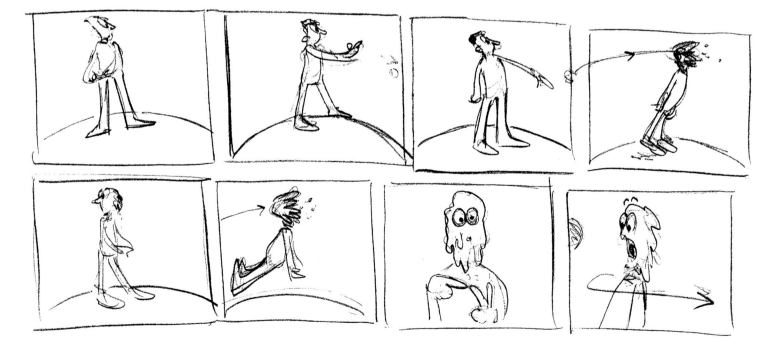

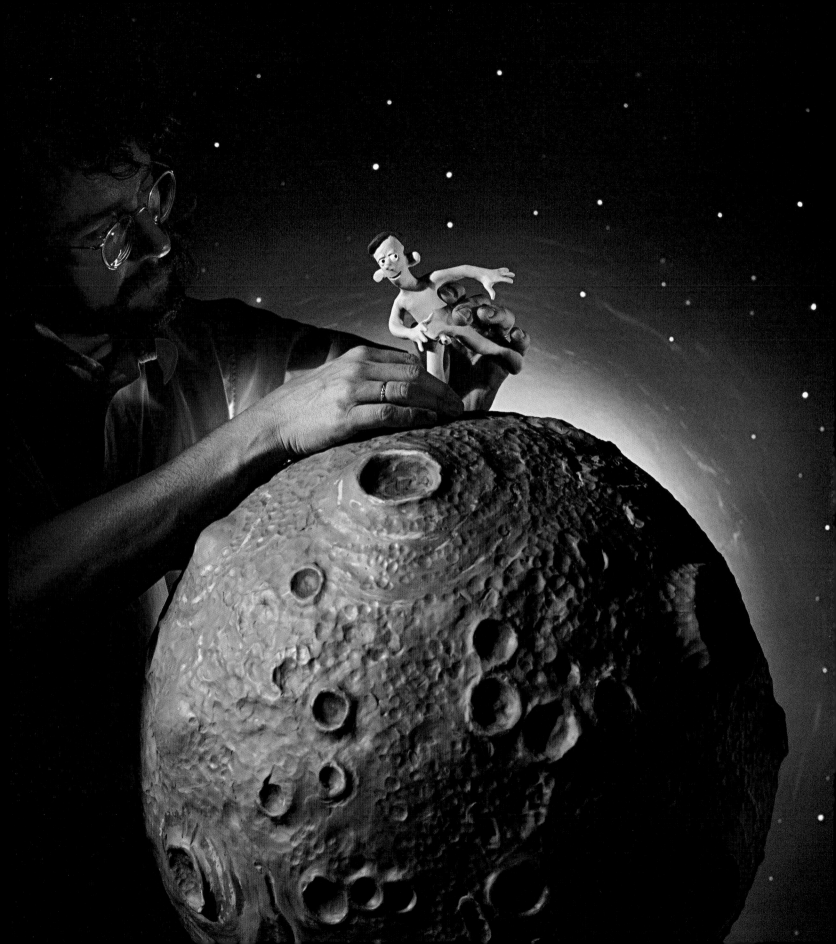

War Story

An old man recounts his memories of the Second
World War - under the bombs in Bristol, when the
cupboard under the stairs doubled as a coalhouse
and an air-raid shelter - 'I sits on the coal, then in
comes 'er mother and sits on my lap, and my missus
sits on 'er mother's lap. My missus was expecting a
child at the moment, so I reckon I had about three of them on me.'
Humour and nostalgia were key notes in our treatment of the main character.

After 'Conversation Pieces', Channel 4 commissioned a similar series which we
called 'Lip Synch'. We took the opportunity to try out new directors and new
styles. In *War Story*, we abandoned the formula of recording conversations, and
went instead for a recorded interview. We talked to Peter Lawrence of Radio
Bristol, and he recommended this guy, Bill Perry, then probably in his seventies.
Bill was a great raconteur, and Peter had interviewed him several times for
radio. As usual, we decided not to meet him because we preferred to work in
a state of innocence, so we asked Peter to do the interview, and he came back
with two and a half hours of tape.

At the time I was quite tempted to do a serious piece, concentrating on the
darker side of Bill's war memories. He had worked at the BAC aircraft factory

**Images from the Home
Front in the 1940s - a
propeller aircraft at the BAC
aircraft factory, Bristol, and
the coalman emptying his
sacks into the cupboard
under the stairs.**

on the outskirts of Bristol when it was bombed, and I thought I could make a faintly mournful, regretful film based on this side of his story. But, at about that time, I'd finished another film in the series, called *Going Equipped*. This was a serious piece about a petty criminal and the awful barren life he falls into. I liked the film, and still do, but simply because it did not have any laughs in it, people had been unsure how to react. This made me decide to go for a more light-hearted take on the material we had for *War Story*.

There was plenty of material to choose from, so we selected the bits we liked and tried to arrange them in a coherent order. One of the attractions was being able to mix scenes of the old man telling his stories in the present with others showing him acting them out as a younger man. The most difficult part was the ending. Bill had a lot of stories, but he never got to a really white-hot punchline with any of them. Fortunately, while describing the after-effects of sitting on a heap of coal with the other members of his family piled on top of him, he says, 'It was agony, Ivy, I was tattooed all over,' which I believe is an old radio catch-phrase. Then I had him clamp his pipe firmly between his teeth with a loud 'click', rather like Eric Morecambe used to do, waggle his eyebrows - and that was it. That was our ending. Not the world's best, perhaps, but it is quite a good example of how to bring your film to a pleasing end when the action or dialogue does not provide you with an obvious choice.

A happy ending - simply achieved with a click of National Health teeth on pipe, a grin and a quick waggle of the eyebrows.

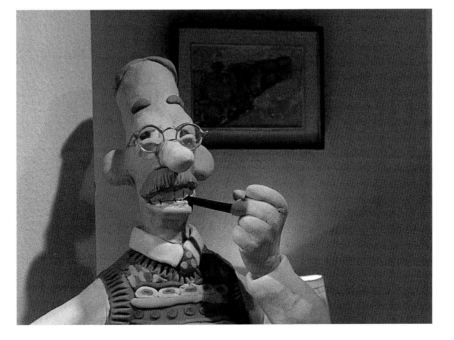

The Pearce Sisters

This extraordinary film based on an extraordinary tale. Created by Mick Jackson in his collection of short stories called Ten Sorry Tales, it takes us to a dark fantastic part of the world that is still somehow recognisably in the far north of Britain. There under teeming skies and next to broiling dark seas, two hideous sisters eke out a living fighting constant storms to bring in a catch of herring. The tale becomes even darker as the sisters discover the doubtful pleasures of becoming 'fishers of men'.

Luis Cook's BAFTA-winning animation short takes this odd tale and creates a brooding magic from the start. In its brief ten minutes the film leaves its audience feeling as though they have been held at the very centre of an unforgiving storm, witnessing grotesque events that are played out in an eerily beautiful world, fractured but still coherent. The two sisters have become oddly opposed as little and big sister, their personalities apparent and clearly delineated from the start.

The film began life as the winning project in an internal competition at Aardman to create a short film. The studio was aware that it had not made a short in a number of years and, as in all good creative businesses, there is a need to keep story-telling alive just for its own sake. The critical success of the film has fully justified the effort.

The oddly sympathetic hideousness of the sisters is reminiscent of the work of Georg Grosz and Otto Dix, but the graphic effects were not easily achieved. Highly complex story boards and visuals were created initially. When the characters had been given some visual form, they were modelled in clay - the only nod in this film towards Aardman's stop-motion roots. From the clay figures, CGI figures were modelled and much of the animation was created using the CGI forms. The resulting frames were then used as the basis for animation of details such as facial expressions in 2-D animation, and then everything was tied together in post-production. Such was Luis's hunger for texture and detail that at one point fish were being photocopied in the studio in large numbers.

The relentless sea and storms that pervade the atmosphere of the film; the dark emotions that drive the sisters are constantly reflected in their environment.

Close-up shots throughout the film emphasise the oddly naive cruelty of the Pearce sisters - the film portrays a horrifying mix of innocence and barbarity that is present in the original story.

The interplay between 2-D and 3-D in its making becomes apparent when one of the sisters reaches into the water and is seen from below, or when the herring are raised in the smoking tower and we see through them up into the tower. The resulting, lovingly made film deserved its plaudits. Its look and the sound create an expressionist feel and in some ways it is reminiscent of work from eastern Europe in the 1960s, but closer examination shows that the carefully considered cinematic shots, using the language of expert film-making, place it firmly in an Aardman tradition.

Another close up shows one of the grisly sisters shouting into the whistling wind. She has just seen a boat helplessly pitching in the waves.

Two pages from Luis Cook's highly inventive sketchbooks; the sketches show a mass of initial thoughts from which the style and characterisation of the movie was to emerge.

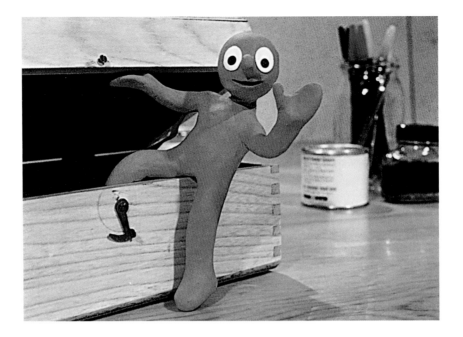

Morph

When Dave and I brought Morph into the BBC series 'Take Hart', he was not much more than a human-shaped blob. The challenge for us was to develop him into a fully-fledged character.

Back in 'Vision On' days, we had created a group of little clay characters, called the Gleebies, who ran round the tabletop and created havoc, knocking over paint pots and stuff like that. The producer liked them, and when he was preparing the 'Take Hart' series he asked us to create a new character who could interact with the artist Tony Hart, and who would apparently live in his studio. He also liked the fact that our characters could change shape. So we made a very simple terracotta-coloured figure who could instantly change back into a lump of modelling clay. Because he could metamorphose, we called him Morph. The problem then was to find things for him to do.

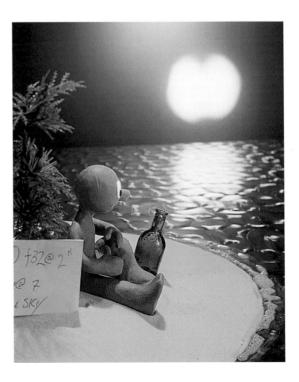

Morph was a troublemaker from day one, and from that came his personality. He was disrespectful of authority, viz Tony Hart, and gradually, story by story, he acquired more and more characteristics. In each episode we set him a problem to solve, and the way he reacted to it gave him another dimension. We also decided to cut down on the amount he changed shape, because that did not interest us as much as his character.

Soon he had a mass of distinctive traits: he was short-tempered, rather pompous, a know-all and a show-off - all rather negative things, but oddly enough they made him seem attractive. People could laugh easily if he took a prat-fall, but he was clearly not all bad. He was full of genuine enthusiasms, and these helped him to grow. For example, one day he appears wearing a beret and holding a palette and paint brush. Obviously he fancies himself as a great artist. He flings himself into his new role with huge energy. His paintings are pretty awful, but he strikes grand poses as if he is Van Gogh, and is insufferably pleased with his work.

Then Chas arrived, Morph's alter-ego. One day Morph is carving a statue of himself from some pale-coloured material. He chips away at the figure, which suddenly comes to life and immediately starts a fight with him. Originally this was just a story about a statue, then afterwards we thought, 'This is a good character, let's keep him in.' This was excellent for us because a double-act gives you so many more story possibilities. Like brothers, they could not get away from each other, and because of this they were constantly arguing, fighting and competing with each other.

We tried out some other characters too, like Folly (a tinfoil female) and Gillespie (a big blue figure), but they were less successful because they were *invented* to fit into an ongoing series, whereas Morph and Chas had the luxury to evolve through a much longer creative process. I'm sure it's made them much stronger as characters.

On these pages Morph displays some of his many characteristics. On the plus side, he is friendly and full of genuine enthusiasms. Less positively, he is pompous and definitely likes to get his own way, especially with Chas, the brother-figure he cannot stop arguing and fighting with.

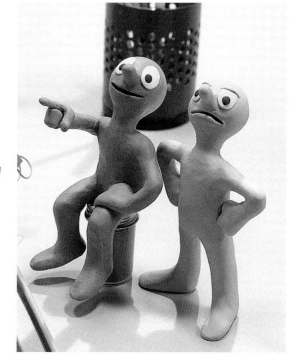

Angry Kid

The antics of the alarming boy anarchist won a cult following on the Internet before he moved to BBC3. Darren Walsh, his creator, describes how he developed the character and the unusual process they use to make the films:

'Angry Kid started off as a joke voice I used to do about ten years ago to make my friends laugh. The voice is based on my brother, when he was a kid. He is three years older than me, and the character's look is based on him too, with his Seventies parka, chopper bike and so on. He didn't have red hair, but I thought I'd stick that on for good measure. He was horrible to me in those days, so it's all a revenge thing really.

'When we began, I was still learning to do lip-sync, so we did a test. We recorded the voice, made some masks for the actor to wear, and filmed this as a screen test. The idea was, you put a kid in front of a camera and for the first half minute or more he's having a good look at the camera - "What you lookin' at? You lookin' at me?" - but the real question was what he would do after that, when he had run out of things to say. In this case he attacks the camera and kicks it over. A simple enough storyline, but we thought we had captured something lively and interesting. Really, it was no more than an experiment, but it seemed to go down well when we showed it around, and gradually it built up a following at festivals.

'Then we thought, if we are going to make more "Angry Kid" films, we need to master the stupid little things he does - the sniffs, the snot, the awkward pauses, little bits of business like that. We don't know how old he is, somewhere betweeen eight and 13. It's difficult to decide, because sometimes he plays with toys and other times he really wants to be a grown-up. He's full of that angry innocence.

'When Atom Films came along and put "Angry Kid" on the Internet, the word must have spread quickly enough because by the end of the first year it had scored around ten million hits. Then BBC3 picked it up. They don't schedule it, they just put one on when they have a spare minute between programmes. This way, it's like he's infiltrating the airwaves - which is nice because they're not masterpieces, they're little snippets of "stuff"'.

Below: Line-up of masks worn by the actor who plays Angry Kid.

The 'Angry Kid' films are made by a combination of pixillation - animating a live actor - and replacement animation. The actor (Clayton Saunders) wears one of a series of masks to show the character's changing expressions (all the blinks, sniffs, twitches, smiles, etc, and all the vowel and consonant positions too). Each phase of a movement is shot (two frames), then he moves to the next position, maybe with a change of mask, and that is shot (two frames). It's a great strain on the actor because he can't see out through the mask and, along with the sensory deprivation, it gets very hot in there.

192

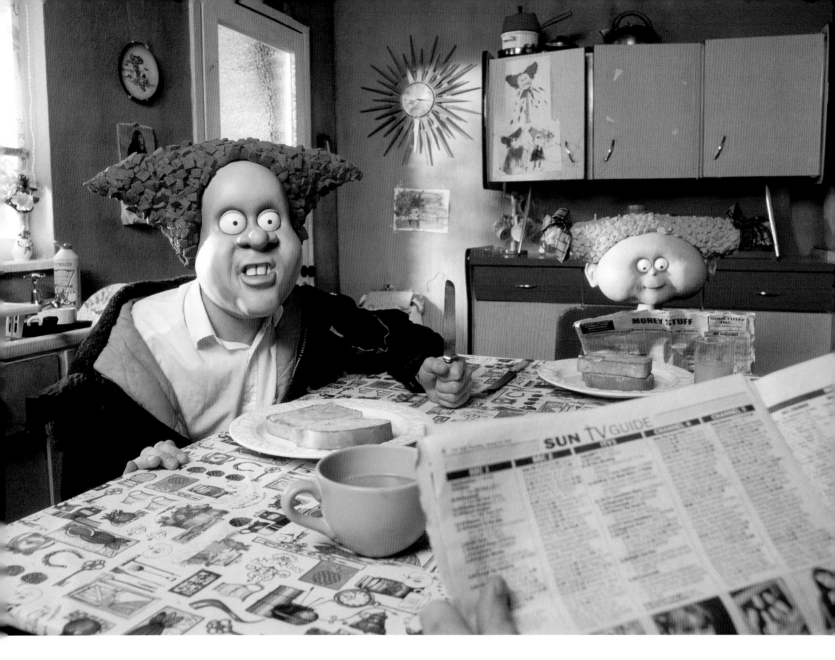

Above: Angry Kid, the boy who could ruin anyone's breakfast.

Right: Actor Clayton Saunders shaves his hands to make them look younger. Director Darren Walsh supplies the tea.

Far right: On the back seat of Dad's car, cut away to the basic elements the audience needs to see.

Creature Comforts

The action takes place in a zoo where the animal characters - a Jaguar, a Gorilla, a Terrapin, three Polar Bears and others - talk about their lives and how they are treated. The film won director Nick Park his first Oscar. Here he discusses the characters and how he developed them.

The title frame of *Creature Comforts* shows a professional tape recorder. A voice says, 'Sound running. When you're ready'. This sets up the film as a series of interviews, and conveys to the viewer that the voices in the film are 'real'.

'The idea came from what Pete and Dave were doing on 'Conversation Pieces', using the voices of ordinary people on a pre-recorded soundtrack. Rather than get other people to do all the sound recording, I did half of it myself. Also, instead of eavesdropping on the subjects, we interviewed them. In my mind I had the zoo theme planned out, so in the interviews I tried to ask questions that would produce the kind of answers that animals might make. I found a Brazilian student living in Bristol, so I asked him not only what he thought about zoos but also about the weather, the food and student accommodation. He said a surprising amount of things which fitted perfectly. Asked about the food in his hall of residence, he said, " ... and food that look more like dog food than food proper for wild animals. All right?"

'He was so good that later I was able to let the soundtrack dictate to me what we should do when we filmed him as an animal. For some reason he kept mentioning double-glazing: "Here you have everything sorted out - double-glazing, your heating and everything, but you don't have *space*!" So I put a big glass window next to him to convey both the glazing and the fact that it helped to shut him in.

'Once we had recorded a voice, I tried to match it to a particular animal. People now say how well-suited the voices are to the animals, but in fact I changed things round a lot. At one point I thought the Brazilian could be a penguin rather than the Jaguar he became. My theory is that you can make anything fit anything. What is most important is how you do it.

'I found working with pre-recorded voices very refreshing. Although the format might seem rigid, and the filming process very straightforward, in fact it frees you up. Unlike a commercial, where you have to tell a complete story in thirty seconds, here you have time to let the voice give you ideas about how to animate and play with the character, all within the discipline of a static, held frame. To me this was liberating and very enjoyable to do.'

Each of the captive animals has a different view of what it is like to live in a zoo. Clockwise, from top left: The anxious but not unhappy Bush Baby - 'I know, whatever happens, they'll look after me'; Andrew the young Polar Bear, who takes a precociously global view of things; the Terrapins, reasonably comfortable but 'I can't actually get out and about'; the Armadillos, contented in a downtrodden sort of way; the young Hippopotamus who thinks that most of the cages are a bit small, and the philosophical Gorilla. Below: The spokesperson for the Birds, who reasons that animals in the zoo are better off than animals in the circus because 'they can do their own thing'.

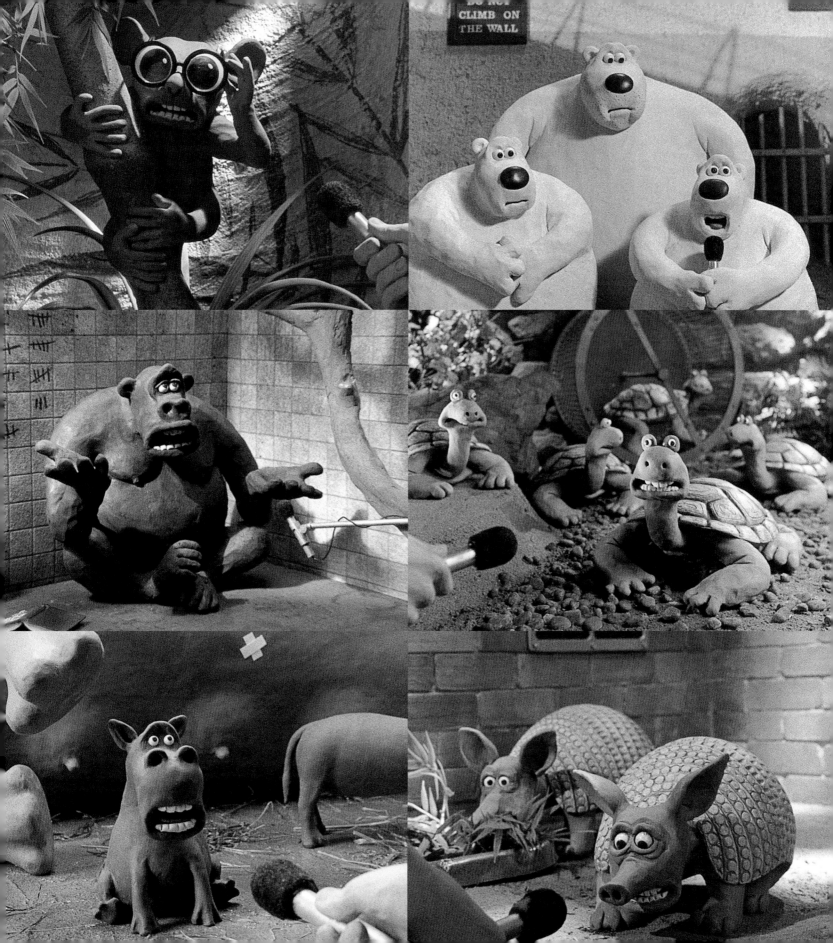

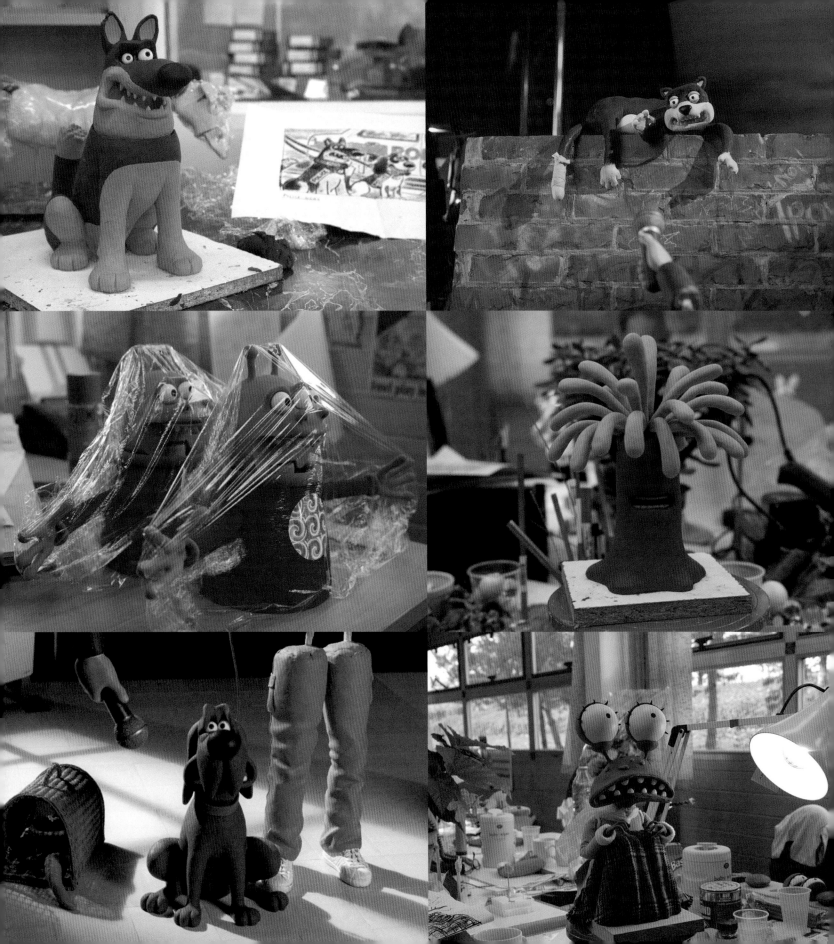

A series of images showing 'Creature Comforts' characters at different stages of development, from first build to final shot.

For some years after the success of the original *Creature Comforts*, Nick Park had wanted to go back and make more films with animals talking about their lives. When the opportunity came to go ahead, Nick was still heavily committed to feature film work and Richard Goleszowski took over as director of the new series. He describes how they developed the scenario further into a series of longer films, each taking a set theme such as 'The Circus', 'The Sea', 'Feeding Time' and so on.

'When we kicked off, we were not sure whether the talking animals would hold up well enough in a longer format. The original film was only five minutes long and now we were going to make a series of ten-minute films. But once we started to try it out, we realised that this need not be a problem. At first we were not thinking in terms of fully worked-out films. We had plenty of ideas, so we recorded lots of material very quickly on a range of different subjects and then decided which of these to use in the 13 episodes of the series.

'We used the established method of interviewing the kind of people who would talk and answer questions in a way that could be matched to a set of animal characters. For "The Circus", for example, we spoke to amateur actors, jugglers, street performers and so on. Although it very rarely happens, we found that the most successful characters start from a voice which sounds like a particular animal. The Posh Horse, for example, immediately came to mind once we had captured the voice on tape, giving us such wonderful lines as: "I think the standard of British food is first class ... somehow clean."

'This time we also introduced a computer-generated character: the Plankton. We wanted to get that look of a microscopic creature that you might see on Open University biology programmes. Because of the way these creatures are built, with tiny tentacles that wave about all the time as it bobs up and down in the water, it was much easier to achieve this effect on CGI than with modelling clay. We were very pleased with this character, and now we want to do an episode called "Micro World" which will feature a cast of germs, cells, plankton and other microscopic bodies.'

The public certainly enjoyed what they saw. When the new 'Creature Comforts' series went out on ITV, it was claiming audiences of up to 8 million, prompting further series.

Shaun the Sheep

We didn't realise how very popular Shaun had become until a little time after his first appearance in *A Close Shave*, and its recognition as a classic short animation film. The way we knew Shaun was a hit in his own right was through the great success of the merchandise. Shaun's instantly recognisable face was to be seen adorning countless shirts and backpacks from Toronto to Tokyo for many years, and it became obvious that Nick's character could easily take on a life of his own

How the model for Shaun conveys cleverness and a humorous cunning while never speaking a word remains a mystery.

But we had to decide on the right format for Shaun. His popularity with children was obvious, so it seemed clear that we should create a children's series around him. At first it was thought that he would fit well into a pre-school series, but as ideas were being thought out, and especially when Richard Goleszowski ('Golly') was asked to take on the creative direction, we realised that a series for older kids would work better. A key element in our thinking was that what made us all laugh and smile would amuse an audience of all ages, and, just as important, it would ensure that the story lines and the characterisation didn't patronise in any way. In lots of ways, it is a family show.

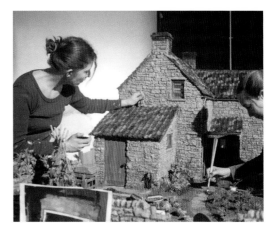

The brilliantly constructed set for Shaun being readied for a shoot. Modelled on countless English and Welsh sheep farms, the dry stone walls are a constant feature.

So then, in classic 'sit-com' style, we needed to think out the setting for Shaun's adventures and the characterisation of the other members of the 'cast'. As Golly says, the key to many sit-coms is the fact that most of the characters have a view of themselves and their reality that is utterly different from the one that others, including the audience see. Thus we have a farmer who is sure that he is entirely in charge and is totally unaware of the wiles of Shaun and the knowing behaviour of the flock of sheep. He is assisted, or thinks that he is, by his faithful sheepdog, but the dog finds himself in a fraught role as the farmer's lieutenant. He wants to please his master, who usually ignores him until the dog's services are needed, and he finds it difficult to assert his authority over the sheep, especially as Shaun works his ingenious plots on the flock. There are noisome neighbours, too, particularly in the form of the pigs, who are none too careful about their habits, and who form a foil to the usually well-intentioned, if none too bright sheep.

It is Shaun, of course, who is the hero. While the sheep eat grass, which is what sheep do, Shaun is the individualist. He is seen, perhaps, as the slightly older, organising child, maybe 11 years old, and some of his ways of thinking arise from the childhood memories of the animators. Aardman's work has often concentrated on characterisation and implausible plots within plausible settings such as, for instance, Wallace's bakery in *A Matter of Loaf and Death*. For Shaun's series, too, it seemed right to set the antics of a flock of sheep on what is clearly a sheep farm in England or Wales. The animals then are basically still playing out variations on what might be a normal role, and this reinforces the strangeness of the plots. The farmer's utterances are non verbal, but they still communicate all his frustrations and bemusements. They seem to do so in what is a regional accent from one of the sheep-farming areas of Britain.

This lack of the spoken word places great demands on visual story telling, but it has paid dividends in just the way it was intended. Shaun and his friends are a big hit on children's networks around the world, and can be understood in any language. Shaun is instantly recognisable, too, and, like so many of Aardman's characters, he blends charm with humour, a winning combination all over the globe.

Wide-eyed at their own audacity the sheep have taken over another reliable prop of British farming, the battered but faithful Land Rover.

Right: The Storyboard for *Off the Baa*

Many of the titles for Shaun's episodes display a reckless love of the sort of puns that schoolchildren have laughed and groaned over for centuries - at least since Shakespeare. Off the Baa is a pun on 'off the bar', a phrase often used by football commentators, and the episode relates the scratch game of soccer played by Shaun and his companions with a stray cabbage. The sheep construct the goal, but in the face of a great shot from Shaun they drop the level of the bar they made, thus incurring the referee's wrath and becoming the only goalposts in the history of soccer to be shown the yellow card!

The sequence of frames shows Shaun lazing on a summer's day, but then demonstrating his ball skills with the cabbage. The sheep saw down a post to construct the goal, but meanwhile the pigs have taken a great interest in the cabbage and construct a gun to capture it. They fail and capture the sheepdog instead, immediately assuming the innocent air and nonchalant whistle that Laurel and Hardy perfected to try to cover their misdemeanours. The sheepdog uses his beloved whistle to assume the role of referee and the goal is constructed ready for the game. Shaun takes aim at the goal, and we once again see a movie reference as his eyes narrow in the time-honoured way personified by all gunslingers from Fonda to Clint. As more play ensues, Shaun is shamelessly tripped and appeals in a universal, wordless gesture to the ref. The 'ball' then goes astray and both Shaun and the baby pig jump after it – both miss, but Shaun lands safely on one of the other sheep, while baby pig makes a rather bigger splash.

Timmy time

There is a classic heist episode of *Shaun the Sheep* in which Shaun leads an expedition into the farmhouse to rescue a toy from the farmer's cat: the toy belongs to Timmy, the baby of the flock. Miles Bullough, Aardman's Head of Broadcasting, had the idea that since Shaun was now so successfully entertaining the older kids, perhaps his initial mission to entertain pre-school children could be taken on by Timmy. He brought in a Creative Development Producer who had overseen an array of successful TV series for that audience, Jackie Cockle. He showed her the model of Timmy, and asked the apparently simple but actually very difficult question: 'Can we make a pre-school series with him?'

Timmy's open face and ready smile create an immediate appeal.

Jackie could see immediately the appeal of the character, and rapidly thought through a scenario for a series: Timmy, of course, would grow older, and he would undergo that inevitable and dramatic rite of passage as he says goodbye to mummy for the first time, and heads for nursery school. The idea is that this event has either happened or is about to happen to the two to five-year olds who are the target audience. And this simple idea is the central element to all the story lines: they are tales that are easy for pre schoolers to relate to of some of the simple events and ideas that children might come up against in nursery, but played out by a range of characters, headed by Timmy.

The characterisation is key to the playing out of each plot, and is surprisingly complex behind a simple look. Timmy is of course well meaning but often over enthusiastic to the point where he finds himself in scrapes. His enthusiasm is shared by his particular friend Yabba, the duck: she talks a lot and shares most

Jackie, nearest the camera, plans the episodes: pinning up storyboards and visual ideas is a working method adopted by most of Aardman's animators.

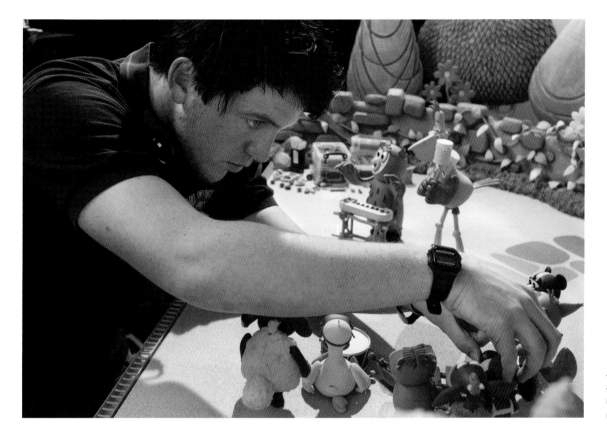

Animating on set;
a full cast of characters
means that each shot often
requires a lot of animation.

of Timmy's enthusiasms. Other characters carry clear character traits, emphasising that we are at just that age when we first begin to map out other's personalities and establish our own. The young ones are watched over by two teachers; the schoolmaster is an owl, while the schoolmistress is what Jackie describes as a 'helican', a cross between a heron and a pelican.

This is not an elaborate setting, but it is deliberately bright, colourful and stylised: a splash of strong colour adorns everything in Timmy's world, even most of the other characters. But it is the strength of the narrative that is the most important element in the series, and the power of subtle animation to

The set's use of bold colours
is emphasised in a snow
scene.

convey feelings and thoughts to the young audience without language. Most of the characters make animal sounds, and the actors are skilled in conveying a range of intonations. This lack of dialogue can be a help in conveying emotions and the story line to the viewer, just as it could be - in some hands - in the days of silent movies.

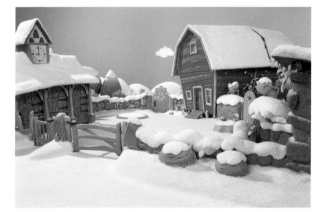

Each ten-minute story is hung around the sort of concern that a young child might have when encountering something funny or strange for the first time. Each plot, such as the story of

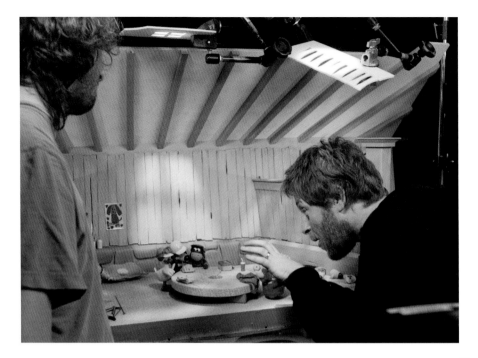

Kid's hiccups, takes the audience with Timmy as he tries to understand what is happening and then sets about resolving the issue, as he does, by accident, in curing Kid's hiccups only to find that he has taken them on himself. The scripts are written by one of a team of writers, and are then broken down into shots by the director and mapped out by one of the storyboard artists as a sequence of shots. The director will look at the storyboard and again edit, mapping out movements and interactions between the characters, and asking for redrawing where necessary. The storyboard is then filmed to become an animatic, a sequence that can be timed and edited further until the director is happy that the narrative will work. This then becomes the visual script referred to by the director, animators and other crew during filming of the episode.

The use of card with cut outs in front of a strong light has ensured that the classroom scene is given the feeling of a sunny day. Timmy and his friends enjoy the sort of good weather that everyone remembers from childhood.

The title sequence to each episode is thought through very carefully: it has to set up the situation by showing Timmy bravely saying goodbye to his mother and setting off for school, eventually leading a happy parade of all the characters to the schoolroom.

The subtlety of the animation is achieved through body movement, facial and hand gestures. The characters are very bouncy just like pre schoolers and the puppets are rigged to enable them to leave the ground and 'bounce' around - this is a strong characteristic of *Timmy time*'s animation style. The models that the animators use in Timmy are not clay, however. They are silicon figures moulded around two types of armature: the arms and the hands use flexible wire, while the legs use more normal jointed armatures. Just as with clay and with CGI, there is a system of replaceable mouths and blinks to speed the animator in changing expression.

The episode in which Timmy's friend Kid gets the hiccups shows Timmy's intention to be helpful, as always. He strives to find a way of ridding his friend of the minor ailment, only to finally eradicate them accidentally by carelessly tossing away a ball that then bursts under a seesaw. The accident is enough to cure Kid, but has alarmed Timmy enough for him begin hiccupping in turn. The frames from the animatic, with the final frames, are from four key points in the unfolding of the story. In the first it is reading time, but Kid is eating his book instead, thus bringing on his hiccups. In the second Timmy is shown in thought, wondering what a solution to Kid's troubles might be. In the third he is trying one of his potential solutions: he and Kid are throwing their heads side to side to make their ears flap violently - they soon realise that this is not effective. In the fourth, although accidentally, Kid's problem is solved, but as he and Timmy are engaged in a celebratory embrace they both realise that Timmy is now afflicted.

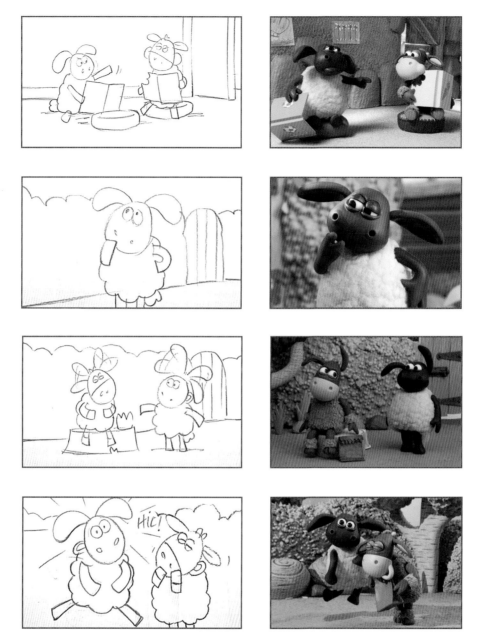

Timmy has been an instant hit: a success made up of a potent mix of Aardman characterisation and animation with a creative producer who has great experience in pre-school programming and a strong sense for the power of narrative in capturing any audience.

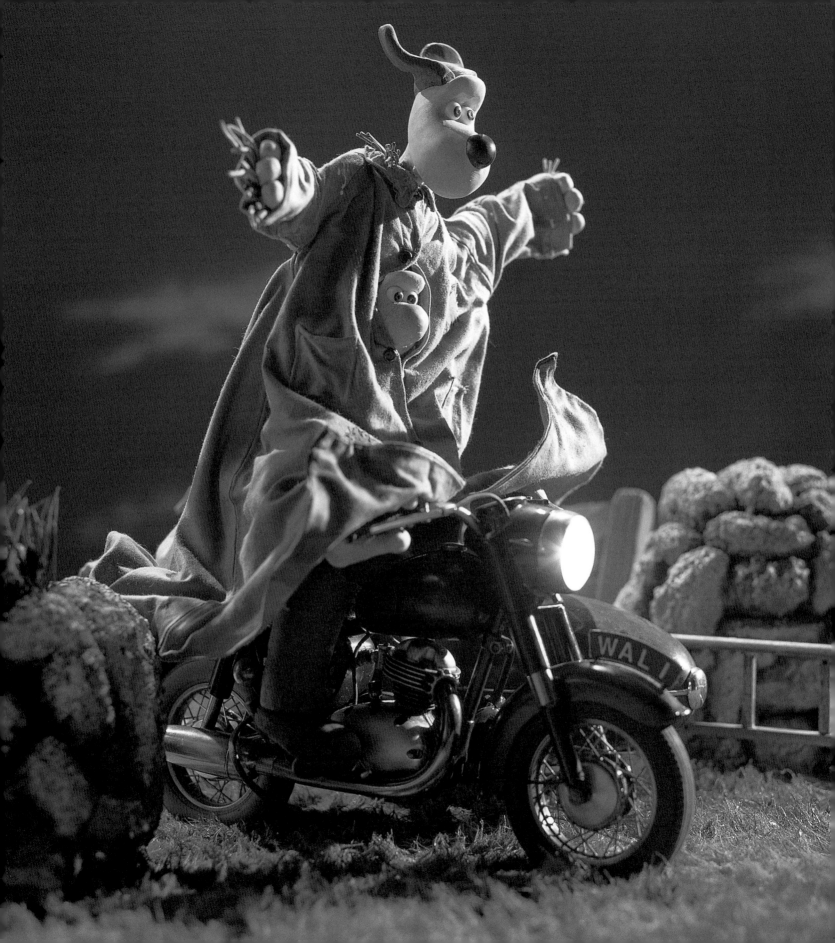

Wallace and Gromit

Nick Park has won three Oscars and two nominations for his films featuring Wallace the inventor and Gromit, his dog. In chronological order they are *A Grand Day Out, The Wrong Trousers* and *A Close Shave*. Here, he describes how Wallace and Gromit came into being and how they have changed during the making of the three films.

'I sketched out my ideas for the characters way back in art school in Sheffield. I resurrected them at film school, and then I had this other idea about somebody - I did not know who - building a rocket in his basement and going to the Moon. I went back to the earlier characters to see if they could build the rocket. Gromit was then a cat, and I changed him into a dog. A dog would be chunkier and larger, and easier to work with in clay. I wrote a script, but this also changed a great deal once we started shooting. Some of the restrictions of working with clay started to dictate their characters.

'For example, Gromit originally had a voice, which we actually recorded. He was also going to leap about a lot and do tricks. At first I did not realise how difficult that would be to animate, but when we came to shoot the first scene I began to rethink the whole character. In this scene Wallace is sawing a door and Gromit is standing underneath acting as a trestle (see page 80). Because he was stuck under there, all I could move was his head, ears and eyebrows. So I did that, and then I saw I could get such a lot of character from just those little movements. This showed me that he did not need a stuck-on mouth as well, so we dropped the whole idea of Gromit speaking. It made a better contrast too, with Gromit now the quieter, more introverted character and Wallace the louder, more outgoing one.

Early sketches by Nick Park of Wallace and (a very different) Gromit.

'I find you can always make economy work for you, even if this is not at first apparent. For instance, it can be harder not to move something than it is to move it. Suppose you are shooting a character with a tail, and now it is eight hours since you last moved it. In film-time this may be only two seconds, but you can still get very impatient because you have not moved it. You have to watch this, otherwise your tail will be wiggling about the whole time and distracting the audience from the main character.

Wallace and Gromit - an unlikely but unbeatable combination. Wallace the loud one, the man in command, the eccentric inventor whose machines are never totally under control. Gromit, quiet, dependable, with much more sense than his master.

'As for the relationship between the two characters, this is still evolving. I am not one of those people who feels he has to know everything about his characters before shooting. People ask me questions like "What would Wallace buy Gromit for Christmas?" This is something I have never thought about, so I do not know the answer. I have not got there yet. I almost feel that they have their own life, so really I would have to ask them about it.'

207

Creating a Storyboard for *The Wrong Trousers*

Nick Park and Steve Box plan the scene where Gromit hides in a cardboard box to spy on the Penguin, and carves out a viewing slot like a pair of binoculars. On the wall, the storyboard shows the view from inside the box and from the Penguin's vantage point.
Right: Character sketches by Nick Park.

The storyboard can be a very exciting stage, the place where a film starts to come to fruition after all the preliminary work. Usually, one drawn storyboard picture represents one event in a shot. Some shots may contain two or three events, and if so we represent them all. We prepare the storyboard piece by piece, or scene by scene, then pin the sections on the wall to see how they fit together. The act of drawing the frames really helps you to grasp the story and get it into your head.

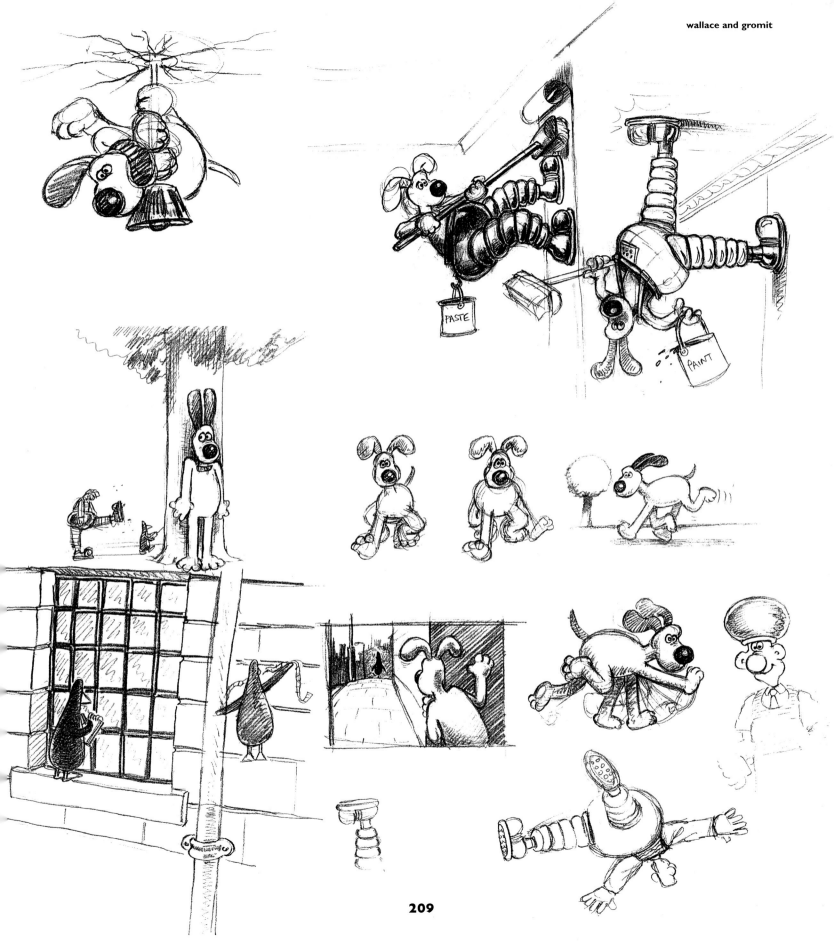

Sc 65. Shot 3. INT. DINING ROOM. NIGHT.

GROMIT CROSSES PENGUINS TRACK,
PENGUIN ABOUT TO COLLIDE WITH TRAIN.



Sc 65. Shot 3. INT. DINING ROOM. NIGHT.

GROMIT CROSSES PENGUINS TRACK,
PENGUIN ABOUT TO COLLIDE WITH TRAIN.

Sc 65. Shot 3 continued,

WALLACE TRIES TO GRAB PENGUIN,..

Sc 65. Shot 3 continued,

...BUT PENGUIN TRUNDLES ON ENGINELESS.

Sc 65. Shot 4. INT. DINING ROOM. NIGHT.

WALLACE HAS GRABBED THE ENGINE

TRACKING SHOT.

Sc 65. Shot 5. INT. DINING ROOM. NIGHT.

GROMITS TRAIN CURVES AROUND TO COME
UP PARALLEL TO PENGUINS TRACK..
GROMIT RUNS OUT OF TRACK AND DISCARDS
THE BOX. TRACK WITH PENGUIN.

Sc 65. Shot 6. INT. DINING ROOM. NIGHT.

PENGUINS P.O.V. TROUSERS STEP ON HIS
TRACK. (WERE HEADING FOR KITCHEN)

TRACKING SHOT.

Sc 65. Shot 7. INT. DINING ROOM. NIGHT.

PANICKED PENGUIN TRIES TO BRAKE AND
WALLACE AND GROMIT OVERTAKE.

TRACKING SHOT.

Sc 65. Shot 7. continued.

TROUSER FOOT COMES DOWN ON THE TRACK.
PENGUIN GOES FLYING.

Sc 66. Shot 1. INT. KITCHEN. NIGHT.

WALLACE REACHES UP TO GRAB PENGUIN.

TRACKING SHOT

Sc 66. Shot 2. INT. KITCHEN. NIGHT.

GROMIT ANTICIPATES A CATCH.

TRACKING SHOT.

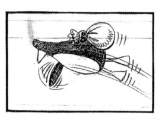

Sc 66. Shot 3. INT. KITCHEN. NIGHT.

PENGUIN SAILS THROUGH THE AIR.

TRACKING SHOT.

Sc 66. Shot 4. INT. KITCHEN. NIGHT.

GROMIT SMASHES INTO KITCHEN UNIT CUPBOARDS.

TRACK THEN STOP.

Sc 66. Shot 5. INT. KITCHEN. NIGHT.

THE CRASH CAUSES A BOTTLE TO TOPPLE
OFF THE COUNTER.

Sc 66. Shot 6. INT. KITCHEN. NIGHT.

PENGUIN DESCENDS TRY TO FLY ? ONE
WING.

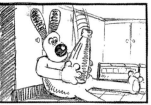

Sc 66. Shot 7. INT. KITCHEN. NIGHT.

BOTTLE LANDS IN GROMIT LAP....

Sc 66. Shot 7 continued.

..PERFECTLY POSITIONED TO CATCH THE
PENGUIN AND THE DIAMOND.
"ATTA BOY GROMIT LAD!"

Sc 66. Shot 8. INT. KITCHEN. NIGHT.

WALLACE SLIDES INTO FRAME:
"WELL DONE! WE DID IT!"

Nick Park: 'This sequence in *The Wrong Trousers* was the first one we storyboarded. Even before we started writing the script, I storyboarded this whole sequence - and we stuck with it. Sometimes scenes change a lot, either when we shoot or in the cutting room, or they may be dropped entirely, but we managed to keep this one. It was edited down quite a lot, but the essence of the storyboard is still there.'

Creating a Storyboard for *A Close Shave*

Nick Park: 'We had less time to storyboard this film, so we tended to skip events and represent the shot in just one frame. I roughed out what we wanted and then Michael Salter, who was working with me, drew up the frames more elaborately. With most films we do the storyboard after the script has been written, so we already have a clear view of what we are going to do. The storyboard helps us to refine that view and put the words into a coherent visual form.'

The storyboard frames show **Gromit flying in to attack Preston. In the completed version, right, he then opens fire with the porridge gun before Preston manages to get his paws on the propeller.**

Wallace and Gromit come of age

With two Academy Awards and a nomination behind them, it seemed obvious that Wallace and his dog were ready to become the central characters in a feature film: *The Curse of the Were-rabbit*. Their character development through the previous films was subtle, but clearly allowed Nick and his colleagues to build a bigger and more complex script around them. The plot revolves around a very British institution: the prize vegetable show, and is set in the townscape 'somewhere up north' that has become familiar to us as Wallace's home.

From the first shots of the title sequence, however, it is clear that we are dealing with something dark. As always with Wallace and Gromit it is the language of film that engages us: the first shot after the titles is that of a heavy boot crunching on wet cobbles. As the camera pulls back we see that it is a constable on his beat, the music suggests something sinister and for a moment he hears something. A shadow passes unnoticed. The good constable, who is, of course, a cheery comic character in the Ealing tradition is oblivious, but we know….

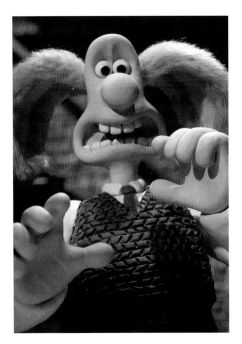

Left and far left, below: As *The Curse of the Were-rabbit* opens we are on a darkened street where fleeting shadows go unnoticed by the bobby on the beat, and menace is immediately suggested

Above: Fear and dismay are all too apparent in Wallace's face as he begins to realise that terrible transformations are happening to him: Nick Park's original drawing is beautifully realised in the frame.

Below left: Wallace and Gromit share the horror in a scene reminiscent of a television horror classic, Quatermass.

Throughout the movie, the language of cinema is employed to tell us when we should be wary, when we should be gleeful. There are quotes from many movies: alongside the Ealing comedies, there are references to the darkened shadows of 1940s film noir and to more recent Hollywood thrillers, particularly *An American Werewolf in London*, with its potent mix of comedy and the quasi-horror of a character's helpless transformation into a monster. Perhaps the most subtle moments occur when it is first gradually revealed that a tormented Wallace is somehow trapped within the Were-rabbit.

As with any British comedy there are a number of 'character actors': the vicar, in particular has several roles to play from the comic to the sinister, with his religious role reminding us of the vogue for spiritually based horrors like *Omen* and *The Exorcist*. In this film, Wallace and Gromit are also joined by other full-blown characters: sketches of the female lead and her villainous suitor existed, but the full characterisation of the two parts awaited the lengthy casting process and the appearance of Helena Bonham-Carter and Ralph Fiennes, keeping within the long Aardman tradition of using the voice as the final basis for the full characterisation.

Nick's decision to use fur for the Were-rabbit became a technical problem calling for lots of creative solutions. As this book has made clear, stop-motion requires endless tiny adjustment to a character as it moves, and fur, of course, refuses to hide the fact that it has been touched. So a lot of ingenuity went into devising hidden handles for manipulating the puppet, and special fur had to found, on which much advice was sought. The effect was just as Nick wanted.

Nick Park received an Oscar® for *Were-rabbit* in 2006, and Wallace and Gromit's next excursion in a TV short called *A Matter of Loaf and Death* received yet another nomination. For the first time, the duo were shot on digital cameras (in fact *Were-rabbit* had been Aardman's last film-based project). After a brilliant sequence of fast-moving shots showing Gromit working hard in the bakery while rousing Wallace from his slumbers in the usual mix of over-complicated mechanics we are introduced to the murderess in a sequence that melds Indiana Jones with a famous advertisement for wholemeal bread. While there are a lot of great visual jokes in this film, many of them reminiscent of the days of silent comedies, both Wallace and Gromit also have to come to terms with a love interest. It is telling that their characters and their range of expression are up to the task: they have come a long way from *The Wrong Trousers*.

Right: Preparing the central scene in *A Matter of Loaf and Death*, in which Gromit comes to realise Wallace's peril as he stares at the terrible shadows in Piella's bedroom.

Bottom right: Two frames showing moments of high emotion for Wallace and Gromit as they grapple with love. Wallace has built a bust of Piella in dough and stares dreamily into space, while Gromit is clearly engaged in very meaningful eye contact.

Below and left: The initial characterisation of Lady Tottingham and its realisation as she towers over an awe-struck Wallace, together with a very early sketch of Victor and Philip as they are threatened by the monster.

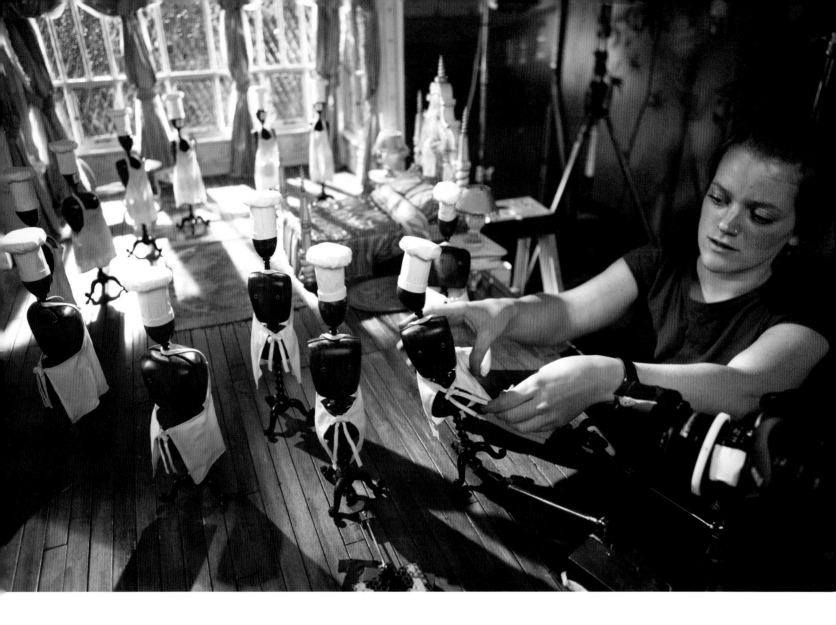

Opposite: Ginger in the escape tunnel, pulled along on a roller skate and clutching her digging equipment - a kitchen spoon.

Right: Rocky in 'flight'.

Below: Co-directors Nick Park and Peter Lord burst into fresh air from the tunnel, demonstrating the massive scale of the set, where the chicken huts were each as big as Wallace's entire house.

Chicken Run - the Challenge Peter Lord

When faced with the prospect of making our first full-length feature film, we looked back at our past productions to calculate how long it would take, and what kind of crew we would need. The maths looked deceptively simple: a feature film is three times as long as our last thirty-minute short film, so we'd just multiply the time, the crew and the cost by three. Oh, and double it for safety. How far wrong could we be? Well the answer is: very. In longer-form films, every part of the process seems to grow exponentially, and provides you with huge problems of scale.

A Close Shave is thirty minutes long, and the total crew consisted of about thirty people, six of whom were animators. On *Chicken Run*, which is eighty minutes long, the number of animators grew to 34 and the crew to about two hundred. On that kind of scale, you can't just operate by common sense and instinct; you can't expect everyone on the crew to understand the bigger picture. You have to set up structures and systems to communicate your wishes to the whole team.

Nick and I both come from a background where basically you do everything yourself. When you start out in stop-frame, you're liable to be writer, director, animator, model-maker and caterer as well. As you gain experience, and take on bigger projects, you learn to delegate more of the processes, but instinctively you still feel the same way you always did. You still believe you can do everything yourself. The trick is to find a system that gives you all the control you need, without burying you under a mountain of work and drudgery.

We started with a terrific germ of an idea: we'd do a prisoner-of-war escape film - with chickens. We were happy to create the story by ourselves, but knew we would need a writer to dramatise it and write the screenplay. Nick and I spent a whole year kicking the idea around, shaping and re-shaping the story. I found it was helpful to map the plot out by pinning cards to a wall. It allows you to play with ideas and the ordering of events, and it keeps the whole story graphically in front of you. Otherwise you can easily end up with a muddled soup of ideas in your head.

It's surprising how few POW escape movies have been made, and we must have watched them all in our search for inspiration. In addition I'd been a big

fan, as a schoolboy, of thrilling escape yarns like *The Colditz Story* and *The Wooden Horse*, so we quickly worked out what ingredients we wanted in our film. We decided we must have a tunnel escape at some stage; the good guard and the bad guard; a strong prisoner and a weak one, and a grumpy one; watchtowers, searchlights and dogs, of course. We were also influenced by *Stalag 17*, an American film with William Holden, in which there's a traitor in the camp. We loved that idea, and for ages we tried to incorporate into our story a crooked chicken who was selling the others out to the farmer - a sort of stool-pigeon chicken. We tried dozens of different ways of twisting and turning the plot to fit this in, until eventually, regretfully, we threw the whole idea out.

In our early attempts, the film used to open with the chickens not in captivity, but living happily on an idyllic, free-range farm. Following a comic catastrophe, they all got arrested and sent to Tweedy's Farm for punishment. We also had a huge, elaborate escape at the end involving farm equipment and a cannon, which we reluctantly abandoned. Between them, these ideas would have doubled the length of the film.

Of all the ideas that you take very seriously at the story stage, only about five per cent ever end up in the finished film. Not just jokes but whole set pieces and crucial characters are tried and then rejected. Even your central characters change and evolve. Rocky, in particular, went through all kinds of metamorphoses until he reached his final version. As a way of working, I don't actually mind this, but it is very greedy of ideas.

Early on, we were writing down versions of the film that, conservatively, were three hours long - great rambling storylines which make what finally appeared on the screen seem almost minimalist. We were probably still at the three-hour stage when we called in our screenwriter, Karey Kirkpatrick, whose job it then was to tell us gently that we could not possibly film our present story in the time allotted, and to encourage us to cut things down and simplify.

Once Karey had delivered a first draft of the script we started storyboarding -

chicken run

which is really another form of writing, only this time the ideas are visual. When you create the storyboard, you begin to direct the film. The choices you make - where and when and why to cut, when to use a close-up and when to go wide, why to move the camera - are all directorial decisions. It's also quite cheap to make those choices at this stage, working with just a pencil and paper, whereas it's very expensive to make them later. Nick and I storyboarded as much of the film as we could, then we had to take on other people to help us.

One thing that completely took me by surprise on *Chicken Run*, was how often the storyboarding was rethought and redone over the life of the movie. When you make a short film, and you do the storyboarding yourself, it's relatively easy to hold the whole film in your head. There's a good chance that a lot of your first storyboard will stay in the film. It's much more difficult to hold all of an eighty-minute movie in your head. Of necessity, you divide the film up into shorter, manageable sequences. But there's a big danger lurking here, which we call Sequencitis. You refine and polish a short section of the film - perhaps three minutes long - but later you find you haven't paid due attention to how it fits in with the rest of the film. Because of Sequencitis, and because the story is continually evolving, you end up storyboarding the whole film many times over.

After storyboarding, we then make a story-reel, which at its simplest level is a filmed and assembled version of all the storyboard drawings. The idea is to make a 'sketch' of the whole film, partly to explain the film to other people and partly so that you understand it yourself! To make it readable you have to put in many more drawings than there are in the storyboard. If, for example, the point of the shot is to show someone opening a door, you need to draw the door first closed and then open. It's not animation, but it should give a clear impression of what is happening in each shot, and how long the shot is going to be. As well as the visuals, we add the dialogue using temporary voices. Various

Assorted chickens with domestic implements and a chicken feeder - more miniature marvels from the Modelmaking department. On the right, Mr Tweedy upends Ginger, here destined for the pie machine. For this scene, the scale problem was solved by pairing a standard 12 in (30 cm) Mr Tweedy with a miniature Ginger.

221

**Key animator Sergio Delfino
animates Ginger and Rocky
on one of the studio's thirty
autonomous shooting units.**

members of the studio staff stand in for the real
actors - and some of them are surprisingly good.
It brings out the inner thespian in all sorts of
surprising people. We also put in a few key sound
effects, and a temporary music-score.

Ultimately, you do all this so that when you start
the shooting process you are as certain as you can
be that you are filming exactly what you need. In
the happy world of live action, it's a simple matter
to film several big wide covering shots of each
scene, and go in and shoot all the close-ups as well.
Then, when you go into the editing room, you have a huge range of choices,
maybe twenty minutes of film which you edit down to one minute. In animated
films, however, we will have maybe one and a quarter minutes of film to edit
down to one minute. Our filming process is very time-consuming, and this
drives us not to waste anything, which is why we try to make all the story
decisions before we shoot. To me this is one of the most difficult parts of
animation, but without this system or discipline we would not be able to
function properly.

Once the story-reel is complete, or as complete as we can make it, the actors
record their parts and we finally get to the shoot. On *Chicken Run*, the
challenges were endless. Our kind of animation is quite like a live performance
in that you only get one go at it. You can shoot second and third takes of a
shot, of course, but that may take a day, or days, and we don't have that kind
of leeway in our schedules.

It's interesting to compare our way of animating with the CGI process. Take the
example of a single shot that lasts five seconds. In the CGI world, an animator
can block out the whole shot very roughly. First he creates key frames - the
important poses he wants to hit within the shot. Then he can animate the
whole shot roughly, and see how it's working out; perhaps the timing was
wrong, perhaps the key-frame positions weren't exactly right. So the animator
makes changes to any part of the shot - front, middle or end - and then
animates again. And again. In this way the animator is constantly reviewing,
refining and improving. In contrast, the stop-motion animator blocks a shot out
roughly, by way of rehearsal - and may indeed shoot the whole shot quickly as
a rehearsal, but for the final shot, the animator only has one go. He starts with
the first frame of the shot and ploughs on to the end. And though you may
have the clearest possible idea of what the end is going to be you simply can't
be certain until you get there. It's real, it's spontaneous - each step is an

Above: Mrs Tweedy at her most menacing. For this shot, the puppet was placed on elevated rigging to make her loom over the assembled chickens she is leering at.

Above right: The ostrich stratagem. Chickens leg it for freedom under the dubious cover of a drinking trough.

experiment, and you can only check if it's right by going onwards. You can't go back. CGI animation is all about refining and revising, whereas stop-frame animation is all about getting it perfect at the first attempt.

When *Chicken Run* was going full-pelt, we had thirty different 'units' in the studio at the same time, each working on a different shot of the film. On a typical day, ten units would be in preparation - the cameras were being set up, the models being adjusted and so on. But the other twenty units were shooting. Each set was a small self-contained studio with an animator, a camera, set, puppets and a full lighting rig. Nick and I divided the film up, and each of us was responsible for directing on fifteen units every day. We had to check the lighting, the camera move, the timing and above all the performance; and to make sure that when the film was finally completed people would not be aware that it was shot on so many different units by thirty different animators. Compare that with a live-action film where there's basically only one unit shooting at any one time. There may be a second unit filming landscapes or pick-ups somewhere else, but no more than that.

To make it even more difficult, on any given day there might be fifteen different animators all animating Ginger, the one character, and trying to make it look like one performance. Imagine a feature film with fifteen look-alike actors all playing the same role. Meanwhile, Nick and I were running round the studio like lunatics (highly disciplined lunatics) and on each set we had perhaps fifteen minutes to say our piece and then rush on to the next one. It was a mammoth operation, and extremely tiring as well. This is what I meant originally about the challenges being exponential. The bigger the film, the more there is to charge round and control. That is why it was so essential for each unit to have similar, interchangeable equipment such as the light-tight cameras which Tom Barnes describes in the next section.

Our largest set was a wide view of the whole farmyard with the Yorkshire Dales beyond. One particular scene shows Mrs. Tweedy inspecting the chickens

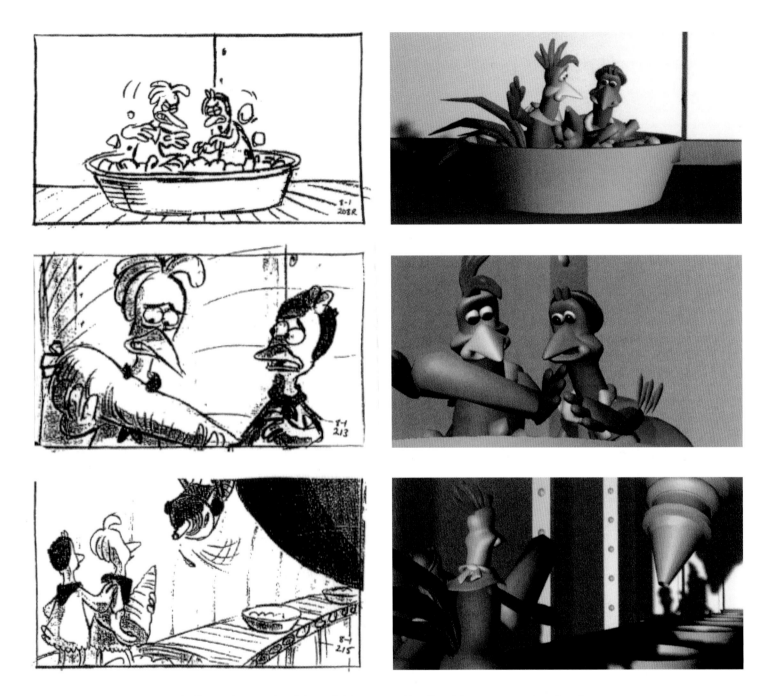

in the early morning. A huge light, representing the rising sun, was placed as far away from the set as we could get it, the idea being ideally to light the whole set with one enormous light-source. The sky itself was a gigantic painting some forty feet (12 m) wide and twenty feet (6 m) high. All the chickens were lined up standing at attention (though incidentally it's very rare in real poultry-farming to hold a roll-call for chickens). In the animation, Mrs Tweedy marches along, then turns to say something to the chickens. On her turn we cut to a close-up of her. That close-up might be shot three months later on a very small

Storyboard version and corresponding CGI visualisation frames of Ginger and Rocky trapped on the conveyor leading to the maw of the pie machine.

Ginger and Rocky on the belt of Doom. The pie machine, a descendant of the Mutton-O-Matic in *A Close Shave*, was based on the sleek, shiny industrial designs of the post-war period.

set, with a different sky, and a different light representing the sun. So everything is different, and it's the job of the DoP to make sure the audience don't think the two shots were filmed three months apart. And it's the job of the animator to pick up the exact speed of Mrs Tweedy's turn - the turn of the head and the shoulders - so that it all looks seamless.

Where you've filmed the wide shot first, that becomes a 'master shot' that sets the look for the entire scene. Sometimes, annoyingly, you are forced to shoot the close-up detail before the wide shot. Then you find yourself in the ridiculous position of establishing the look for a whole scene through a quick close-up shot. It's much more difficult to match a wide shot to the detail than the other way around.

Despite our best-laid plans we didn't finish the storyboard, or the story-reel, before we started on the shoot. In the mornings we'd direct the scenes that were being shot on the studio floor, and in the afternoons we'd have to work on the story-reel, which was constantly evolving as we shot. In an ideal world, you'd complete the storyboard and the story-reel, and only then would you start shooting the film. But in reality, these processes were always overlapping.

Right: Key animator Suzy Fagan working on a scene in which only Mr Tweedy's legs and boots appear. This is the large 3 ft (90 cm) version of Tweedy, awful to animate but OK for more static shots.

Far right: Working with the standard 12 in (30 cm) Mr Tweedy.

We were still working on storyboards and the story-reel when the film had only three months left to run.

We were still recording the actor's voices as well, much to their amazement. An actor might imagine that once the big up-front recording session is over, their work is done. They'd be amazed to be asked back eighteen months later to re-record a scene which didn't seem to have changed substantially. They'd say 'But didn't we do this a year ago?' and we'd say, 'Yes, we did, and we're going to do it again'. Over months the scene gradually evolves and requires slightly different dialogue to make it perfect.

Another thing we learnt about shooting a feature film is that the number of puppets you need is massive. A star like Ginger will appear on pretty well every set, so you need thirty separate versions of her and maybe twenty versions of Rocky. That's something you can plan for, but there was also a huge cast of background chickens. A prison camp, or a chicken coop for that matter, is a crowded place. There would naturally be a lot of 'extras' in many scenes. Somehow, you always needed ten chickens in the background. That was OK; Nick and I liked having lots of chickens around. Sometimes, however, I'd get to the set and say, 'So where's my crowd of chickens?' And be told, 'There's no chickens left. Nick's got them all.' So then, lacking whole chickens, you'd end up with heads on sticks, in the foreground or bobbing about in the extreme distance of a crowd shot. There were never enough chickens to go round.

Then there was the scale problem. Ginger's puppet is very much the same classic size as Wallace, about ten inches (25 cm) high, which is comfortable to handle and animate. However, Wallace is meant to be a human being, so he is about one-sixth scale, but Ginger is a chicken so she's one-half scale. This means that the whole world around her has to be in half-scale too. The huts, for instance, had to be much bigger (and heavier) than our usual models; they were about five feet long (1.5 m) and two feet (60 cm) high - great hefty things the size of Wallace's whole house. Then we had to have human puppets interacting with the chickens. To be in scale, the human puppets would have to be about three feet (90 cm) tall, which is the animator's nightmare. We did make a Mr Tweedy that size, but it was awful trying to animate him and we soon gave up trying. We had to find another way, and in the end we decided to

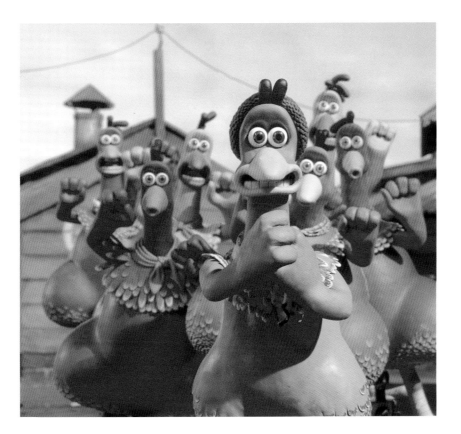

Ginger's fears are echoed and magnified by a chorus of supporting chickens, part of a huge cast of 'extras' which ran into the hundreds.

operate on two different scales. The main Ginger puppet was 10 inches (25 cm) tall and Mr Tweedy was 12 inches (30 cm) tall, which on the face of it is ridiculous - you can't have chickens the same size as humans. So we had to build miniature chickens to go with the humans. These matched terribly well with the others, so well that I almost can't spot it myself.

There were also two classes of chickens, the ones that moved and the 'crowd chickens' that did not. For a big roll-call scene, where all the chickens were lined up, we had about three hundred miniature chickens, most of which couldn't move. This didn't matter much because it was a roll call and they were meant to be standing to attention. To make it realistic, we animated every tenth chicken, so they moved their heads round while the others stood stock-still. For special scenes we made big Tweedy hands to grab Ginger round the neck and big Tweedy boots to kick her into the gate. But those big models were terrible to use.

We got there in the end. After months and years of intensive work, by hundreds of highly talented people we finally got to the last shot, and the film was done, complete. One particular worry that remained was how our characters would look when magnified on cinema screens. After all, Ginger's head is only two and a half inches (6 cm) high, and if you take that and blow it up on a big screen in a big close-up, would it still look good? But I'm happy to say the puppets held up beautifully. If anything, we felt they looked rather too smooth and perfect so we plan to move back towards the handcrafted look in our current project, the new Wallace and Gromit movie.

Editing

Helen Garrard has edited many films for Aardman. Here she explains how the process begins.

'My first task on a film is to supervise the soundtrack. I am given a storyboard, and a script if there is dialogue in the film, and then I go to the dialogue recording. At Aardman, which is famous for its closely synchronised dialogue, we record the dialogue before any filming takes place. We come back with all the dialogue, choose the best takes and edit them down to a final version. It can be spaced out later, if necessary, but the essence of it is there. We then break down the dialogue phonetically and mark this on a series of charts. The animators work very closely to these when they match the movements of the characters to what they say. From the charts they can see the position of the mouth on each frame.'

Although much of Aardman's work is still shot on film, they now edit on computer using systems such as Avid or Final Cut Pro. The film material is transferred to tape on a regular basis during the shooting period (which lasts many months on a full-length feature film), and this is then loaded into the computer editing system, where the editor assembles the shots and does a 'rough cut', which at this stage is quite loose. The editor then works on tightening this edit, and often adds basic sound effects and music which can be done much more easily on a computer system than with the old method of cutting the actual film. This helps the director to see how a sequence is playing emotionally, even though all the sound components may

Capturing the right mood for title-sequence lettering:
a theatrical type for *Stage Fright,* and a rough-edged thriller style for *The Wrong Trousers.*

be replaced with specially created effects and music at a later date.

Computer editing also allows the editor to try a number of different versions of an edit and to keep them for comparison. This is simply not possible with traditional film editing. The systems also allow more than one editor to work on the material at the same time, which for a feature-length film is a huge advantage.

As the film takes shape, the composer is brought in to start work. Initially they compose themes and ideas; only when the picture has been finally edited can they begin putting music to the film in earnest, accurately matching cuts and pace to the music.

Similarly, 'track laying' also starts, although many aspects of the 'sound design' (for example how a certain contraption might sound, or the atmosphere a certain scene might need) will have been started much earlier. Again, computer systems are now used extensively for this process, and an almost infinite number of tracks can be laid. The sound editor can do 'mini-mixes' to assess how all the components will go together before the final mix happens many weeks later.

In the meantime, the film material itself will have been digitised to a very high quality and work started on any visual effects that need to be applied. Eventually, these film files are assembled to match the cutting copy in the computer editing system, and are printed back to film for cinema release. Although the laboratories will still need to be involved in the colour grading of the final release prints, the detailed grading that needs to be done for each sequence is now carried out beforehand on computer, allowing the director of photography to make much finer corrections than can be done in the film laboratory.

Sound

Adrian Rhodes is a specialist sound editor, or sound mixer. He has been responsible for the sound on a large number of live-action films as well as Aardman productions. Here he discusses his role.

'My job is to create sounds rather than to record them. I am not usually involved in the dialogue recording, but come in after about half the film has been shot and edited into a rough cut. At this stage I go through the material with the editor and the director, and then I can start to build up the sound effects that will be needed.

'Take the lorry in A Close Shave. In the beginning, I want to get the concept right, so I work on assembling appropriate lorry sounds that can be stretched or edited down later when filming is completed. I supply all the sounds needed in the film, not just the big ones like lorries or aircraft but also every footstep, rustle, or the noise that someone makes when they put their glasses down on a table. These little sounds are called foley or footstep sounds, and making them is specialised and highly skilled work. I work with a foley artist, who comes into the studio and acts out or makes up the sounds - walking along to the action pictures, for example, to provide the sound of footsteps. On the studio floor there is a panel of different surfaces - paving stone, floorboard, tarmac surface, etc. - which he can walk or run on to get the right sound.

At the mixing desk for the final mix, when all the sound components are brought together and balanced out.

'With animated films, one of the important things to remember is that real sounds, ie those directly imitated from life, can often seem out of place or unsuitable. If you want an exterior sound of tweeting birds, for example, it is probably not a good idea to record real birds in a garden. This is because the characters in the film are not real but clay creatures living in their own fantasy world, and so the sound of real tweeting birds may not sit well on the film. For the Penguin's feet in The Wrong Trousers, it would have been a mistake to record a real penguin flapping about. Instead, we got the foley artist to do it, and his solution was very simple: he just slapped his hands on his thighs to the rhythm of the walk.

'One of our most complex scenes, from the sound point of view, was in the cellar in A Close Shave,

after Preston the dog had turned into a robot. The Preston sounds alone took up more than twenty different tracks, with different sound combinations for his head movements, feet, the roar, and so on. Also in that sequence there were several other elements - the conveyor belt, the machine that chews up the robot, the sheep, etc. What you can then do is focus on one particular element, building up the robot, for example, until you have got him working, and then you can mix all his separate tracks down to something more manageable, put them on one side and then focus on the sheep, and do the same for that character. This is what we call the premixing stage, where all the sounds are assembled and then mixed together so that, when we come to the final mix, all the sound components of the film have been reduced to the three strands of sound, dialogue and music. For the final mix we go into a big studio and all sit there together - the director, editor, sound editor and composer - and work through everything until we get the balance that we think is right.

'I would encourage anyone starting out to make films to try and get in as much sound as possible. Sound brings a film to life, and even the tiniest details can play a part in this, helping to make your film better and more believable.'

Penguin finally brought to book in *The Wrong Trousers*. Creating an artificial sound for his walk was far more successful than trying to use recorded natural sounds.

Music

Julian Nott composes music for film and television productions. He has written the music for several Aardman films, and here describes how he works.

'The composer can come in at various times, depending on the kind of film and the preferences of the director. In animated films, the music may be needed first if the film is dependent on a song which has to be written before anything else can be done. In more story-led films, I prefer to come in at the end when the editing is finished and I can write music to the pictures.

'This means you probably do not have much time, perhaps three or four weeks for a 30-minute Wallace and Gromit film, but at least I can be as certain as possible that the film will not be changed. If someone decides to change the cut, the composer often has to start work all over again. There is always the temptation to try desperately hard to change what you have already written to fit the new cut, but this never really works and so it means starting afresh.

'On most occasions I see rushes on a big screen, and when the film is finished I get a videotape to work from. At this time I have a meeting with the director, and he or she tells me what in general they are hoping to do with the music, and then we go through the film in more detail to decide where the cues should start and end.

'I take away the video, which has a time-code on it. This is a computer code which is on one of the audio channels of the tape. I can then lock all my computers and machines and instruments on to this time-code and write the music very specifically to each second of the film.

'When I have written a certain amount, I demo it to the director. Nowadays we have a lot of technology to help us, and even at this stage we can demo an orchestral score, using synthesisers which can make an accurate representation of the real instrument. Once the composer gets the final OK, he really has to work fast. With an orchestral score there is not time for him to do the orchestration and the parts copying for all the members of the orchestra. On *A Close Shave*, for instance, we had some 65 musicians in the orchestra and about 25 cues. That means providing the musicians with 1625 sheets, all of which have to be written out for a particular instrument. To cope with this, I sketch out the music and bring in an orchestrator, and he does the detailed orchestration for me. When the parts come back, someone books a studio and arranges for the musicians to come in.

'Many film directors and producers feel quite overwhelmed when they hear the music being played for the first time against their pictures by a full orchestra. It is such a powerful sound. Once we are recording, it is very difficult for the director to make changes. In animated films, people do not have the kind of budget where you can waste time and keep 65 musicians hanging around while you change the music. When all the music is recorded, we mix it and then it goes off to be track-laid against the pictures. The composer may or may not be involved with this, but he will probably go to the final mix, where all the sounds and music are balanced and the film is then ready to go to the final print.'

Julian Nott's sketch for the beginning of the motorbike chase in *A Close Shave*. Sketches such as this go to the orchestrator who works out the orchestration in detail and prepares the parts for the musicians.

A high-point from the motorbike chase in *A Close Shave*, which is accompanied by suitably heroic martial music.

A Career in Animation

With the development of animation in all its forms, and especially with the advancement of CGI, the animated film business is becoming an increasingly popular career choice. Although this makes the field highly competitive, it also provides the opportunity for those with real passion and enthusiasm to shine. Dedication is essential as jobs are limited, and anyone wanting to succeed will need to do plenty of research. Watch television, see films, go to events such as festivals and exhibitions, try to make personal contacts within the industry, and keep up to date with the relevant trade and technical press.

Although it is not essential to have completed a course at art school or film school, it is immensely helpful and is often desirable to employers. Very often people find their individual style during those years. For instance, most of Aardman's really successful directors - including Nick Park - laid down the foundations of their career in their student days. There are a number of courses available covering most aspects of animation: more information can be found online. Seek advice about the most appropriate course for what you're interested in.

Whether you have a traditional animation background or not, the most important asset for an aspiring animator is their showreel. When compiling a showreel, be creative and original, put your best work first and make sure your reel stands out. Remember that film companies will be looking for examples of your animation skills as well, so include a segment that demonstrates walk cycles or stretch and squash moments. Further guidelines can be found on the Aardman web-site. Remember too that all animation companies will have their own submission policy.

It is important to define what kind of work you are best suited to, developing your own style and individuality and considering which areas interest you most. There are a huge variety of jobs available and a career in animation does not necessarily mean directing films or being an animator. Aardman depends not only on well-established film craft skills - storyboard artist, scenic artist, cameraman, producer, modelmaker, set designer, technician, editor, and many more - but also skilled computer technicians who operate motion-control systems or support CGI software, engineers who design and manufacture specialist camera equipment as well as many of the traditional support roles you find in companies - accountants, chefs, site managers, and so on.

Whatever your age or experience, you can find all Aardman's most up-to-date guidelines, information and opportunities at: www.aardman.com.

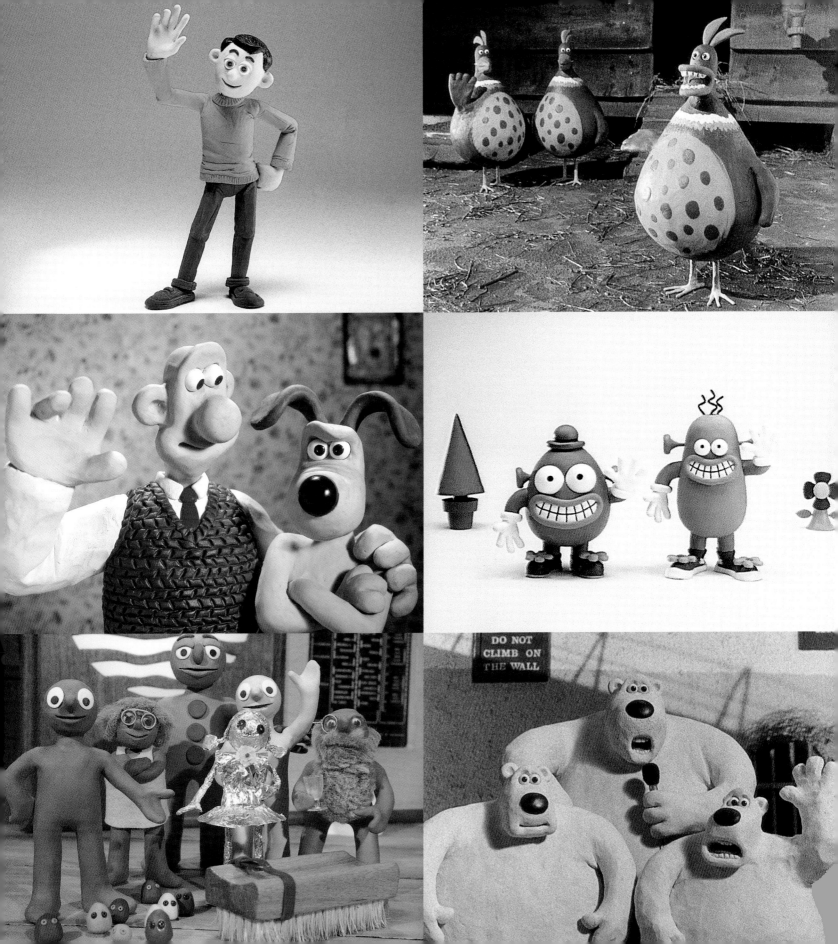

Filmography

D/A = Direction and Animation
D = Direction; A = Animation

Feature Films

2000
Chicken Run
D Peter Lord & Nick Park

2005
*Wallace and Gromit: The Curse
of the Were-rabbit*
D Nick Park and Steve Box

2007
Flushed Away
D David Bower and Sam Fell

Short Films & TV Series

1978
Animated Conversations
'Confessions of a Foyer Girl' and
'Down and Out'
D/A Peter Lord & David Sproxton
5 mins each

1981-83
The Amazing Adventures Of Morph
- 26 episodes
D/A Peter Lord & David Sproxton
5 mins each

Conversation Pieces
'On Probation', 'Sales Pitch', 'Palmy
Days', 'Early Bird' and 'Late Edition'
D/A Peter Lord & David Sproxton
5 mins each

1986
Babylon
D/A Peter Lord &
David Sproxton
14 mins 30 secs

1989
Lip Synch
'Next' D/A Barry Purves
'Ident' D/A Richard Goleszowski
'Going Equipped' D/A Peter Lord
'Creature Comforts'
D/A Nick Park
'War Story' D/A Peter Lord
5 mins each

*A Grand Day Out**
D/A Nick Park
23 mins
*Produced by the National Film &
Television School and finished with
help of Aardman Animations

Lifting The Blues
D David Sproxton
52 mins

1990/91
*Rex The Runt - How Dinosaurs
Became Extinct*

D/A Richard Goleszowski
2 mins

1991
Rex The Runt - Dreams
D/A Richard Goleszowski
2 mins

Adam
D/A Peter Lord
6 mins

1992
Never Say Pink Furry Die
D/A Louise Spraggon
12 mins

Loves Me…Loves Me Not
D/A Jeff Newitt
8 mins

1993
The Wrong Trousers
D Nick Park
29 mins

Not Without My Handbag
D/A Boris Kossmehl
12 mins

1994
Pib & Pog
D/A Peter Peake
6 mins

1995
A Close Shave
D Nick Park
29 mins

1996
Pop
D/A Sam Fell
5 mins

Wat's Pig
D Peter Lord
11 mins

*Rex The Runt - Pilot "North by
North Pole"*
D Richard Goleszowski
6 mins

1997
Stage Fright
D Steve Box
11 mins

Owzat
D Mark Brierley
5 mins

Rex The Runt Series 1
13 episodes
D Richard Goleszowski
10 mins per episode

1998
Hum Drum
D Peter Peake
6 mins

Al Dente
D Mark Brierley
2 mins

Angry Kid X 3
D Darren Walsh
1 min each

1999
Minotaur And Little Nerkin
D Nick Mackie
2 mins

Angry Kid Series 1 (13 episodes)
D Darren Walsh
1 min each approx

Rabbits! pilot
D Sam Fell
4 mins 20 secs

2000
Aztec Shorts
'Chunga Chui' - Stefano Cassini
'Comfy' - Seth Watkins
'Hot Shot' - Michael Cash
'IQ 552' - Ian Whitlock
'Non-Domestic Appliance' - Sergio
Delfino
'The Drifter' - Andy Symanowski
1 min each

2001
The Deadline
D Stefan Marjoram
2 mins 32 secs

Rex The Runt Series 2
13 episodes Created by Richard
Goleszowski
3 episodes directed by Sam Fell, 3
episodes directed by Peter Peake,
3 episodes directed by Chris
Sadler, 4 episodes directed by Dan
Capozzi,
10 mins each approx

2002
Angry Kid Series 2 (13 episodes)
D Darren Walsh
1 min each approx

Chump
D Sam Fell
4 mins

*Wallace And Gromit's Cracking
Contraptions × 10 episodes*
D Christopher Sadler and Loyd
Price (Originated and Produced
by Nick Park)
2 mins each approx

Vacation
D Scott Pleydell-Pierce
2 mins 15 secs

Hobbies
D Nick Mackie
1 min 30 secs

Lens Lens
D Rich Webber
2 mins 45 secs

White Trash
D Dave Osmand
1 min

2003
The Tales
D Dan Lane A Dan Lane
and Wee Brian
50 secs

Creature Comforts Series 1
(13 episodes)
D Richard Goleszowski
9 mins each approx

The Adventures Of Big Jeff
D Tom Parkinson
1 min 10 secs

2004
Big Jeff
3 Episodes
*Nepal, Didgeridoo, Woollydong
Festival*
D Tom Parkinson
1 min 30 secs × 3

*Angry Kid 'Who Do You Think
You Are?'*
D Darren Walsh
22 mins 21 secs

A Town Called Panic
(English reversioning of original
Belgian production)
20 × 5mins Voice Director:
Richard Hansom

Ramble On (co-production
with South West Screen)
D Tom Parkinson
4 mins 30 secs

Tales For the Rest of Us
(co-production with South
West Screen)
D Carmel Doohan
5 mins 9 secs

2005
Planet Sketch Series 1
D Andy Wyatt

Creature Comforts Series 2
D Richard Goleszowski

2006
Purple & Brown Series 2
D Richard Webber

Off Beat (co-production with
South West Screen + UKFC)
D Will Becher
3 mins

Pib & Pog Series 1
D Peter Peake

2007
Shaun The Sheep Series 1
D Richard Goleszowski

Creature Comforts USA
D Richard Goleszowski

Planet Sketch Series 2
D Alex Stadermann

The Pearce Sisters
D Luis Cook

Chop Socky Chooks
D Sergio Delfino
26 × 2 mins

Stuff Vs Stuff
D Ed Patterson & Will Studd
2 × 1 mins

Live Earth - Angry Kid: Gridlock
D Darren Walsh
3 mins 30 secs

Live Earth - Don't Let It All Unravel
D Sarah Cox
1 min 30 secs

*Live Earth - Anyone Can Make
A Difference*
D David Handley
3 mins 40 secs

2008
Jellybeats
D Peter Peake
3 × short films of between
20 secs and 1 min 5 secs.

*The Surprise Demise Of Francis
Cooper's Mother* (co-production
with South West Screen + UKFC)
D Felix Massie
7 mins

*Wallace & Gromit: A Matter Of
Loaf And Death*
D Nick Park
30 mins

2009
Ringbinders
D Tom Parkinson
3 mins

Timmy time
Creative Producer: Jackie Cockle
D Liz Whitaker & David Scanlon
52 × 10 mins

Pop Promos

1986
Sledgehammer
D Stephen Johnson
4 mins 30 secs approx

1987
Barefootin'
D/A Richard Goleszowski
2 mins 30 secs

My Baby Just Cares For Me
D/A Peter Lord
3 mins approx

1988
Harvest For The World
D/A of Aardman sequence:
David Sproxton, Peter Lord,
Richard Goleszowski
4 mins approx

1996
Never In Your Wildest Dreams
D Bill Mather
5 mins

1998
Viva Forever
D Steve Box
5 mins

Television Sequences/Idents

Victoria Wood (BBC)

Heart Of The Country (BBC)

1986
Pee Wee Herman Show - Penny
(Broadcast Arts New York)
D/A David Sproxton, Peter Lord,
Nick Park, Richard Goleszowski

1987
Spitting Image (Central)
Animation: Peter Lord, Nick Park,
Richard Goleszowski, Dave Alex
Riddett

1988
Comic Relief (BBC)
D David Sproxton

Amnesty International - Concerts
For Human Rights
D Stephen Johnson

Friday Night Live (LWT)
D/A Nick Park

1999
Comic Relief (BBC)
D Richard Goleszowski

2002
The Presentators (5 episodes)
D Stefan Marjoram

2003
The Presentators (5 episodes)
D Stefan Marjoram

The Blobs (BBC3)
D Stefan Marjoram

BBC *Big Read Bookworms*
D Stefan Marjoram

The Blobs: Christmas Idents (BBC3)
D Stefan Marjoram

2004
The Blobs (BBC3) (x18)
D Stefan Marjoram

The Presentators (x11)
D Stefan Marjoram and Wee Brian

Coca Cola: Sky Movies Idents
D Peter Peake

2006
Blobs Comedy Shows
D Stefan Marjoram

Bounty Love Island Idents
D Alan Short

Mitchell & Webb Look Titles
D Peter Peake

Wildscreen Festival 2007 Titles
D Bobby Proctor

Bristol Silents Slapstick Festival Titles
D Bram Twheam

Christmas Stings (E4)
D Darren Dubicki

*Ipa Effectiveness Awards 'Female
Planner' & 'Male Planner'*
The Brothers McLeod

Public Information Films

1991
HIV/AIDS
D David Sproxton/Steve Box
A Steve Box

2001
World Wildlife Fund - Biodiversity
D Luis Cook, Mike Cooper
A Dave Osmand, Terry Brain,
Darren Thomson, Richard Webber,
Charlotte Worsaae, Suzy Fagan,
Martin Davies, Pascual Perez

2006
World Environment Day
D Tom Parkinson

Website Design

2007
*Webbliworld:
Wij's Discovery, Wanda's Icy
Interview, Wez The Worm Charmer,
Wez And The Elephant*
D Tim Ruffle

Commercials

1982-2009
Films completed for the following
clients/products:
Access, Ace Bars, American
Express Travel, Airwick, Ameritrade
Proctor, APA 50, Ariston, Asthma
Awareness, AT&T, Baileys, BBC
Christmas Stings, BBC Big Read,

BBC Digital, BBC This Week,
BBC3 Idents, Bitza Pizza, Bowyers
Sausages, Britannia Building Society,
British Gas, BT, Burger King,
Cadbury's, Calvita, Central Office
of Information, Change4life,
Channel Five idents, Charmin,
Chevron, Chewits, Chupa, Clarks,
Coca Cola, Cookie Crisp, Colgate,
Comfort, Comfort Blue, Cook
Electric, Coronation Street,
Crunchie, Cuprinol, DDRTV,
Daewoo, Daily Telegraph, Dairylea,
Dairylea Dunkers, Dishwash
Electric, Domestos, Dr Pepper,
Duracell, Electricity Board,
Enterprise Computers,
Ferrero/Kinder, Frisps, Frubes, Gain,
Glico Putchin Pudding, Goldfish,
Grolsch, Guardian, Guinness,
Hamburger Helper, Hamlet,
Harvey Nicolls, Henkel, Hershey
Big Kat, Homepride, Hovis, Hubba
Bubba, Imodium, Jacobs, Johnnie
Walker, Jordans Crunchy Bars,
Kangoo, Kellogg's, KP, Knorr,
Leonard Cheshire, Lego, Levitra,
Lifesavers, Lipton, Little Caesars,
Lurpak, Lyles Golden Syrup,
Madame Tussaud's, May Co.,
Maynards, McVities, Naturesweet,
Nestea, Nestle, Nike Footlocker,
Nytol, Orange, Pantene, Perrier,
PG Tips, Polo, Prevacid, Pringles,
Quavers, Quickbrew, Ready-Brek,
Red Energy, Resolva, Rice Krispies,
Ritz Bits, Robinsons, Ruffles, Savlon,
Scotch Videotape, Scottish Health
Education Group, Scrubbing
Bubbles, Serta Mattresses, Shower
Electric, Skittles, Slimquick,
Smarties, Smokester, Snack Pack,
St Ivel, Starburst, Stena Line,
Switchco, Tennent's, Terence
Higgins Trust, Texaco, Total Heating,
Trident, Twistables, Virgin Holidays,
Vodafone, Wagon Wheels,
Walkers, Walmart, Weetabix,
Wendy's, Weetos, World
Environment Day, WWF, Wrigley's,
Zabidoo.

Bibliography

Archer, Steve, *Willis O'Brien:
Special Effects Genius* (McFarland
& Co Inc, Jefferson, North
Carolina) 1993
Bendazzi, Giannalberto, *Cartoons:
One hundred years of cinema
animation* (John Libbey, London)
1994
Bocek, Jaroslav, *Jiri Trnka: Historie
dila a jeho tvurce Statni
nakladatelstvi krasne literatury
a umeni v Praze*, 1963
Canemaker, John, *Winsor McCay:
His Life and Art* (Abbeville Press,
New York, NY)1987
Crafton, Donald, *Emile Cohl,
Caricature and Film* (Princeton
University Press, Princeton, NJ)
1990
ibid, *Before Mickey: The Animated
Film, 1898-1928* (MIT Press,
Cambridge, Mass) 1982
Edera, Bruno & (ed) Halas, John,
Full Length Animated Feature Films
(Focal Press, London) 1977
Frierson, Michael, *Clay Animation:
American Highlights 1908 to the
Present* (Twayne Publishers /
Simon & Schuster Macmillan,
New York, NY) 1994
Halas, John, *Masters of Animation*
(BBC Books, London) 1987
Halas, John & Manvell, Roger,
The Technique of Film Animation
(Focal Press, London) 1968
Harryhausen, Ray, *Film Fantasy
Scrapbook* (Titan Books, London)
1989
Hickman, Gail Morgan, *The Films
of George Pal* (AS Barnes and Co
Inc, South Brunswick, NJ) 1977
Holliss, Richard & Sibley, Brian
The Disney Studio Story (Octopus,
London/Crown, New York, NY)
1988
Holman, L Bruce, *Puppet
Animation in the Cinema*
(AS Barnes and Co Inc,
South Brunswick, NJ) 1975
Home, Anna, *Into the Box of
Delights: A History of Children's
Television* (BBC Books, London)
1993
Horne, Maurice (ed), *The World
Encyclopedia of Cartoons* (Chelsea
House Publishers, New York, NY)
1980
Martin, Leona Beatrice & Martin,
François, *Ladislas Starewitch* (JICA
Diffusion, Bibliography 2 Annecy)
1991
Pilling, Jayne (ed), *Starewich 1882-
1965* (Film House, Edinburgh)
1983
Robinson, David, *George Méliès:
Father of Film Fantasy* (Museum of
the Moving Image, London) 1993
Sibley, Brian (ed), *Wallace &
Gromit Storyboard Collection:
A Close Shave* (BBC Worldwide

Publishing Ltd, London) 1997
Thomas, Bob, *Walt Disney the Art
of Animation* (Golden Press,
New York, NY) 1958
Thompson, Frank, *Tim Burton's
Nightmare Before Christmas: The
Film, The Art, The Vision* (Hyperion,
New York, NY) 1993

Picture Acknowledgments

Our grateful thanks to the
following for permission to
reproduce illustrations:
AB Productions: 38 (courtesy
of the BBC)
Bare Boards Productions:
55 BBC Photo Library (Blobs
and Bookworms)
BFI: 20 © DACS 1998, 21, 24,25,
26t, 26b Condor
Hessisches/SGR/Film Four, 28t
C4, 28b, 39b, 46
Columbia: 47 (courtesy of Kobal)
CM Dixon: 16
Mary Evans Picture Library:
17t & b, 18t & b, 19t
Janie Fitzgerald/Axisimages: 111b
Fremantle Media Ltd (Wind in
the Willows)
Kratny Film Prague (tel.
420.2.32.67091.154) 27
(courtesy of Kobal), 32
Pearson International: 38t
Philips, Eindhoven: 29t
Photofest: 22,29b 30, 31t &
b,36,37,40,48,5t
RKO/Warner/Time: 44 & 45
(courtesy of Kobal)
SC4/BBC/Christmas Films Russia:
34, 35
Touchstone/Burton/Di Novi: 41 &
43 (courtesy of Kobal)
Viacom: 50b (courtesy of Kobal)
Thanks to the following for
permission to reproduce images
from advertising commercials:
APL/Hasbro (Burger King)
Mr Potato Head R is a trademark
of Hasbro, Inc. ©Hasbro, Inc.
All rights reserved. Used with
permission.
BMP/DDB Needham Ltd
(Lurpak, 'Love Story')
Electricity Association (Heat
Electric commercials)
Greys/Starburst Fruits (Starburst)
Lyle's (Golden Syrup)
J. Walter Thompson/Nestle
Rowntree (Polo)
Unilever/Ogilvy & Mather
(Comfort)
Virgin/Sledgehammer
(Sledgehammer)
Young & Rubican/Chevron
(Chevron)
Publicis/McVities
Arnold, New York/Hershey's
Dieste/Hershey's

Index

Page numbers in *italics* refer to picture captions.

Acknowledgments

Many thanks also to everyone at or connected with Aardman who in some way helped to make this book happen, especially:

Photography	Tristan Oliver, Dave Alex Riddett

Text Contributions	Tom Barnes, Steve Box, Helen Brunsdon, Mark Brierley, Trisha Budd, Miles Bullough, Jackie Cockle, Luis Cook, Merlin Crossingham, Robin Davey, Sergio Delfino, Rohini Denton, Darren Dubicki, Andrew Lavery, Dan Efergan, Helen Garrard, Robin Gladman, Richard Goleszowski, Karen Heldoorn, Angie Last, Phil Lewis, Jess McKillop, Julian Nott, John Ogden, Nick Park, Tom Parkinson, Peter Peake, Scott Pleydell-Pearce, Bobby Proctor, Mathew Rees, Adrian Rhodes, Dave Alex Riddett, Tim Ruffle, Nat Sale, Jan Sanger, Dorota Sikorska, Debbie Smith, David Sproxton, Darren Walsh, John Wooley, John Wright

Special Photography

Photographer	Richard Laing
Art Director	Darren Walsh
Producer	Zoe Goleszowski
Animation	Peter Lord, Seamus Malone, Loyd Price, Darren Walsh
Modelmaking	Zennor Box, Jeff Cliff, Will La Trobe-Bateman, Debbie Smith, John Wright, Kevin Wright, Mr Jones the Glassmaker
Modelmaking coordination	Chris Entwhistle, Kerry Evans, Jan Sanger
Set Design	Phil Lewis
Director of Photography	Dave Alex Riddett
Sparks	John Truckle
Rigger	Nick Upton
Additional Artwork	Darren Walsh

Archive Stills/Footage/Artwork

	Kieran Argo, Janie Conley, Maggie O'Connor, Andrea Redfern, Sharron Traer

Special Thanks	Jo Allen, Rachael Carpenter, Alison Cook, Kirstie Cooksley, Mike Cooper, Danny Heffer, Liz Keynes, Julie Lockhart, Helen Neno, Paula Newport, Amy Robinson, Alina Roberts, Michael Rose, Gabrielle Ruffle, Arthur Sheriff, Kate Strudwick, Tom Vincent, Jacqueline White, Amy Wood

A Sears Pocknell book

Editorial Direction	Roger Sears
Art Direction	David Pocknell
Art Direction, third edition	Sam Cox
Editor	Michael Leitch
Proof reader, third edition	Sally Lessiter
Designers	Jonathan Allan, Bob Slater, Sam Cox

First published in the United Kingdom in 1998 by
Thames & Hudson Ltd,
181A High Holborn,
London WC1V 7QX
www.thamesandhudson.com

First published in 2010 in paperback in the United States of America by
Thames & Hudson Inc., 500 Fifth Avenue, New York, New York 10110
thamesandhudsonusa.com

Revised and updated in 2004
This edition 2010

British Library Cataloguing-in-Publication Data
A catalogue record for this book is available from the British Library

Library of Congress Catalog Card Number 2010923360

ISBN: 978-0-500-28906-8

Printed and bound in Singapore by Imago